FIRST
PHOTOGRAPHS

Other books by Gail Buckland:

Reality Recorded: Early Documentary Photography *(1974)*

The Magic Image: The Genius of Photography
from 1839 to the Present Day (with Cecil Beaton) *(1975)*

Fox Talbot and the Invention of Photography (1980)

FIRST PHOTOGRAPHS

People, Places, and Phenomena
as Captured for the First Time
by the Camera

GAIL BUCKLAND

MACMILLAN PUBLISHING CO., INC.
NEW YORK

Macmillan Publishing Co., Inc.
866 Third Avenue, New York, N.Y. 10022
Collier Macmillan Canada, Ltd.

Library of Congress Cataloging in Publication Data
Buckland, Gail.
 First photographs.
 Includes index.
 1. Photography—Miscellanea. 2. Photography—
History. I. Title.
TR147.B92 770'.9 80-23768
ISBN 0-02-518070-3

10 9 8 7 6 5 4 3 2 1

Designed by Philip Grushkin

Printed in the United States of America

To Louis Vaczek
whose knowledge and wit
helped make this book

Contents

Acknowledgments

OCCASIONALLY a friend is also a collaborator and Louis Vaczek, novelist and former Senior Science Editor of the *Encyclopaedia Britannica*, gave unstintingly of his time, ideas, and editorial skills to the making of *First Photographs*. I am deeply indebted to him for his assistance.

Hundreds of people answered inquiries and offered suggestions and without their help this book would not contain as many subjects as it now does. Certain individuals, because of their expertise in particular areas, made especially important contributions. They are: Andrew J. Birrell, Chief, Acquisition/Research, and Richard Huyda, Director, National Photograph Collection, Public Archives of Canada, Ottawa; Yorick Blumenfeld, Grantchester, England; Walter Clark, Rochester, N.Y. (suggested the photograph taken in complete darkness and the Hindenburg explosion taken on Kodachrome); Laverne Mau Dicker, former Curator of Photographs, California Historical Society, San Francisco; Frances Dimond, Royal Archives, Windsor Castle; Dr. Harold Edgerton, Cambridge, Mass.; Thomas Featherstone, Assistant Audio-Visual Curator, Archives of Labor and Urban Affairs, Walter P. Reuther Library, Wayne State University, Detroit; William Frassanito, Gettysburg, Pa. (who suggested the photograph of Fort Sumter, April 12, 1861); Arthur T. Gill, Curator of the Museum, Royal Photographic Society of Great Britain (who suggested the "medical," "story-telling," "movement," and "stereograph" as possible firsts of their kind); Dr. Dorrit Hoffleit, New Haven, Conn. (whose knowledge of first photographs in astronomy is unequalled); André Jammes, Paris; Jerry L. Kearns, Head, Reference Section, The Library of Congress, Washington, D.C.; Fritz Kempe, Hamburg (who made many suggestions related to early Germany photography); Gérard Levy, Paris; Peter Palmquist, Arcata, Calif. (whose suggestions included the pictures of Yosemite, Crater Lake, and Sutter's Mill); Grant Rohmer, Conservator, International Museum of Photography at the George Eastman House, Rochester, N.Y.; Barbara A. Shattuck, Illustrations Requests, National Geographic Society, Washington, D.C.; S. F. Spira, Whitestone, N.Y. (whose private collection proved an excellent source of firsts); William F. Stapp, Curator of Photographs, National Portrait Gallery, Washington, D.C.; Horst Tietzel, Curator of Photography, Deutsches Museum, Munich; and Dr. David B. Thomas and John Ward, both of the Science Museum, London.

Others who gave assistance and to whom I should like to express my appreciation are: Roy Ainsworth, Chief Photographer, Barnardo's, Ilford, England; Michèle Bachelet, Conservatoire National des Arts et Métiers, Paris; Lieselotte Bandelow and Axel Schulz, Ullstein GMBH, Bilderdienst, Berlin; Martin Bander, News Office, Massachusetts General Hospital, Boston; André Barret, Paris; Helga Bauer, Bildarchiv Preussischer Kulturbesitz, Berlin; Mlle. Beausoleil, Collections Albert Kahn, Boulogne, France; Sam Beaufoy, Ipswich, England; H. Becker, Head of Sendebild Department, ADN-Zentralbild, Berlin; Alfred M. Bingham, Colchester, Conn.; Dr. Duncan Blanchard, Albany Center of Atmospheric Research, State University of New York; Hilda Bohem, Associate Librarian, Boni Collection, University of California, Los Angeles; Elise M. Bossi, Curatorial Aid, History Department, The Oakland Museum, Calif.; Neill S. Bruce, Newbury, England; David Buckland, London; Denis Buckland, Sydling St. Nicholas, England; Janet E. Buerger, Ann Copeland, Andrew Eskind, Mariellen Magnera, and Susan Wyngaard, all of the International Museum of Pho-

tography at the George Eastman House, Rochester, N.Y.; Lucinda V. Burkepile, Curator of Photography, New Haven Colony Historical Society, Conn.; Marion S. Carson, Philadelphia; Judy Champolee, Pictorial History Curator, Missouri Historical Society, St. Louis; Cathy Cooper and Doris Jean Waren, Keeneland Library, Lexington, Ky.; Nat Cowan, Bensusan Museum of Photography, Johannesburg, South Africa; Stephen Dalton, Ardingly, England; William Culp Darrah, Gettysburg, Pa.; Janet Davis, Department of Film and Photography, National Portrait Gallery, London; J.S. Dearden, Curator, Ruskin Galleries, Bembridge School, Isle of Wight; Donna De Salvo, Assistant to the Registrar, Museum of Modern Art, New York; Lawrence Dinnean, Curator of Pictorial Collections, The Bancroft Library, University of California, Berkeley; Harvey Dixon, Statue of Liberty N.M., National Park Service, N.Y.; Ute Eskildsen, Museum Folkwang Essen, Germany; Michael Fardell, London; Bonny Farmer, Assistant Editor, and H.K. Henisch, Editor, *History of Photography*, University Park, Pa.; Phyllis Fenner, Manchester, Vt.; Kenneth Finkel, Curator of Prints, The Library Company of Philadelphia; Bill Fitzgerald, Wide World Photos, New York; Bill Flaherty, Rochester, N.Y.; Dennis Flanagan, Editor, *Scientific American*; Roy Flukinger, Acting Curator, and Trudy Prescott, Research Associate, Photography, Humanities Research Center, University of Texas, Austin; Harvey V. Fondiller, Librarian, Photographic Historical Society of New York and Contributing Editor, *Popular Photography*; Linda Forcht, Assistant Director, Rinhart Galleries, New York; John A. Fairfax Fozzard, Cambridge, England; Paulette Gaudet, Rights and Permissions, *Playboy*; Les Gaver, Chief, Audio Visual Branch, NASA, Washington, D.C.; Charles Gibbs-Smith, London; Sheila Gill, Museum Assistant, Scottish National Portrait Gallery, Edinburgh; Elaine Gilleran, Wells Fargo Bank History Room, San Francisco; Dr. Antjekathrin GraBmann, Archiv der Hansestadt Lubeck, Germany; Stephen Green, Curator, Marylebone Cricket Club, London; Adele Greene, Eastchester, N.Y.; Professor L. Fritz Gruber, Cologne; Pamela Haas, Librarian, Photo Collection, Dr. Jane Safer, Department of Anthropology, and Dr. Richard G. Van Gelder, Curator of Mammals, American Museum of Natural History, New York; David Haberstich, Division of Photographic History, Smithsonian Institution, Washington, D.C.; Mrs. Robert H. Haire, International Tennis Hall of Fame, Newport, R.I.; Maj. J.T. Hancock, Head Librarian, Royal Engineers, Chatham, England; Dr. Peter Hansell, Director of Medical Illustration, Westminster Medical School, London; Marion Harding, Director of Photographic Archives, National Army Museum, London; Mark Haworth-Booth, Assistant Keeper, Department of Photographs, Victoria and Albert Museum, London; Dr. M.A. Hayat, Kean College, Union, N.J.; Maria Hedges, Assistant to Dr. J.D. Watson, Director, Cold Spring Harbor Laboratory, N.Y.; Dr. Dyveke Helsted, Thorvaldsens Museum, Copenhagen; Ann Elizabeth Heslop, Archivist, Armed Forces Medical Museum, Washington, D.C.; Klaus op ten Höfel, Curator, Agfa-Gevaert AG, Leverkusen, West Germany; Clive Holland, Curator, Scott Polar Research Institute, Cambridge, England; Tom Hopkinson, University College, Cardiff; Eric Hosking, London; Bernard Howarth-Loomes, London; Betsy Jablow, Department of Photography, Museum of Modern Art, New York; Dan Jones, Peabody Museum, Cambridge, Mass.; Alan Jutzi, Rare Book Department, The Huntington, San Marino, Calif.; Michael Kaplan, Special Collections, The Newberry Library, Chicago; Cherry Kearton, Caterham, England; Ron R. Kinsey, Photo Archivist, Southwest Museum, Los Angeles; Zdeněk Kirschner, Curator, Museum of Decorative Arts, Prague; Gary Klein, Washington, D.C.; Hardwicke Knight, Dunedin, New Zealand; Mary Jane Knight, Librarian, Hawaiian Mission Children's Society, Honolulu; Fred Knubel, Director, Public Information, Columbia University, New York; Clifford Krainik, Graphic Antiquity, Arlington Heights, Ill.; Judith Kremsdorf Golden, Photograph Librarian, Colorado Historical Society, Denver; Dr. Josef

Kuba, Director, Národní Technické Muzeum v Praze, Prague; William Langen-
heim, Holden, Mass.; Robert Lassam, Curator, Fox Talbot Museum, Lacock,
England; Marianne Leach, California State Library, Sacramento; Janet Lehr,
N.Y.C.; Martha H. Liller, Harvard College Observatory, Cambridge, Mass.;
Margaret B. Livesay, Chief, 1361st Photo Squadron, U.S. Air Force, Arlington,
Va.; Bernd Lohse, Leverkusen, West Germany; Patrick Lynch, New York Racing
Association, Jamaica, N.Y.; F.R. Maddison, Keeper, Museum of the History of
Science, Oxford, England; Jerald C. Maddox, Curator of Photography, Library of
Congress, Washington, D.C.; Charles Mann, Chief, Rare Books and Special
Collections, The Pennsylvania State University, University Park, Pa.; John
Mansfield of De Martin, Marona, Cranstoun, Downes, New York; G.A. Matthews,
Department of Botany, British Museum (Natural History), London; Carl Mautz,
Folk Image Publishing, Oregon House, Calif.; Steven Miller, Curator of Pho-
tography, Museum of the City of New York; Harry Milligan, North Western
Museum of Science and Industry, Manchester, England; Philip F. Mooney,
Manager, Archives Section, The Coca-Cola Company, Atlanta, Ga.; Mrs. Allen
Morris, Florida Photographic Archives, Florida State University, Tallahassee;
Richard Morris, London; Anita V. Mozley, Curator of Photography, Stanford
University Museum of Art, Calif.; Lloyd Ostendorf, Dayton, Ohio; Charlotte
Parker, Juliette Gordon Low Girl Scout National Center, Savannah, Ga.; Nissan
Perez, Curator of Photography, Israel Museum, Jerusalem; Barbara Perry,
National Library of Australia, Canberra; Dr. Ursula Peters, Museen der stadt
Köln, Cologne; Rev. Will Philpot, Oxford, England; Anni Praetorius, Senior
Preparator, Buffalo Society of Natural Sciences, N.Y.; Kenneth W. Rapp, As-
sistant Archivist, United States Military Academy, West Point, N.Y.; R.C. Reed,
Royal Geographical Society, London; Jean Reese, Manager, H.H. Bennett Studio,
Wisconsin Dells, Wis.; Jessie Reiss, Brooklyn, N.Y.; Floyd and Marion Rinhart,
Athens, Ga.; Dr. J. Van Roey, Stadsarchief Antwerpen, Belgium; Christianne
Roger, Curator, Société Française de Photographie, Paris; Pauline Rohatgi, India
Office Library and Records, London; L. Roosens, Het Sterckshof, Deurne, Bel-
gium; Richard Rudisill, Curator, Photographic Archives, Museum of New
Mexico, Santa Fe; Gerd Sander, Director, Sander Gallery, Washington, D.C.;
Carol Schonauer, Librarian, Royal Photographic Society of Great Britain, Lon-
don; Barrie M. Schwortz, Santa Barbara, Calif.; Catherine D. Scott, Librarian
National Air and Space Museum, Washington, D.C.; Frank Searle, Loch Ness
Investigation, Inverness-shire, Scotland; Shari Segel, New York; Susan Seyl,
Photographic Librarian, Oregon Historical Society, Portland; W. Eglon Shaw,
Director, The Sutcliffe Gallery, Whitby, England; Anthony P. Shearman, City
Librarian, Central Library, Edinburgh; Mrs. M.P. Smith, Curator, Museum and
Art Gallery, Kingston-upon-Thames, England; Cdr. E.P. Staford, Timonium,
Md.; D.J. Stagg, Archeological Division, and R.F. Thornton, Librarian, Ordnance
Survey, Southampton, England; Faith I. Stephens, Public Information Office, Los
Alamos Scientific Laboratory, New Mexico; Nancy Stevens, New York; D.W.C.
Stewart, Librarian, Royal Society of Medicine, London; D.S. Stonham, Research
Assistant, Historic Photograph Section, National Maritime Museum, London;
Dr. William C. Sturtevant, Curator, North American Division, Department of
Anthropology, Smithsonian Institution, Washington, D.C.; Frances Rainey,
President, James K. Polk Memorial Auxiliary, Columbia, Tenn.; Roger Taylor,
Sheffield, England; Richard Terry, California State Library, Sacramento; Julia
Van Haaften, New York Public Library; Sam Wagstaff, New York; Paul Walter,
New York; M.A. Welch, Keeper of Manuscripts, University of Nottingham
Library, England; Volkmar Wentzel, Foreign Editorial Staff, National Geo-
graphic Society, Washington, D.C.; Raymond E. Westberg, Area Manager,
Sacramento Area State Parks, Calif.; Stephen White, Stephen White's Gallery,
Los Angeles; Phyllis Wiepking, Community Affairs Representative, Geological

Survey, Sioux Falls, S.D.; Elizabeth Wilson, State College, Pa.; Reece Winstone, Bristol, England; Larry A. Viskochil, Curator, Graphics Collection, Chicago Historical Society; and Charlotte Young, Stonington, Conn.

Although all the above gave guidance and help to the project, the author is solely responsible for identifying the photographs as firsts and including them in the book.

And finally, special thanks to Barry, my husband, who supported me, as always, through it all.

Introduction

PHOTOGRAPHY steadily enlarges our knowledge of the world and at the same time inevitably changes the way we view it. We cannot go everywhere, gaze through every microscope, spot every landscape of exquisite beauty, every famous face. We know that in this modern world, photography has the potential to provide us with information, insight, or delight on every conceivable subject. And each photograph was taken by someone with a sense of responsibility to the public or family, for the sake of posterity or the record, for profit, for fun, for art, as an accident—or to have the satisfaction of doing something first.

First Photographs is about the first time things were captured by the camera. The people who took them had never seen that subject, under those specific conditions, depicted as a photograph. This gave the photographer a sense of discovery and achievement, and to anyone else at the time, a sense of discovery and awe. Artists may have made paintings and sketches of the same subject, but they could not compete with the magical accuracy of a lens, for the camera has the power to include details—extraneous to an artist's esthetic purpose—that the human eye seldom picks up. However, a viewer's reaction to a picture of something he has never seen before has nothing to do with whether it is truly the first photograph ever taken of it. But the true first photograph of a subject must be credited with the opening of new worlds for investigation with the camera and often new worlds of the imagination. It is to that end that *First Photographs* is devoted.

The first picture of the planet Earth floating above the moon's horizon, published within days of its being taken, instantly gave us a new vision of ourselves as inhabitants of a small and clouded sphere in the depths of space. No drawing of an imagined view from the moon, no description or formula of planetary relations, had the impact of that first portrait of Mother Earth from the vicinity of her celestial companion, the moon.

If it is true that "seeing is believing," we act on our own private sets of beliefs based in part on what we have all seen. William M. Ivins, Jr., author of *Prints and Visual Communication* (1953), wrote "The 19th century began by believing that what was reasonable was true and it would end up by believing that what it saw a photograph of was true." According to these sentiments, then every first photograph added something to the reservoir of "truths" available to us over the past 140 years. In some way or other, truth about many things had become linked to the charting of new territories—which includes the making of first photographs. We demand them! Our mind's eye is full of pictures of all kinds and the collecting never stops.

But the camera is far more than a picture maker. It also gives quantitative data about how things work or move, about phenomena too small, too fast, too slow, too big, too far away, too complicated, or hidden in darkness. It is a machine that can be attached to other machines to take first photographs of events of which our senses could never become conscious.

And photographs themselves can do much more than just delight or inform or move the viewer—they help us think by providing an image that we can use as a model of reality. Reality is too complex and constantly changing; the model we can contemplate. The physicist needs his bubble chamber photographs not just to identify a new particle but to think about it. Sometimes first photographs are instrumental in developing new theories, not only because they provide new

information but because they jolt the imagination. This is just as true of the first photograph of famine victims as it is of the first photograph of a DNA molecule showing how its parts are arranged as it is of the first photographs of a running horse that illustrated how its legs coordinated.

Each of us sees hundreds of photographs every year that are firsts, for us personally or because they really are firsts. But how many of them are important historically? Each person would draw up a different list for a book such as this. Any selection is therefore quite personal, but the captions generally explain why the photographs are included, or your own laughter will provide the reason.

First Photographs is, in a real sense, one introduction to the history of photography with emphasis upon the evolution of its technology and a study of how the camera fixes an image of reality.

The book is intended to be provocative and cannot escape being controversial. Because finding firsts is an ongoing process in which both scholars and public participate, *First Photographs* establishes reference points against which other photographs can be placed.

During many years of visiting archives and museums and being a curator of many exhibitions, as well as looking at countless publications, catalogues, and journals, I have seen millions of photographs. Without that experience, and a good memory, I could not have undertaken the research for this book. Some firsts were easy to remember because they are seen over and over again, captioned as being the first. The rest had to be discovered. Actually, those identified as firsts may not be, but the errors get perpetuated by historians, and rigorous checking of all such claims was part of the job. For example, even the photograph which everyone has accepted as absolutely the very first—Nicéphore Niépce's "View from his window at Gras"—turned out to have a challenger, as you will see. And the halftone reproduction of "Shantytown" in the New York *Daily Graphic* of March 4, 1880, cited in many sources as the first halftone in a newspaper, was preceded, by more than six years, by another halftone in the same newspaper.

Hundreds of letters were sent to people all over the world explaining the book and asking for suggestions. Specific advice was sought from photographic historians, local history librarians, curators, photographers, government agency staff, university faculties, scientists, engineers, picture researchers, private collectors, and editors. A great number responded enthusiastically, and they are listed in the Acknowledgments. Also, it was necessary to visit dozens of archives in the United States and Europe, the names of which will be found in the Picture Credits. The actual research principles, of course, varied according to the subject and some of these are mentioned below.

In searching for first photographs of explorations, the questions that have to be asked are who?, where?, when?, and did they have a camera? Did the camera work? Did the pictures survive the trip back? Do they still exist? Who sponsored the expedition? Where are they now? Were they ever published? And then there is the delicate question: Was it really taken from the peak? Is this snow field really the Pole?

In science, the maker of a first photograph is a scientist aware of its importance and publishes it with his article in a learned journal. If he claims it is a first, it usually is, and usually its importance is recognized by everyone else in that field.

In trying to locate the visual documents of a nation's history, one turns first to the public archives where the staff has often searched long and hard for firsts, seeing it as part of their job. They already feel quite certain that an image is the earliest extant of, for example, a president of the United States. When the picture is not in their own collection, they often know where it can be found.

Photographs of natural history subjects are also well documented. If someone in the early days of photography shot a charging rhinoceros or a leaping

cougar or a lynx at night with a camera, it was the result of years of pioneer efforts in developing cameras, flash equipment, and methods of tricking dangerous animals to pose for their portraits while assuring their own safety. After a safari, the trophies were published with captions explaining their importance.

There are collections throughout the world devoted to the history of photography itself, and *First Photographs* reproduces the first daguerreotype, the first negative, the first wet-collodion, the first color photograph—all found in such collections. Cameras, lenses, and photographic emulsions have changed vastly over the years, and without an understanding of what was technically possible in any given time, one would not know where to start searching for firsts. There was a time before portraits of people could be routinely made, before action could be stopped on city streets, before plates could be successfully exposed underwater, before bees could be caught on the wing. But one day, each of these goals was accomplished.

There is a photograph in this book of a tornado in 1884, just when hand-held cameras became popular. Attempting a photograph of a tornado prior to this date could only be imagined as a scene in a Buster Keaton comedy: The twister is coming. The photographer sets his large, cumbersome camera on its heavy tripod and tries to focus. The winds sway the camera this way and that. Our hero goes into his dark tent to coat his glass plate with sticky collodion and then sensitize it with silver nitrate. He puts his glass plate in a dark slide and then places it in the unsteady camera. He removes the lens cap. The tornado is almost upon him. He estimates the exposure at two minutes and starts counting. After thirty seconds he decides that his camera has moved and his plate will be blurred, but then he suddenly remembers to look back on his subject: The tornado is upon him and he runs for his life. Thus, in searching for the first photograph of a tornado, one has to assume it would have been made after the introduction in the 1880s of hand-held cameras that used prepared plates one could buy in a store with exposure speeds in seconds.

In hunting for the first color photographs, the closer the date of the picture to 1907, the more likely it is to be a first. Although in the nineteenth century there were attempts at developing a practical color photographic process, none were successful until the Lumière Brothers of France marketed the autochrome in 1907, a system anyone could use. That most irresistible subject for the color photographer—a sunset—was first done with autochrome.

Albert Kahn, a French multimillionaire banker and friend of the Lumière Brothers, was intrigued by the possibilities of using color photography to bring about understanding and cooperation among the peoples of the world (the names of some of his foundations were "Scholarships around the World," "Circle around the World," "Archives of the Planet"). In 1910 he decided to equip photographers with two new inventions—autochrome plates and movie cameras—and send them to every corner of the world. Kahn's goal was "to establish a sort of photographic inventory of the surface of the globe, inhabited and shaped by mankind, as it looks at the beginning of the 20th century." By 1931, when he stopped funding the project, his teams had made color photographs—many being firsts—in Afghanistan, Albania, Algeria, Austria, Belgium, Bulgaria, Cambodia, Canada, China, Cyprus, Dahomey, Egypt, England, Germany, Greece, Holland, Hungary, India, Iran, Iraq, Ireland, Italy, Japan, Monaco, Morocco, Outer Mongolia, Norway, Palestine, Saudi Arabia, Spain, Sweden, Switzerland, Syria, Viet Nam, Thailand, Tunisia, Turkey, and Yugoslavia. The autochromes are now carefully kept in a special archive on the outskirts of Paris.

But not all photographs have had such a propitious fate. Photographs are perishable objects and for the last century and a half countless numbers have deteriorated, been lost, or destroyed. Among these were many that were known as firsts because there are engravings of them. But since the aim of *First Photo-*

graphs is to show the reader what the actual photographs looked like, no wood-cut, engraving, or lithograph is included, no matter how faithfully the artist tried to copy the original photograph.

In 1839 and 1840 many daguerreotypes were made for a publishing project organized by the French optician N.P. Lerebours. They were copied by artists and reproduced as aquatints in *Excursions Daguerriennes. Vues et monuments les plus remarquables du globe* (1840-42). Unfortunately, this damaged most of the daguerreotypes, and those that were not destroyed have apparently been lost. But because the publication contained so many firsts, it is important to mention the subjects of the daguerreotypes: Algeria, America (a H.L. Pattinson of Newcastle-on-Tyne made the first photograph of Niagara Falls), Egypt (Luxor, Pyramid of Cheops, the Valley of the Kings), England (St. Paul's Cathedral, Cleopatra's Needle), France (forty-eight views including Avignon, Chartres, Bordeaux, Grenoble, Lyon, Normandie, Fontainebleau, Versailles), Germany (Hotel de Ville, Bremen), Greece (the Acropolis and Parthenon), Italy (twenty-eight views including Florence, Naples, Paestum, Pisa, Rome, Venice, Milan. Note: The plate of the Roman Forum still survives and is reproduced here), Nubia (Philae), Palestine (Jerusalem), Russia (Kremlin, Moscow in the snow), Saint Helena, Sardinia, Savoy (Mont Blanc), Spain (the Alcazar, the Alhambra, Granada), Sweden, Switzerland, and Syria.

The earliest copy of a stereo-photograph is a lithograph of the sterograph made with Sir David Brewster's binocular camera and published in the Transactions of the Royal Scottish Society of Arts (Vol. II, part IV, 1850), but the original seems to have been lost. It is well documented that the first high-speed photograph was made by William Henry Fox Talbot in 1851 when he photographed a piece of paper with writing on it. He attached paper to the face of a spinning wheel which was sychronized with a very quick bright flash. However, there is not even an engraving, not to mention the photograph itself, to show the result.

In 1843 the Langenheim Brothers of Philadelphia made what is considered the first advertisement with a photograph. It is a daguerreotype of a group of gentlemen enjoying themselves at a table in a restaurant which wanted to attract patrons. The picture, probably no more than 6 by 8 inches, was hung in a corridor of the Exchange building in Philadelphia, which housed both the restaurant and the Langenheim's studio. Presumably it was successful in informing people about the restaurant, although it provoked a storm of protest by people who said that it was "demoralizing" to show men drinking. Advertising photography (like all advertising) never had an age of innocence.

Of course, there are other significant firsts—many I know of, but was unable to obtain. One, for example, is the earliest photograph of a Pope (Pius IX blessing the Column of the Immaculate Conception in Rome on September 8, 1857). Another is the earliest extant photograph made in Japan, a daguerreotype portrait of a Japanese nobleman taken in the 1840s. Before the recent discovery of this photograph, an 1857 one was the earliest known photograph taken in Japan.

Interesting photographs which mark the beginning of certain esthetic considerations have, for the most part, not been included. How does one know if an early photograph shows a tilted horizon, a distortion, a solarizing effect, an unusual camera angle, high contrast, low contrast, that it was made intentionally or accidentally?

There are first photographs of everything. Most can never be identified, many are not worthy of note. By no means is *First Photographs* a definitive list, or an absolutely accurate one. If the reader has suggestions for other firsts or finds mistakes, then the author would like to be the *first* to know, and changes or additions will be duly acknowledged in a second edition.

FIRST
PHOTOGRAPHS

King of Siam. The real king of *The King and I* sits as if eternal on his royal throne. The hand-colored and now tarnished picture by an unknown daguerreotypist of the 1850s portrays the King of Siam as he must have wanted to be seen by the Queen of England, to whom this token of friendship was sent. Photography had the magic to allow two monarchs, thousands of miles apart, one glittering in gold and the other austere and matronly, to look each other in the eye. What exactly Queen Victoria thought when she gazed at Somdetch Phra Paramendr Maha Mongkut can only be conjectured. What the Major King of Siam thought when he saw Victoria's portrait is the stuff of which musical comedies are made.

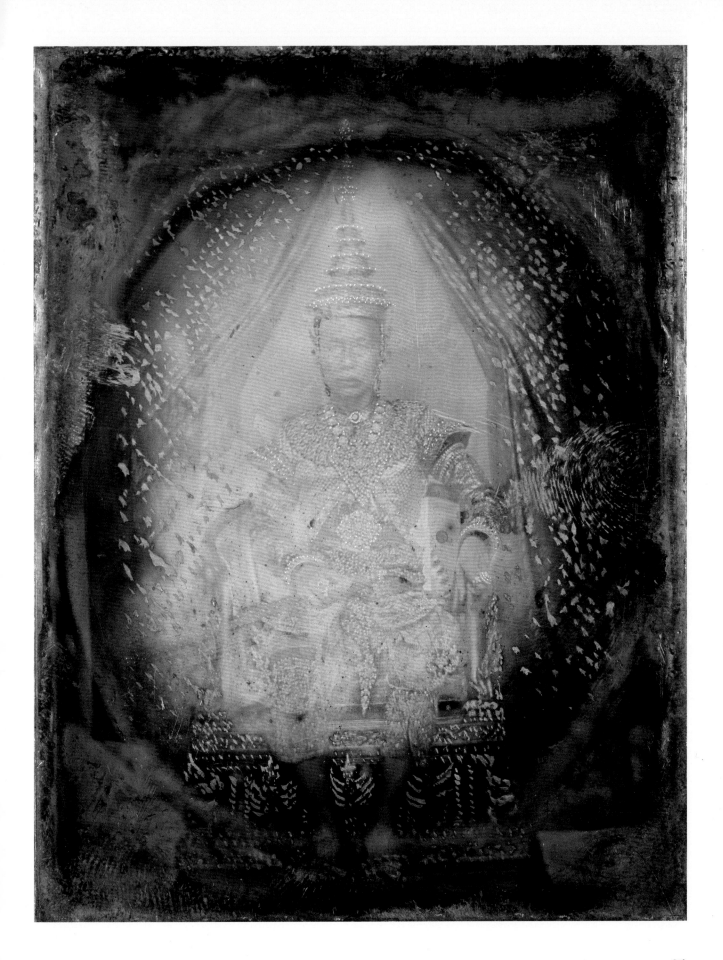

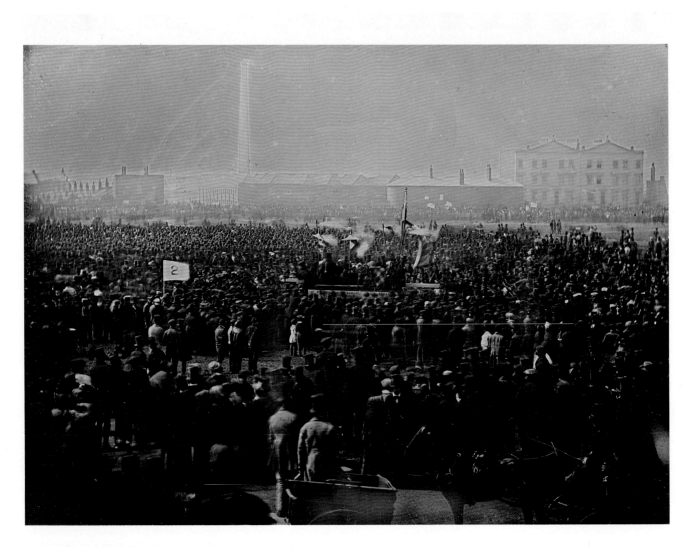

Mass rally (Chartist). The *Columbia Encyclopedia* states that the Chartist meeting—Chartism was an English working-class political movement—due to be held in April 1848 never took place. But this hand-tinted daguerreotype *was* taken on April 10, 1848, of the Great Chartist Meeting at Kennington Common, London. Looking at the photograph, it is hard to argue that the event never happened.

 The Chartists were demanding greater representation in government and a better way of life. Their six points—universal male suffrage, vote by ballot, equal electoral districts, annually elected parliaments, salaries for members of Parliament, and abolition of property requirements for those desiring public office—helped to rally poor people all over Great Britain and started discussions on other issues such as shorter work days and better working conditions. The photograph was made when the movement was nearing its end; it was but ten years old. It shows men, women, and children congregated before a factory with a chimney rising like a church steeple, marking the powerful new world of industrialization.

India. The earliest paper photographs appeared in an assortment of colors, due to the variations in every step of the production of the picture, especially in the fixer used. In different climates, too, the temperature and humidity affected tints. This photograph, circa 1843, is from the first group ever made in India. Who the photographer was and where it was taken is not known. He was a romantic, however, pasting his photogenic drawings and calotypes into an album containing poetry, paintings, and engravings.

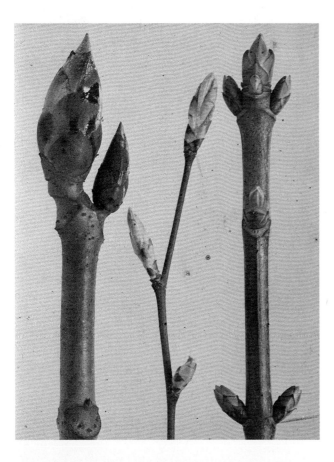

Ulva latissima.

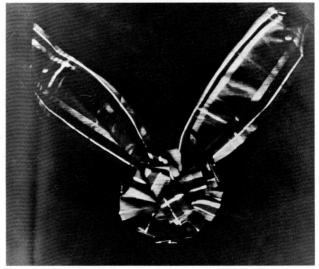

Sticky buds in color. The first popular process for making color photographs was invented in 1903 by Auguste and Louis Lumière and was called the autochrome. It was based on the use of equal amounts of microscopic starch grains dyed red, green, and violet mixed and sifted onto a sheet of glass with a tacky surface that was then coated with a pancromatic emulsion. This plate was then exposed in the camera, starch grains toward the lens.

When the autochrome came on the market in 1907, the most popular subjects to be photographed in color were floral arrangements and children. However, an Englishman, Henry Irving, already a professional nature photographer, immediately used the color plates to make botanical studies. The *Aesculus hippocastanum*—or sticky bud of the horse chestnut tree—seen here was one of his earliest.

opposite, bottom left:

Algae. In 1842, the astronomer Sir John Herschel presented a paper to the Royal Society describing a process he invented and called the cyanotype (blueprint). This, with his other major contribution to photography—the use of hyposulphite of soda (hypo) as a fixer—are still used today. The picture was made by a remarkable Victorian, Anna Atkins (1797-1871), who, between 1843 and 1854, in Fox Talbot's own words, "photographed the entire series of British seaweeds, and most kindly and liberally distributed the copies to persons interested in botany and photography." The first part of her *British Algae: Cyanotype Impressions*, which was issued in parts over ten years, with pages exclusively blueprints and devoid of set type, predates even the first book with a photograph, *The Record of the Death Bed of C.M.W.*

Although Atkins gave the volumes to a number of institutions and individuals, they are probably more accurately described as albums rather than books. In the introduction to her work, Mrs. Atkins mentioned "the difficulty of making accurate drawings of objects as minute as many of the Algae and Conferva, has induced me to avail myself of Sir John Herschel's beautiful process of Cyanotype, to obtain impressions of the plants themselves. . . ." The Prussian blue of this photographic process, which uses iron salts rather than silver salts, is not suitable for many subjects but it is a perfect background color for seaweed.

opposite, bottom right:

Color photograph. James Clerk Maxwell is often ranked next to Newton for his fundamental contributions to science. One was his explanation that light is an electromagnetic wave; it was also he who formulated a theory of color photography based on three primary colors. He showed that any subject could be broken down into three primary colors and that by "adding" them up again, they would produce a color photograph.

In 1861, Maxwell produced the first color photograph—of the tartan ribbon— although he could achieve this only by projecting three black and white transparencies through color filters. His process was this: photograph an object three times—once through a blue filter, once with a red filter, and once using a green filter. Then, using a magic lantern, project each of the three positive transparencies through the same color filter that it was photographed by, in such a way that the images are superimposed on the screen. The picture that results is in color.

Aerial. In 1855, the Frenchman Nadar (pseudonym for Gaspard-Félix Tournachon), well known as a caricaturist and portrait photographer, patented the idea of photographing from a balloon for surveying and mapmaking. In 1858, he achieved his first success, as seen here. In the same year Nadar went below the streets of Paris and, using electric lights, photographed in the city's ancient sewers. He liked to say that he was the first man to take pictures from the sky and underneath the ground.

Daumier thought his friend's struggles with wet-plate equipment high up in a balloon worthy of a cartoon and in 1862 produced a lithograph titled "Nadar Raising Photography to the Height of Art."

Aerial in the United States. On October 13, 1860, James Wallace Black, a Boston society photographer, and his partner Samuel A. King, an early balloonist, rose in a tethered balloon "The Queen of the Air" to a height of 1200 feet above Boston. They made eight wet-collodion negatives, of which only this one turned out. Generally, on a windy day, a tethered balloon swings in great arcs, and even if it was not too windy on that day, the balloon must still have been quite unsteady, making the coating of the plates a comedy of errors and the steadying of the camera for the long exposures equally funny. It is not surprising that the yield was so low. Air sickness is also common under such conditions, but in any case the two men made the first aerial photograph in America.

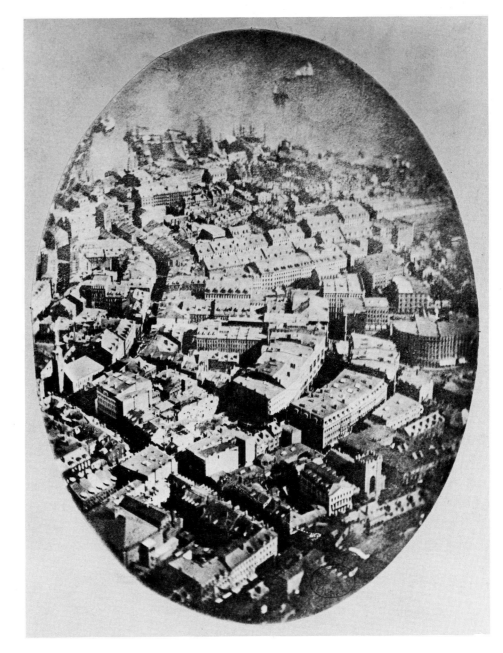

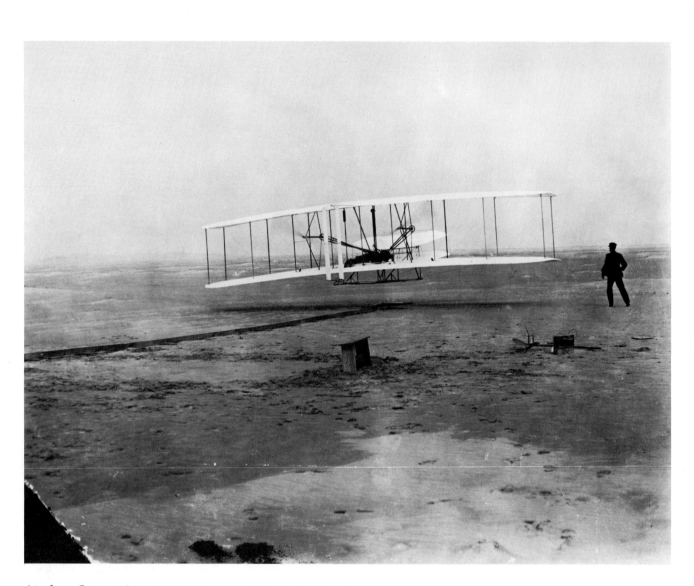

Airplane flying. This photograph of the Wright brothers' invention on its first successful takeoff is famous. It shows Orville at the controls and Wilbur just letting go of the wing that he was steadying as he ran alongside the plane. The picture was taken by a friend, John T. Daniels of the Kill Devil Life Station. The place where this 12-horsepower bird flew was, as everyone knows, Kitty Hawk, North Carolina, December 17, 1903. Many octogenarians can remember that momentous day as they climb aboard a jumbo jet. The brothers are generally thought of as super-tinkerers who, because they manufactured bicycles, could fool around with the pipes and wires of flying machines. On the contrary, because of their studies of other men's failures, and especially their own researches and trial designs, they knew more about the aerodynamics of flight than anyone else in the world at that time.

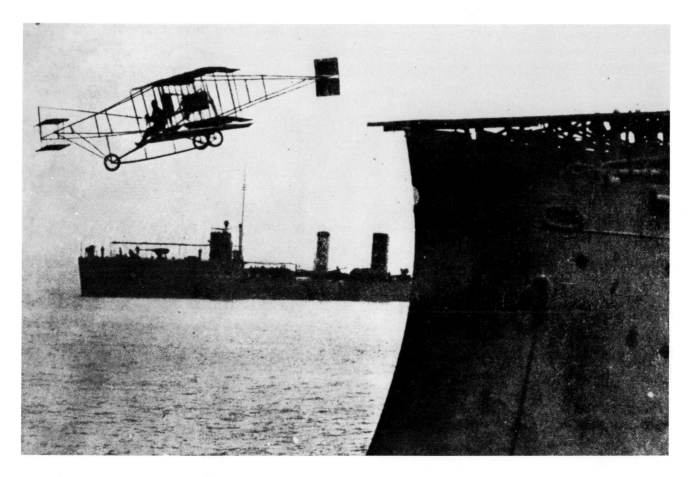

Aircraft carrier. On November 14, 1910, a warship's deck was adapted for the takeoff of this handsome aircraft. The incredibly brave pilot was Eugene Ely. Who was the cameraman and where was he? Was he a sailor who happened to have a Kodak? Or a press photographer who had planned to witness the event? Whoever he was, it was more fun being there with a camera than without one.

Airline passenger service. On January 1, 1914, the world's first scheduled airline service began between St. Petersburg and Tampa, Florida. The seaplane, or, as it was called, the air boat, carried one passenger and cargo. On the right is Tony Jannus, looking more like a matinee idol than a pilot, while the passenger in the center looks more like a mayor than a daredevil. He is, indeed, Mayor A.C. Phiel of St. Petersburg, who paid four hundred dollars for a ten-dollar ticket; nobody disputed his right to be the first passenger. On the left is the General Manager—who looks the part—of the Benoist Air Craft Company of St. Louis, which built the airplane. The usual thrill seekers have climbed poles in the background.

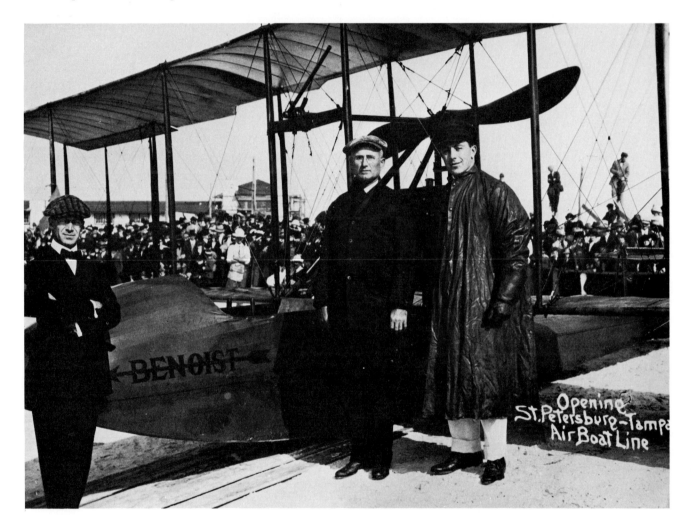

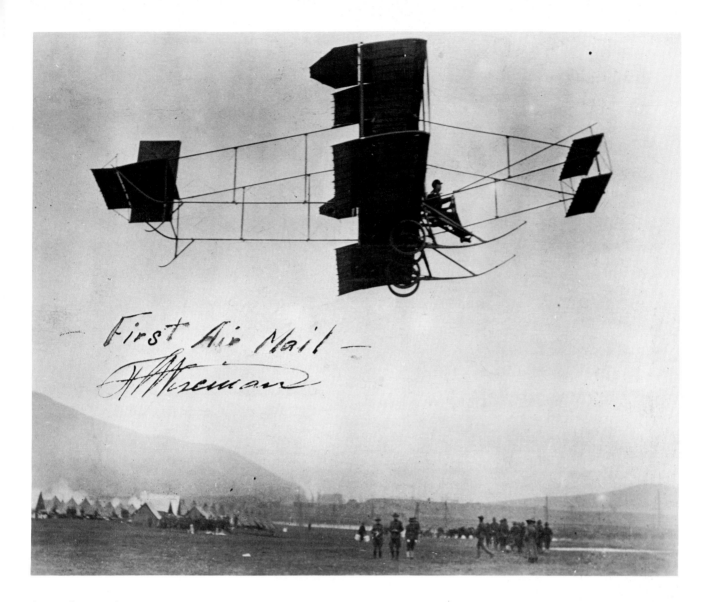

First Air Mail —
F. Wiseman

Airmail. On February 17, 1911, Fred Wiseman carried the first airmail in the world, in a plane he built himself, from photographs of the Wright brothers' plane. The flight from Petaluma to Santa Rosa, California, lasted twelve minutes. In addition to the letters from the mayor of Petaluma to the mayor of Santa Rosa, he also carried a sack of groceries and the morning newspapers. Wiseman once said, "I knew I flew the first airmail, but Earle Ovington's widow used to get a big kick out of her husband being first so I never said anything about it."

 After making improvements to his airplane, Wiseman shipped it to fairgrounds in northern California. "We couldn't set up," said Wiseman, "for less than five hundred dollars. But people were satisfied just to see it go up in the air. You didn't have a stunt—just fly up and come down. But you couldn't play a second day or they'd all stand outside the grounds instead of paying to come in. They found out they could see just as well that way." Wiseman went into the automobile business. Of flying he said, "I got out in 1913. Didn't see much future in it."

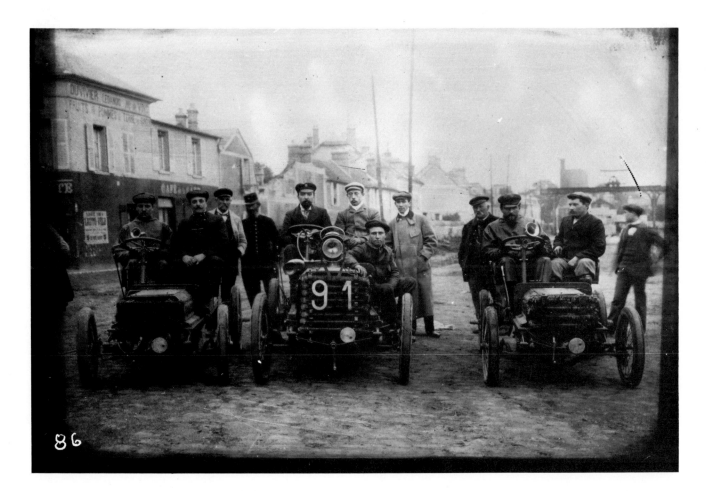

Automobile race. On July 22, 1894, twenty-one cars set off at 8:00 A.M. from Paris toward Rouen in what was called a reliability test, organized by the newspaper *Petit Journal*. The first true automobile was built in 1769 by Nicolas-Joseph Cugnot of France; it ran on three iron-shod wheels, had a monstrous boiler like a spider's pod hung outboard, and hit 2½ miles an hour. Carl Benz and Gottlieb Daimler independently developed the internal combustion engine and during 1885 and 1886 built their first cars; others had preceded them with experimental models.

Putting the engine where the horse used to be, running the thrust to the back wheels as if they were a horse's hind legs, and sitting between the legs on the contraption's back seemed logical. Holding on to the steering wheel, in lieu of reins, and keeping in mind the need to feed, groom and doctor the beast regularly, the driver became a knight in shining armor mounted on a gloriously mechanical charger. The men in this picture, photographed eighty-six years ago, really started something—the idea that me and my machine can go faster and faster and faster. Giddyap! Whoa! *You are now entering a 30-mph speed zone.*

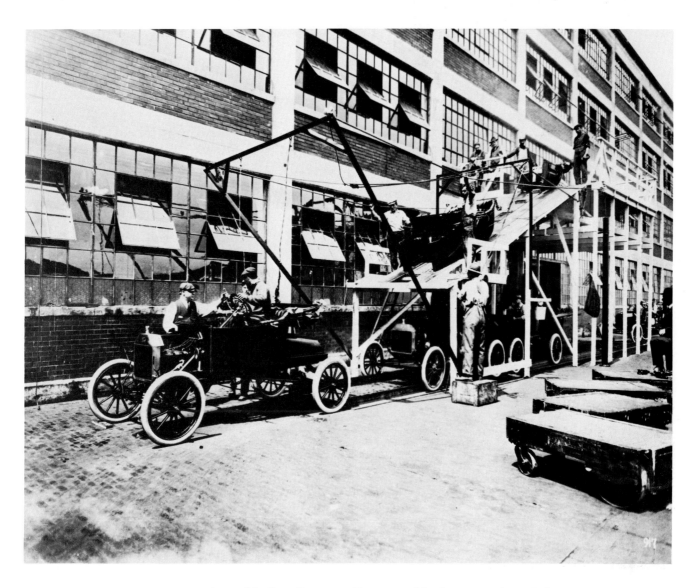

Assembly line. By 1913, Henry Ford had put together all the elements necessary to mass-produce Model Ts, at his plant in Highland Park, Michigan. Many of these principles were already commonplace in other industries, for example, the meat-packing plants attached to slaughterhouses. The basic principle was to move the object slowly past stationary workers, each of whom performed a different operation on it. Just as important was the interchangeability of parts worked out by ship block makers and gun manufacturers long before.

The Model T, selling for a few hundred dollars, helped transform America from a lingering colonial, largely rural, nation to the world's foremost industrial giant, but it also ran on its skinny wheels all over the world. Its incredible success came from its incredible reliability, and anyone, even illiterates, could be taught to maintain it with a few simple hand tools.

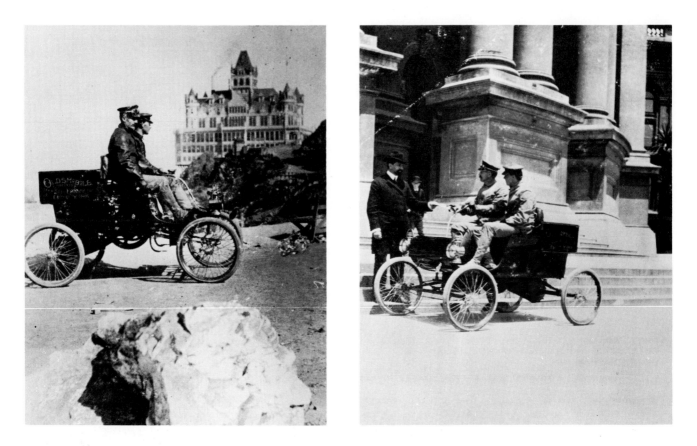

Automobile crossing of the United States. Not only do these pictures record
the pioneer automobile trip from sea to shining sea, they also show the mayor of
San Francisco asking the drivers, Lester Whitman and Eugene Hammond, to
deliver his letter to the mayor of New York City. On July 6, 1903, the
rear wheels were wet by the Pacific and on September 22 the front wheels kissed
the Atlantic.

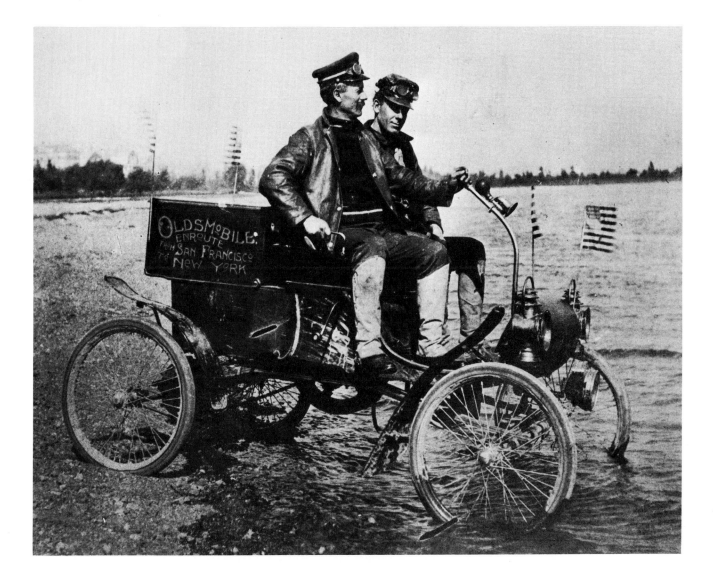

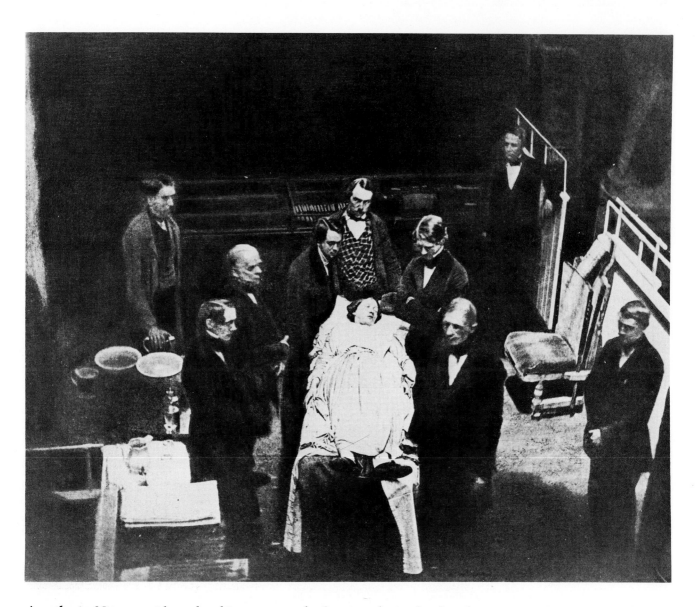

Anesthesia. Nitrous oxide, or laughing gas, was the first anesthetic, developed for use in 1844. Ether and chloroform soon followed. On October 16, 1846, painless surgery was demonstrated in the Massachusetts General Hospital's Ether Dome. Soon after, daguerreotypes of the reenactment of the earliest operations performed using anesthetics were taken. Until then, pain was a normal part of living and dying.

Ether made agony avoidable and it became the doctor's duty to prevent pain. This developed a hitherto impossible view of ethics concerning problems that involved human suffering of any kind, not just physical, but also mental, emotional, social, and even financial. Because pain has become something that can be eliminated, any cost is justified; to allow pain to persist is considered criminal.

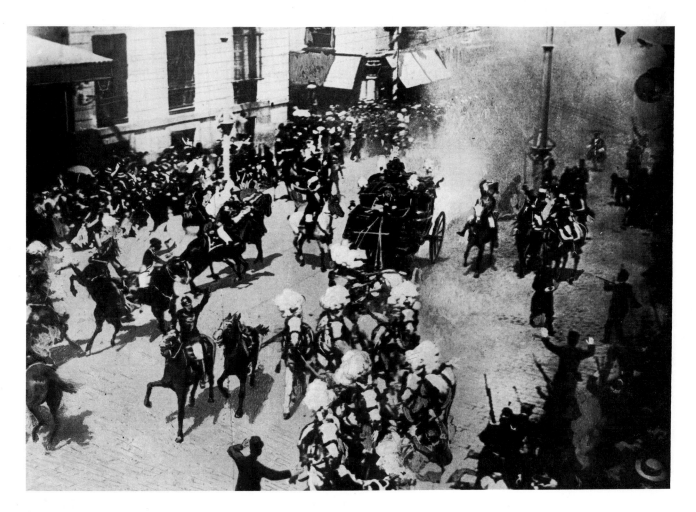

Assassination attempt. On his wedding day in 1906, King Alfonso of Spain was the target of an assassin, who ran out of the Madrid crowd with a gun. The attempt failed. A London *Daily Mirror* photographer was there and took this picture but when he discovered that the Madrid to Paris train would be delayed and would therefore miss the Dover ferry, he commissioned racecar driver M. Fournier to meet the train in Paris, pick up the plate, and race with it to Calais. After a drive reported as one of the wildest in history, he made the connection.

Ever since the 1880s, when the first photographs were reproduced by halftone in newspapers, the daily press has peddled picture scoops, and for years, *The Daily Mirror* (of London) was days ahead of its rivals. Like many aspects of civilization, the assassination of rulers is as old as Egypt and always makes good copy.

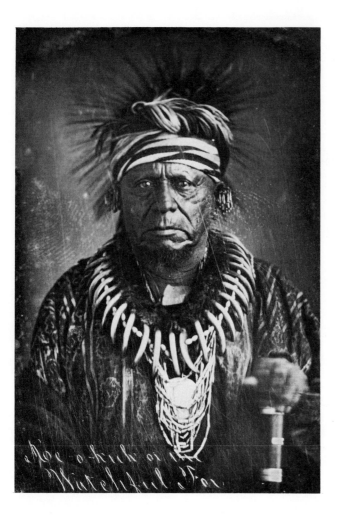

American Indian (in America). When President Thomas Jefferson greeted the first delegation of Plains Indians to Washington in 1804, a year after the United States had acquired the Louisiana Territory, he was so impressed with their appearance that he said they were "the finest men we have ever seen." A French artist, Charles Balthazer Julien Févret de Saint-Mémin, was asked to make portraits of them and did so using a mechanical device known as a physiognotrace. It was not until four decades later that a daguerreotypist named Thomas Easterly made the first photographs of Indians on American soil.

Easterly probably began photographing Sauk, Fox, Plains, and Iowa Indians in 1846 or 1847. The advertisement he ran in the St. Louis, Missouri, newspaper said he made "likenesses of Distinguished Statesmen, Eminent Divines, Prominent Citizens, Indian Chiefs, and Notorious Robbers and Murderers" as well as landscapes and "a Bona Fide Streak of Lightning, Taken on the Night of June 18th, 1847" (see Lightning).

Taken in 1847, this photograph is of Keokuk (Watchful Fox), who was chief of the Sauk and Fox tribes and who died the following year. It is not known if Easterly traveled to Keokuk's reservation in Kansas or if Keokuk sat for him in his studio, 60 miles away in Liberty, Missouri. Other early photographers of Indians were S.N. Carvalho, W.H. Jackson, J.M. Stanley, T. O'Sullivan, C. & W. Bell, C. Watkins, J. Hilliers, and A.Z. Shindler.

opposite:

American Indian village. By the time cameramen wandered West, the Indian's ways of life were well known from the work of exploring painters and writers. These tepees were photographed probably by S.N. Carvalho, an artist and daguerreotypist on John Charles Frémont's expedition of 1853-54, made to survey a southern route for the transcontinental railroad.

What photographs added to the public's knowledge of Indians were mostly humdrum details of housekeeping, and the finer characteristics of racial features. However, some nineteenth-century photographers dressed up Indian models in trappings they carried around with them for this purpose; these supposedly documentary pictures would be more marketable back East than the genuine versions. But this chicanery was the exception rather than the rule, and early photographs of Indians constitute some of the richest and most sensitive notations to the history of America.

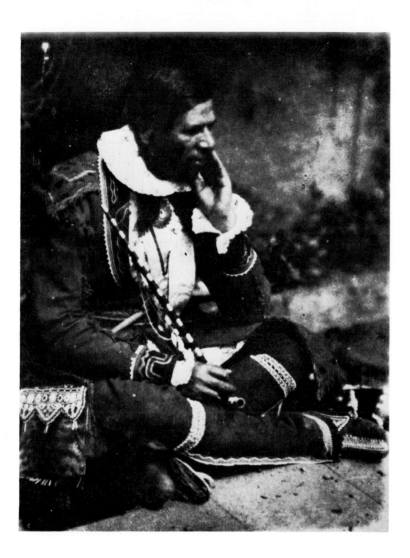

American Indian. Columbus was the first to show Indians to Europeans, and through the centuries, many were taken on tours organized by impressarios and circuses. The first photograph of an American Indian was taken not in the Western Hemisphere but in Scotland, and the Indian was on tour not as an oddity in a sideshow but as a lecturer on theological subjects. Kahkeqaquonaby ("Sacred Waving Eagle's Plume"), or the Rev. Peter Jones, as he was also called, was the son of a Welshman, Augustus Jones, and a Mississauga Indian from Ontario. He was raised with the tribe until the age of sixteen, when his father took him away and had him baptized. He later became a missionary to the Indians and on four occasions visited Britain. On one trip, sometime between October 1844 and April 1845, he was photographed by the Scottish calotypists Hill and Adamson. For years historians thought that the sitter was not an Indian but a Scotsman dressed up to look like one.

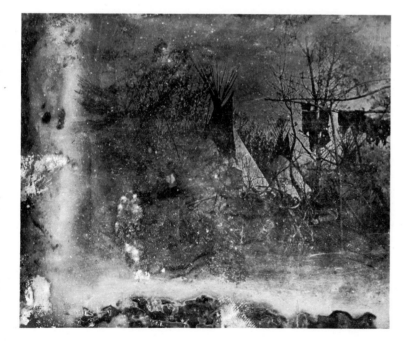

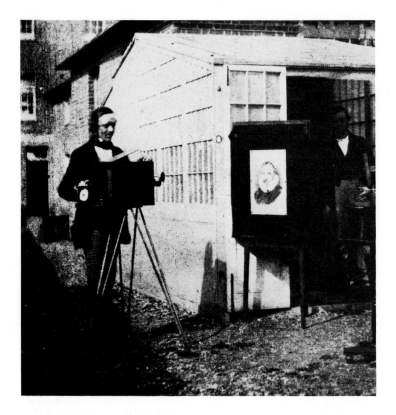

Art book. The first published photographic reproductions of works of art appeared in Talbot's *The Pencil of Nature* (1844-46). The first art book illustrated with photographs was William Stirling's *Talbotype Illustrations to the Annals of the Artists of Spain* (1847). The painting on the easel in this picture (a detail from the panorama of Talbot's printing establishment at Reading) is being copied by a photographer for inclusion in the latter.

Before the invention of photography in the 1830s, the layman and the scholar were dependent on illustrators' interpretations of a painting or sculpture. With photography, people had an accurate reproduction and felt justified in criticizing the work from the copy. Even the texture of a sculpture was ascertainable from a photograph. Often a picture called a masterpiece by the few authorities who had studied it was seen as something else by the growing numbers who now had good copies to look at. Art history books had to be rewritten.

The camera, as a machine, not only eliminated from the copy of the painting or sculpture another artist's distortion and expenses but also multiplied enormously the number of pictures copied. And they were vividly realistic compared to, for example, those done as etchings. With photography, everyone could now have a collection. The camera popularized art. A nineteenth-century painter often received more money from the sale of photographs of his painting than he did for the sale of the canvas. And painters began to feel that the camera freed them of the responsibility to record certain aspects of nature and of society with fidelity and they moved toward impressions, cubism and abstraction.

opposite:

Art exhibition (indoors). Gustave Le Gray, a painter and photographer, made the first photographs at art exhibitions. The picture shows sculpture exhibited in the Paris Salon of 1850-51 at the Palais Royal. The pieces are naturally lit and the waxed-paper negative was able to reveal their soft lines and textures.

The picture opposite, below, was made the following year at the Louvre. Many of the paintings are familiar to visitors to the museum, but the manner in which they are presented has changed over the years. The crowding of objets d'art (clutter) in the Victorian home seems to have been inspired by the museums, which after all do set cultural tastes. Framing was big business.

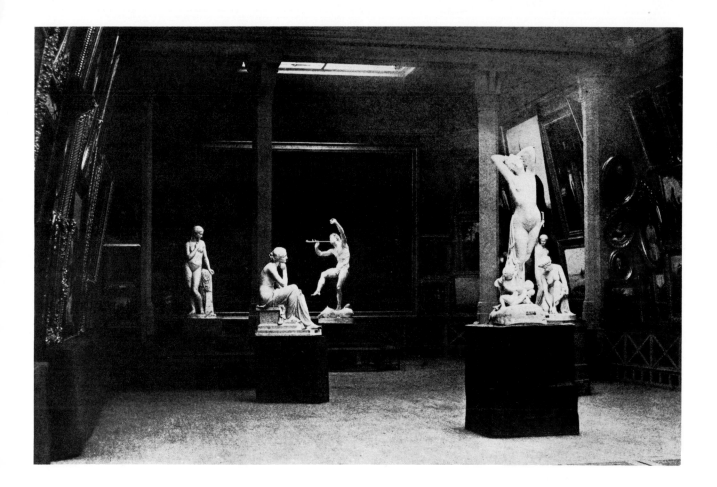

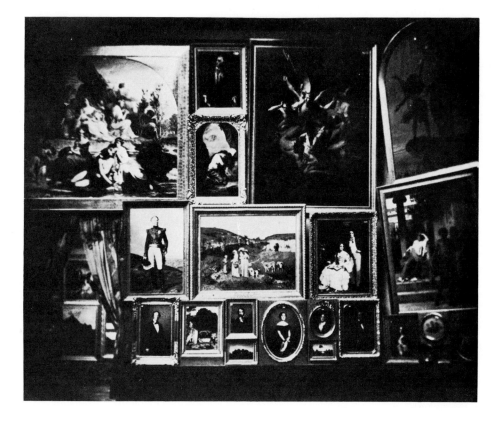

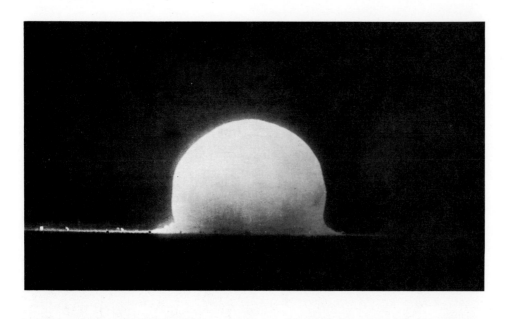

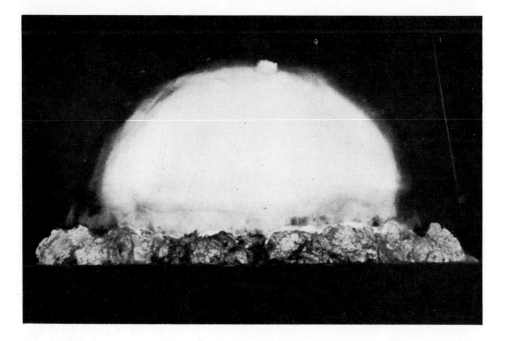

Atom bomb. The vast mushroom cloud of a nuclear explosion, symbolizing instant annihilation of all things within its realm, first appeared July 16, 1945, over the desert at Alamogordo, New Mexico. Total destruction spread more than a mile in all directions beneath it. This sequence shows the incredible speed with which the debris and torn-up earth begins to rise many miles, mingled with radioactive dust. The heat, light and winds that radiated from the cloud proved that this plutonium bomb had released energies never before dreamed of.

On August 6—three weeks later—a uranium bomb was triggered above Hiroshima (opposite). Two-thirds of the city was completely vaporized, blown away, or burned, and seventy-five thousand inhabitants were killed in that instant by the innocent-looking smoke shown in the picture. The blow it delivered amounted to that of twenty thousand tons of TNT. Today's arsenal of atomic bombs worldwide can destroy more than two hundred thousand Hiroshimas.

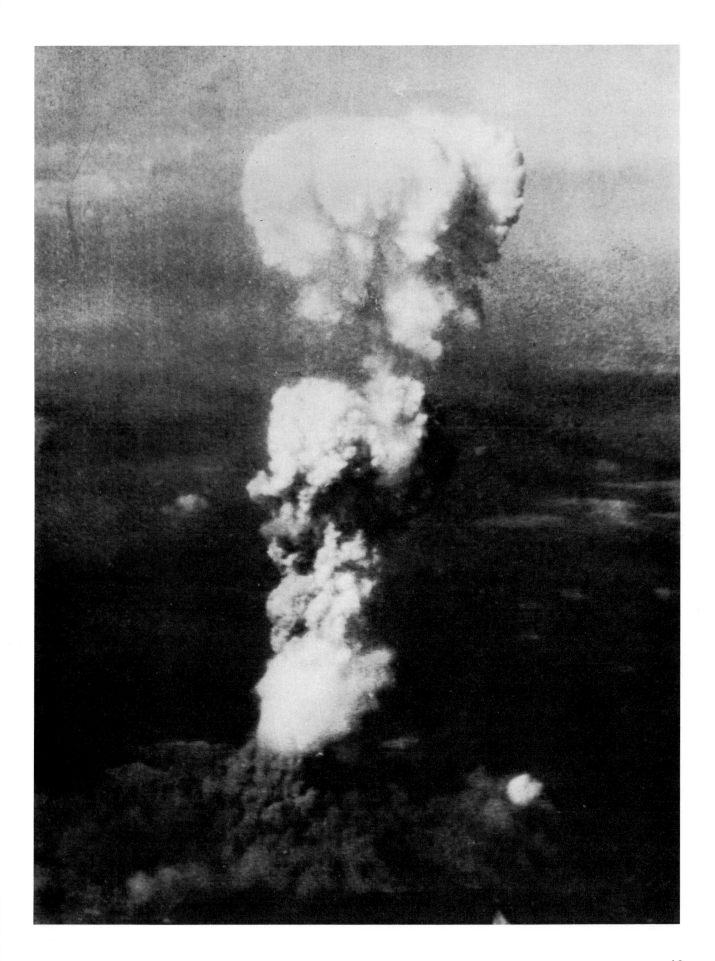

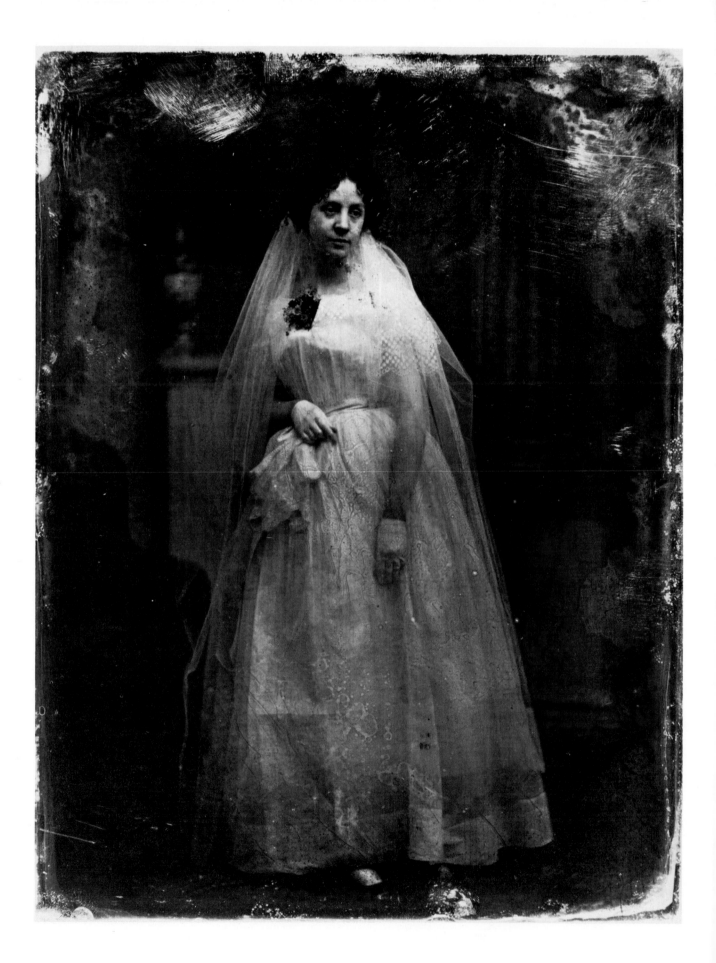

opposite:

Bride. The daguerreotypists Southworth and Hawes made a number of bridal portraits during their years of operation, 1843-62. Here a young woman poses in her wedding dress in their Boston studio about 1854. Her expression is rather more serene than the usual excitement seen on a bride's face moments before or after the ceremony.

Bridesmaids. On her wedding day, January 25, 1858, when she was eighteen, Victoria, the Princess Royal of England, was photographed with her parents, Queen Victoria and Prince Albert. Her bridesmaids, shown in this photograph by Caldesi, were the Ladies Lennox, Hamilton, Molyneux, Murray, Clinton, Stanley, Villiers, and Noel. The bridegroom was the German Crown Prince, who later became Emperor Frederick III, thus turning Vickie into the Empress of Germany. What wedding is complete without someone present to make the photographs?

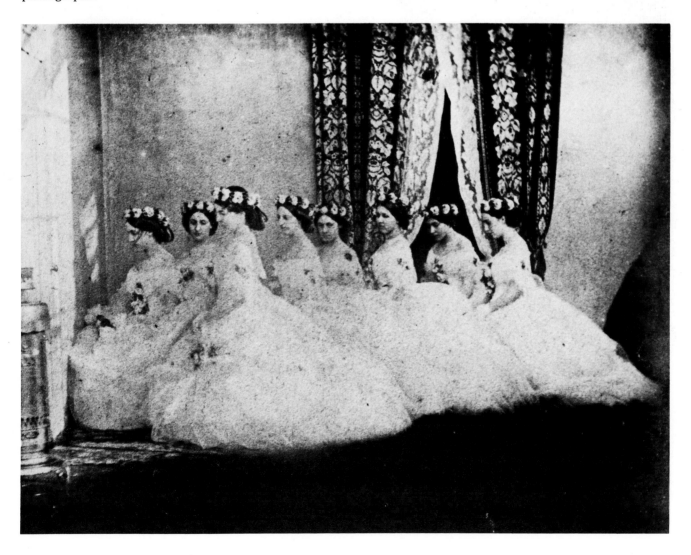

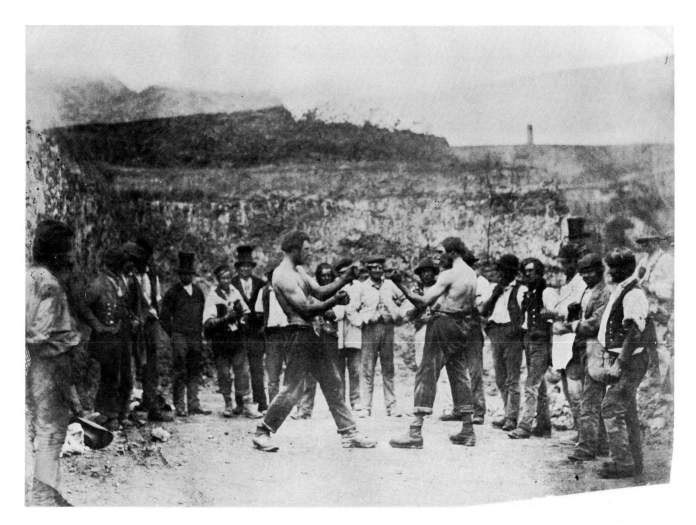

Boxing. This manly art is as old as the human species and is rediscovered by every child. Depicted by ancient artists on pots and walls, it has never ceased to attract a crowd, largely gamblers. Here, two boxers stripped to the waist are in classic stance, watched by their admirers of 1855. Why did O.G. Rejlander, the photographer, send the picture to Queen Victoria? Or was it to Prince Albert? Or did one or the other decide to purchase it? The fact is, it is still at the Royal Library, Windsor, in the ocean of portraits and royal drawings.

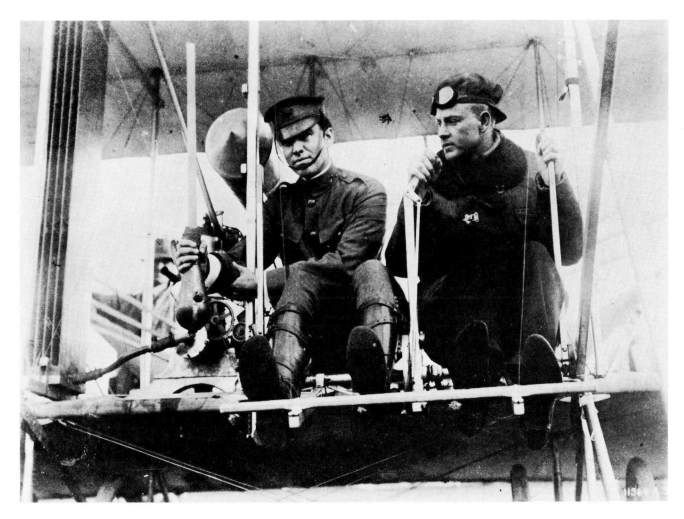

Bomber. The Wright brothers took to the air in 1903. Eight years later, the American army had already developed a system for dropping bombs, as can be seen here. Of course in those days the bombardier, Lt. M.S. Crissy, held the bombs in his lap and functioned as the bomb bay, the bombsight, the release mechanism and everything else. The pilot, Philip Parmelle, seems to be less happy about the system than the lieutenant. They are sitting in a Wright Model B biplane, in San Francisco, January 1911.

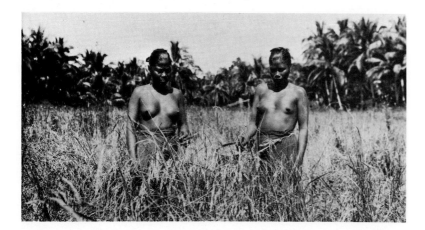

Breasts, in "National Geographic Magazine." This photograph in the *National Geographic Magazine* (vol. X, no. 5, May 1903), as reported by the editors many years later, "established policy to portray people in natural attire, or lack of it." The ladies happen to be harvesting rice in the Philippines.

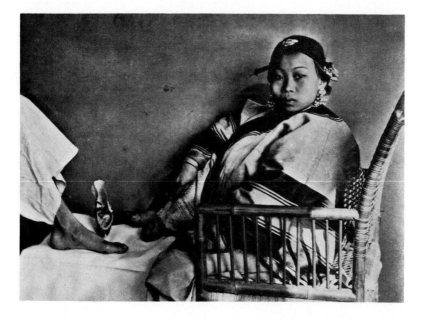

Bound feet. For some reason John Thomson wanted to photograph the tiny feet of upper-class Chinese ladies. Perhaps it was only because he in the nineteenth century, as we in the twentieth, had learned about the practice in school. He made the photograph in Amoy about 1870 and later wrote:

I had been assured by Chinamen that it would be impossible for me, by the offer of any sum of money, to get a Chinese woman to unbandage her foot . . . with the aid of a liberal minded Chinaman, I at last got this lady privately conveyed to me, in order that her foot might be photographed. She came escorted by an old woman, whom also I had to bribe handsomely before she would agree to countenance an act of such gross indecency as the unbandaging the foot of her charge. And yet, had I been able, I would rather have avoided the spectacle, for the compressed foot, which is figuratively supposed to represent a lily, has a very different appearance and odour from the most sacred of flowers.

Nevertheless, the Chinese adored such "lily" feet for centuries, and Thomson's picture, reproduced in his book *Illustrations of China and Its People* (1873-74), made Westerners less curious about this practice.

opposite:

Burmese. Sometimes an old photograph looks like the work of a contemporary artist. This grainy, salted paper print from a calotype negative of a Burmese man is reminiscent of the fashionable, super-sharp photographs of Richard Avedon. From the black border to the white background, to the strong shape the body assumes in the tight space and the direct look of the subject, posed by Dr. John McCosh, the picture has many of the distinguishing elements of an Avedon print.

John McCosh was a surgeon in the East India Company's army, and photographed during many campaigns including the Second Sikh War (1848-49) and the Second Burmese War (1852-53), from which this photograph dates. His portraits were of his friends and colleagues and anonymous natives of the lands he visited. In one story told of his adventurous life, he was shipped out of Tasmania severely ill with jungle fever; the ship was wrecked, and McCosh was the sole survivor.

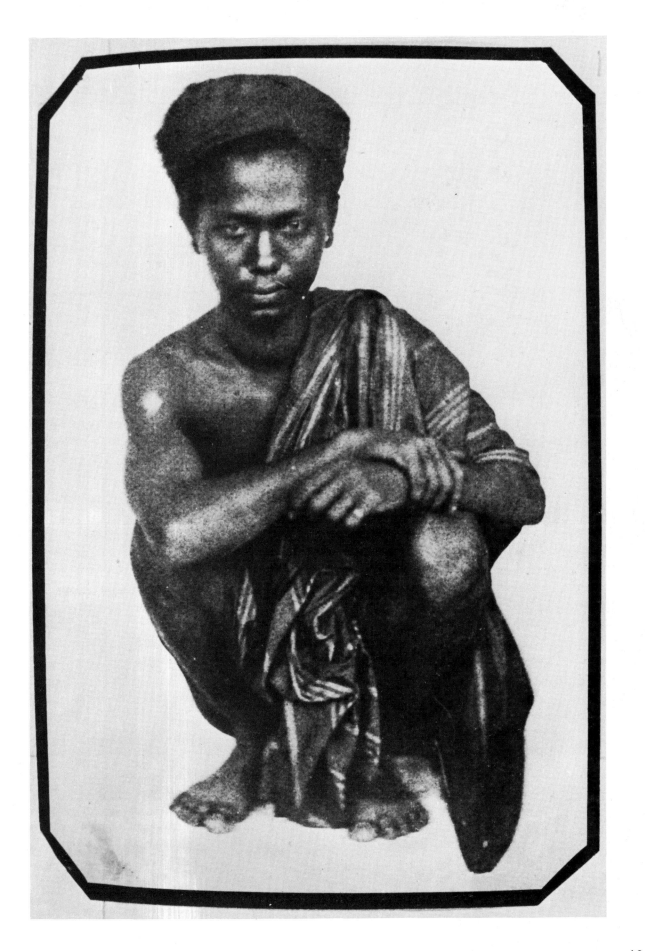

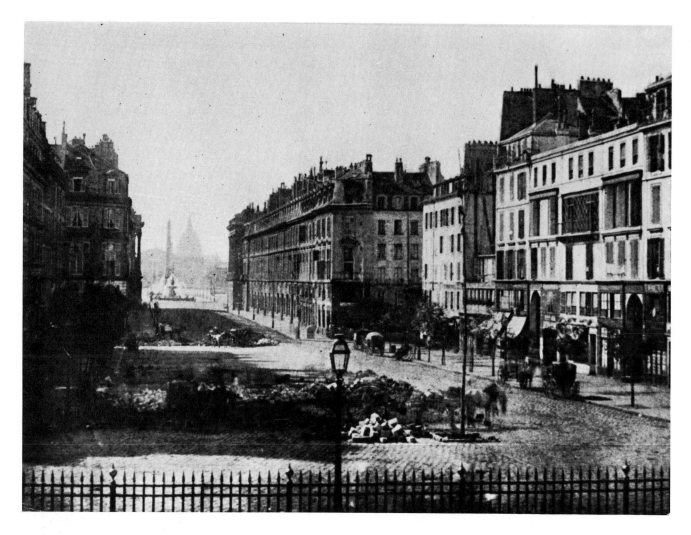

Barricades. In 1848, revolutions swept every country in Europe, and in Paris the activities of the revolutionaries included tearing up the paving stones, building barricades and defying the forces of the state. This calotype, taken in 1849 by Hippolyte Bayard, a Frenchman who was an independent inventor of photography, shows the aftermath of street fighting. The cobblestones heaped next to the cart also served as ammunition in the cause of common suffrage and parliamentary government. There is no earlier photograph known that reflects the political violence of the time.

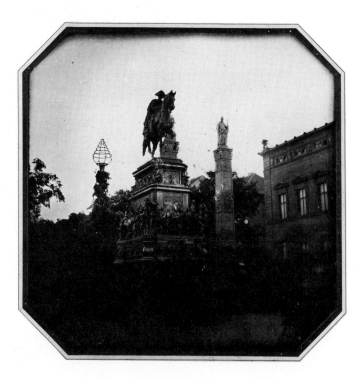

Berlin. The earliest known photograph of Berlin is this daguerreotype, made in 1840 by Wilhelm Halffter of Hausvogteiplatz Nos. 5, 6, and 7.

Baghdad. Baghdad, capital of Iraq, situated near the ruins of ancient Babylon, was founded in 762 by the Abbasid Caliphate, who led the conquering armies of Islam. This city on the Tigris became the richest and most cultured in the world, and here Caliph Harum ar-Rashid walked incognito among his subjects. In his palace he listened to Scheherezade, for a thousand and one nights.

Civil wars and the Mongols destroyed Baghdad, the caliphate moved to Cairo, and the glory of Islam has not yet again achieved such heights. In 1858, a photographer whose signature is hard to decipher took this picture, years after other cities and antiquities of the Middle East had been recorded with the camera.

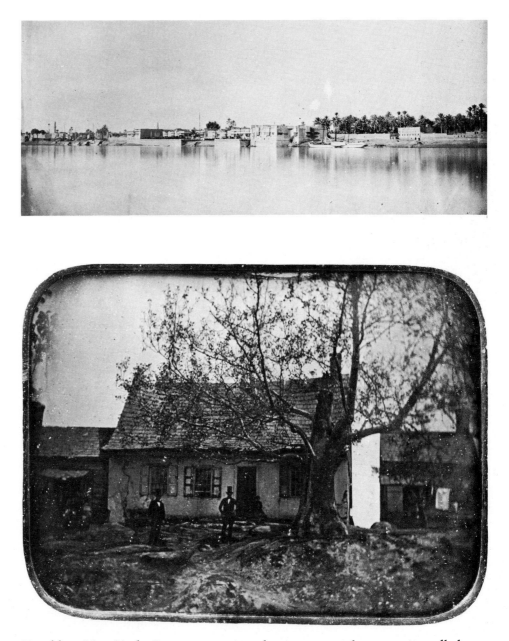

Brooklyn, New York. Once upon a time there was a rural community called Brooklyn, New York. Many trees grew there but the human population was small. This daguerreotype made in the 1840s is of a private home in the Wallabout section of Brooklyn, one of the earliest settled by the Dutch farmers who came to the southwestern part of Long Island in the early 1600s.

FIRST PHOTOGRAPHS · 51

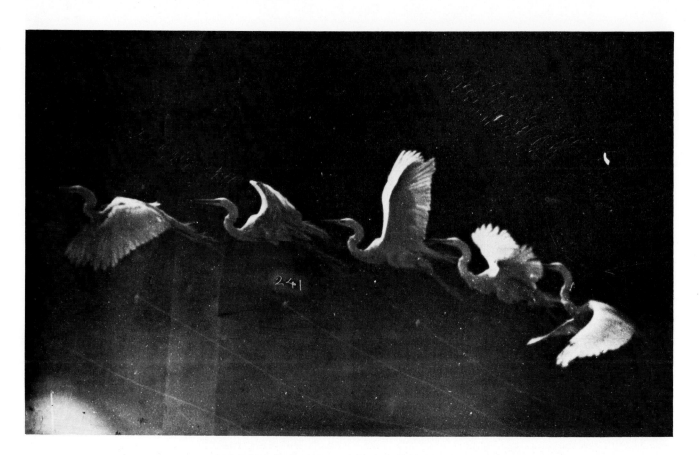

Bird in flight. Sometimes, not often, men and women who make photographs affect the course of art profoundly. Marcel Duchamp once said that the futurists were more influenced by the photographs of Muybridge and Marey, whose works they all knew, than by his own work.

Etienne-Jules Marey was a Parisian physician interested, among many other things, in physiology and aerial locomotion. In the early 1880s, he started to study the flights of birds and invented a camera that allowed him to take many quick exposures in succession. His pictures were made for scientific purposes, but they have an excitement and elegance that enthralls the viewer. This one was done in 1882.

opposite, top:

Blimp (U.S.A.). The first steerable, self-propelled gas-bag in America, whose descendants are the blimps and dirigibles, is seen here. Its name was "Avitor," and in 1869 it got off the ground. The photograph, a stereograph, was made by George S. Lawrence and Thomas Houseworth of San Francisco.

opposite, bottom:

Bicycle race. The bigger the wheel, the faster the bicycle could go. It was the chain connecting the pedals to the rear wheel sprocket that equalized the wheels and brought the cyclist down to earth. The League of American Wheelmen, founded in 1880, organized this big-wheel bicycle race in 1890, and George Barker, famed for his instantaneous photography, made the shot of the finish. Two years earlier an unknown cameraman made a photograph of the start of a bicycle race in Berlin, but did not capture any of the action.

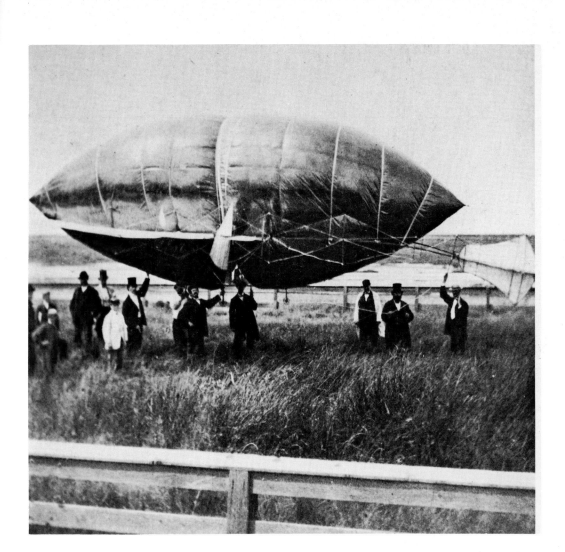

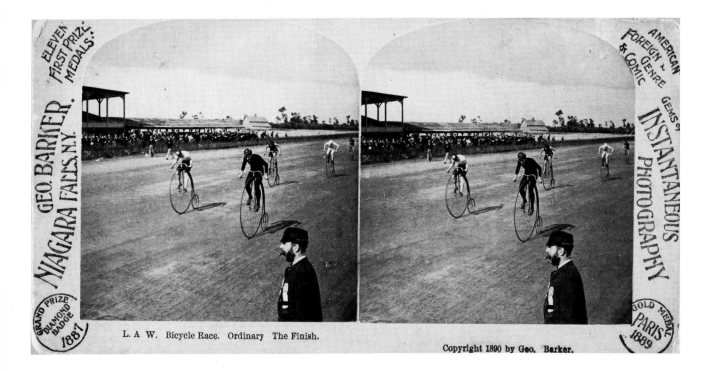

L. A W. Bicycle Race. Ordinary The Finish.

Copyright 1890 by Geo. Barker.

opposite:

Baseball cards. In 1887, Goodwin & Co., New York, copyrighted cards depicting players on the Boston, Pittsburgh, Washington, Philadelphia, and Indianapolis teams. They do not seem to be playing quite the same game today's baseball heroes engage in.

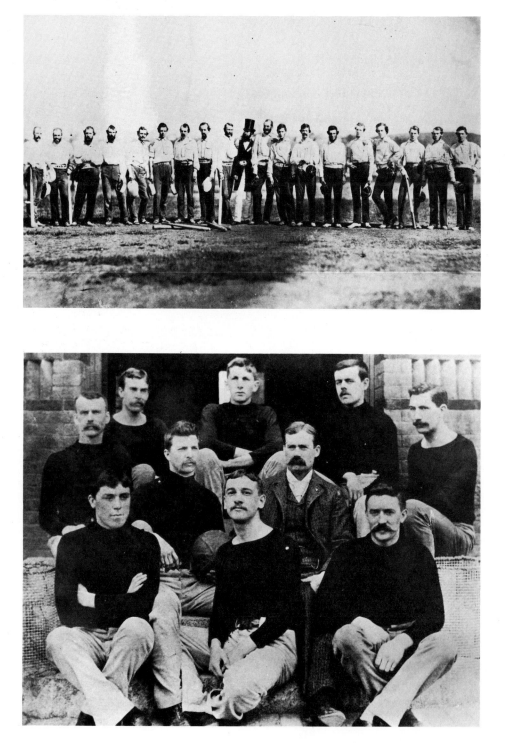

Baseball team. Left of the man in the top hat are the New York Knickerbockers; to the right is the team called Excelsiors. They are posing in 1857 for the first photographer ever to shoot baseball players. The Knicks, the first baseball team, was formed in 1842 and for a long time played in a gentlemanly manner on Sunday afternoons on a vacant lot in lower Manhattan. Four years later, having drawn up their own rules, the team played the New York Club at the Elysian Fields in Hoboken, New Jersey, and were wiped out 24-1. The rules, however, became the foundation for modern baseball.

Basketball team. Basketball was invented in 1891 at YMCA College, Springfield, Massachusetts, by Dr. James Naismith, a physical education officer. He is the one with collar and tie, seen with the first team to play the game.

BOSTON BASE BALL CLUB.

BOSTON.

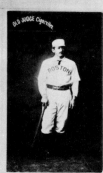

.0119 Wise.
Short Stop.
Boston
COPYRIGHTED, 1887.
GOODWIN & CO., NEW YORK.

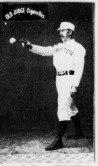

.0115 Sutton.
Third Base.
Boston
COPYRIGHTED, 1887.
GOODWIN & CO., NEW YORK.

.0116 Sutton.
Third Base.
Boston
COPYRIGHTED, 1887.
GOODWIN & CO., NEW YORK.

.0118 Wise.
Short Stop.
Boston
COPYRIGHTED, 1887.
GOODWIN & CO., NEW YORK.

.0104 Johnston.
Centre Field.
Boston
COPYRIGHTED, 1887.
GOODWIN & CO., NEW YORK.

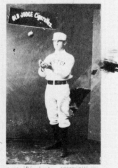

.0103 Whitney.
Right Field.
Boston
COPYRIGHTED, 1887.
GOODWIN & CO., NEW YORK.

.0107 Radbourn.
Pitcher.
Boston,
COPYRIGHTED, 1887.
GOODWIN & CO., NEW YORK.

.0105 Radbourn.
Pitcher.
Boston
COPYRIGHTED, 1887.
GOODWIN & CO., NEW YORK.

.0156 Nash.
Third Base.
Boston
COPYRIGHTED, 1887.
GOODWIN & CO., NEW YORK.

.0112 Sutton.
Third Base.
Boston
COPYRIGHTED, 1887.
GOODWIN & CO., NEW YORK.

.0117 Wise.
Short Stop.
Boston
COPYRIGHTED, 1887.
GOODWIN & CO., NEW YORK.

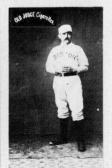

.0109 Radbourn.
Pitcher. Boston
COPYRIGHTED, 1887.
GOODWIN & CO., NEW YORK.

.0106 Radbourn.
Pitcher.
Boston
COPYRIGHTED, 1887.
GOODWIN & CO., NEW YORK.

.0105 Johnston.
Centre Field.
Boston
COPYRIGHTED, 1887.
GOODWIN & CO., NEW YORK.

.0113 Sutton.
Third Base.
Boston
COPYRIGHTED, 1887.
GOODWIN & CO., NEW YORK.

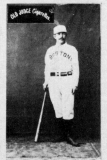

.0111 Sutton.
Third Base.
Boston
COPYRIGHTED, 1887.
GOODWIN & CO., NEW YORK.

.0155 Nash.
Third Base.
Boston
COPYRIGHTED, 1887.
GOODWIN & CO., NEW YORK.

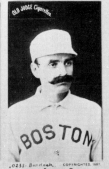

.0114 Sutton.
Third Base.
Boston
COPYRIGHTED, 1887.
GOODWIN & CO., NEW YORK.

Third Base. Boston
GOODWIN & CO., NEW YORK.

.0204
Hon. John Morrill. First Base.
Manager Boston Club.
GOODWIN & CO., NEW YORK.

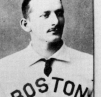

.0138 Wise.
Short Stop.
Boston
COPYRIGHTED, 1887.
GOODWIN & CO., NEW YORK.

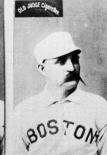

.0154 Radbourn.
Pitcher.
Boston
COPYRIGHTED, 1887.
GOODWIN & CO., NEW YORK.

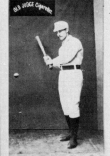

.0255 Burdock.
Second Base.
Boston
COPYRIGHTED, 1887.
GOODWIN & CO., NEW YORK.

.0203 Nash.
Third Base.
Boston
GOODWIN & CO., NEW YORK.

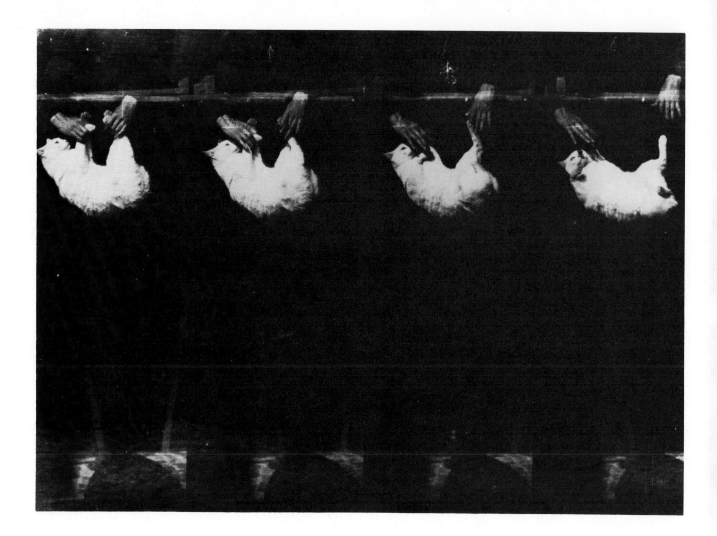

Cat falling. Everyone knows that a cat dropped upside down twists about and lands safely on all four feet. Etienne Marey, in France, captured this clever pussy executing this feat about 1893.

Dr. E.J. Marey (1830-1904) was an avid and brilliant experimenter, one of the first inventors of cinematography. Along with Muybridge he pioneered the analysis through photography of human and animal locomotion. Marey's studies inspired painters; one example of his influence is witnessed in Marcel Duchamp's "Nude Descending a Staircase." Marey made many contributions to medicine, especially in the design of artificial limbs, for which his sequential photographs were of great help. He invented the pedometer and the odometer.

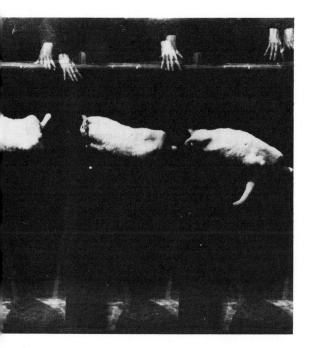

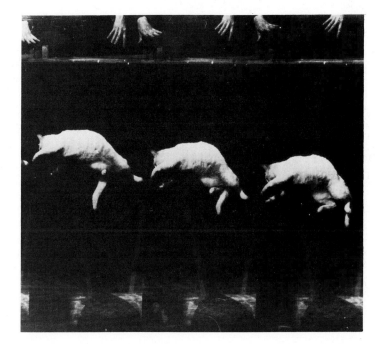

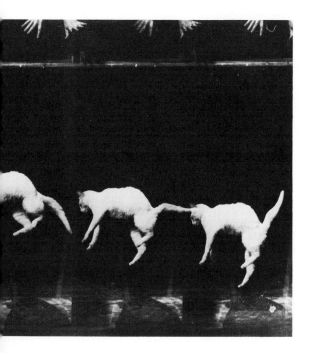

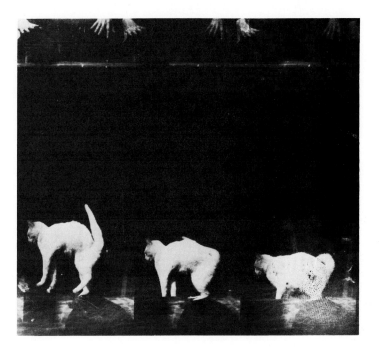

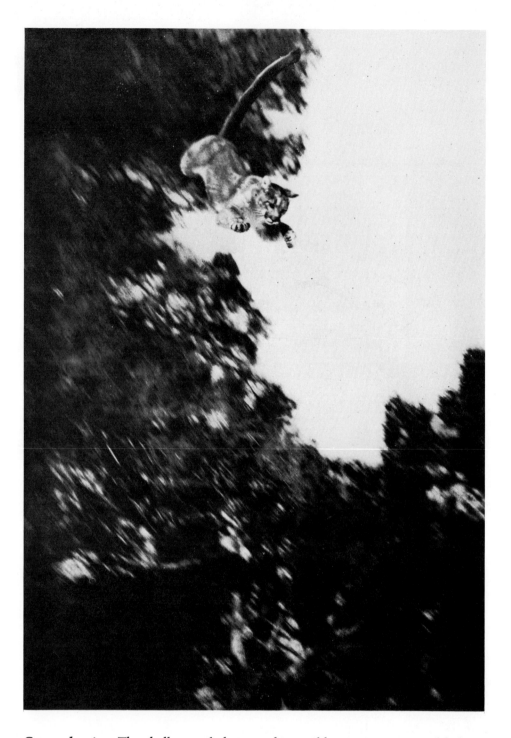

Cougar leaping. The challenge of photographing wild game in its natural habitat was met enthusiastically by some photographers after they or others had adapted cameras to be more maneuverable and plates to be speedier yet give sharp exposures. A.G. Walliham was one of the earliest wildlife photographers. He stood beneath a cougar crouched in a tree and took this picture as the animal began its leap, landing six feet from him. There is no record of who ran which way after that, or whether a friend with a gun finished the story. The photograph, copyrighted 1895, was published in *Camera Shots at Big Game*, 1901. Mrs. Walliham, who also was a photographer, coauthored the book, and of course Teddy Roosevelt wrote the introduction.

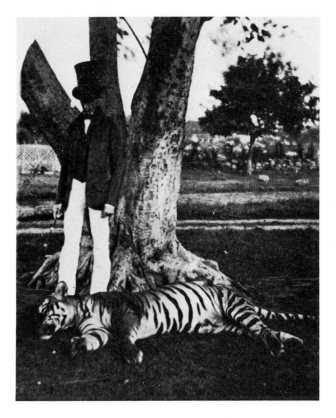

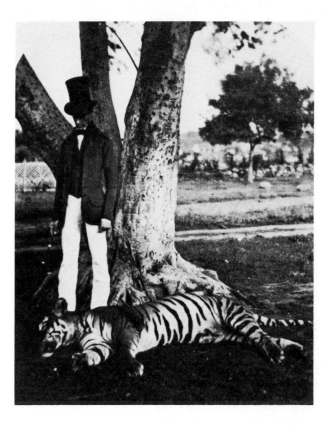

Cat hunt. This natty Englishman (above), a veteran of the Indian army, contemplates the 101st tiger he has shot, this one near Hyderabad, India. The picture (the first to show someone who had killed more than one hundred tigers) appeared in *The Stereoscopic Magazine*, Vol. 5, 1865, because a hundred such "victories" seemed worthy of commemoration. The white man's burden included carting home innumerable trophies, as shown in the 1876 picture (left) (Settite & Royan regions, N.E. Africa).

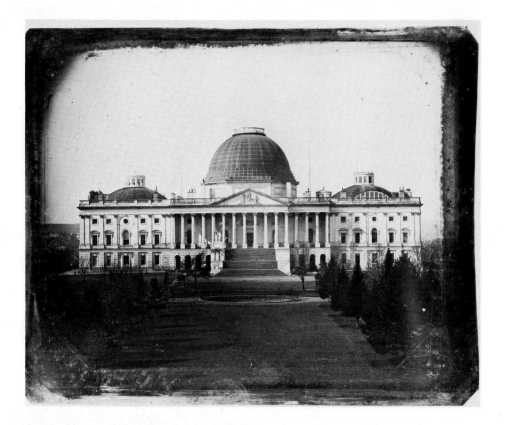

Capitol. The building in Washington, D.C., where the United States Senate and House of Representatives meet was first photographed by John Plumbe, Jr., in 1845 or 1846. There·are two extant daguerreotypes made at the same time, this one and another taken from the southeast.

The dome was designed by Charles Bulfinch to replace the original one, which had been destroyed by fire in the War of 1812. The cistern in front of the building served as a water supply to be used in case of another such disaster. On the left pedestal is the statue by Luigi Persico called "The Discovery Group," which was erected in 1844, only a couple of years before the daguerreotypes were made. The one on the right remained empty until 1853.

Today these government buildings are familiar to people all around the world. It is easy to forget that before the advent of photography, not that very long ago, people had only a vague impression, if any, of them.

opposite:

Cabinet of the United States. Not only is this daguerreotype the first photograph of cabinet members, but it is also the earliest known photograph showing the interior of the White House. From left to right are Attorney General John Y. Mason, Secretary of War William L. Marcy, Postmaster General Cave Johnson, President James K. Polk, Secretary of the Navy George Bancroft, and Secretary of the Treasury Robert J. Walker. Notably absent is Secretary of State James Buchanan, who often had fallings-out with President Polk and did not show up when he should have. Buchanan became the fifteenth president of the United States. The picture was made by John Plumbe, Jr., before September 1846, when Bancroft left for England to become U.S. ambassador there.

Cotton fields. Photographs of blacks—either slaves or freed men—in the cotton fields are very rare. This one, taken about 1867, by George Barnard, shows the habits of slave labor lingering after the Civil War. A black overseer with his traditional cane leads the burdened workers.

People who could afford to buy pictures (this is a stereoscopic card in Barnard's "South Carolina Views" series published 1868-70) generally didn't want to be reminded of misery and hopelessness, or even drudgery. Also plantation and factory owners jealously concealed from curious eyes the conditions in which their people worked. Just as writers did not probe or were not allowed to probe the lower-class way of life until the late nineteenth century, photographers also, for the most part, did not acquire the investigative eye until that time.

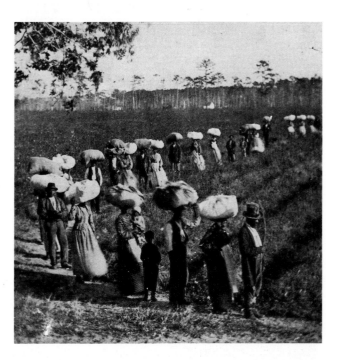

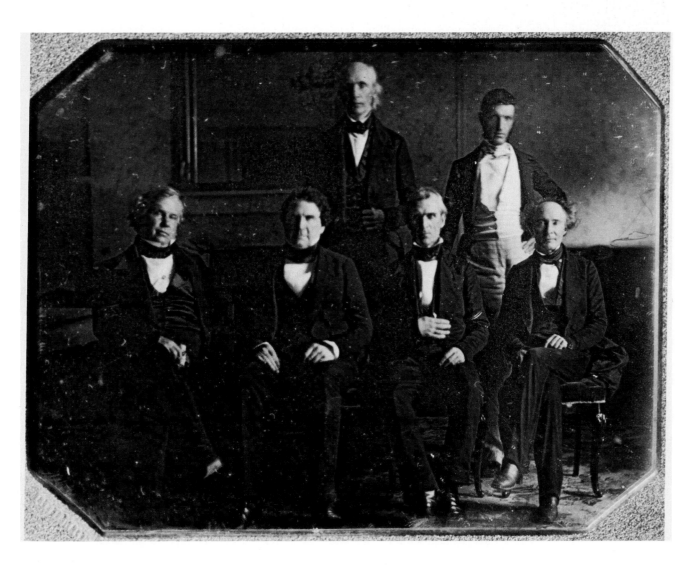

China. This is apparently the earliest surviving photograph of China. The calotype, made in Canton in 1851, is not definitely attributed, but it is thought that it might have been the work of Dr. John McCosh.

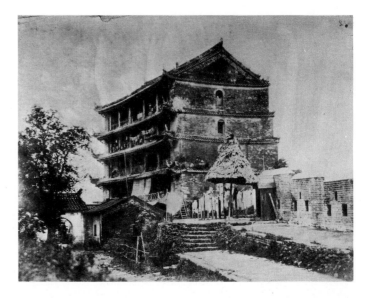

Crimean War. These ships of 1854 brought the English, French, and Turks to Balaklava in the Crimea to fight the Russians. Later came the charge of the Light Brigade, swords waving against Russian cannons, and Florence Nightingale, founder of nursing as a profession for women. The caption on the photograph reads: "Balaklava, 1854. This was Photo'd on first occupation of Balaklava, and shews what the place was like before it was changed by huts, tents, etc."

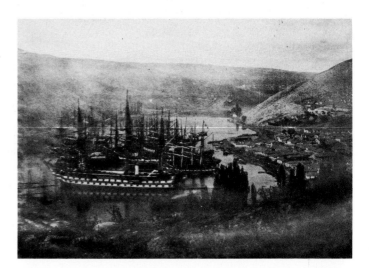

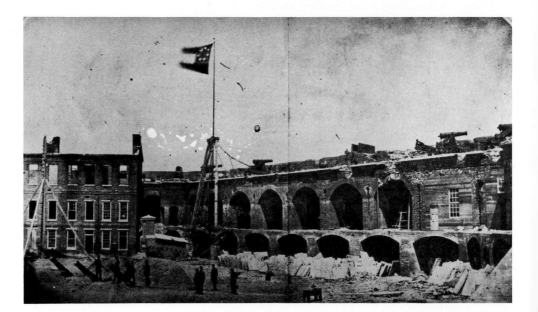

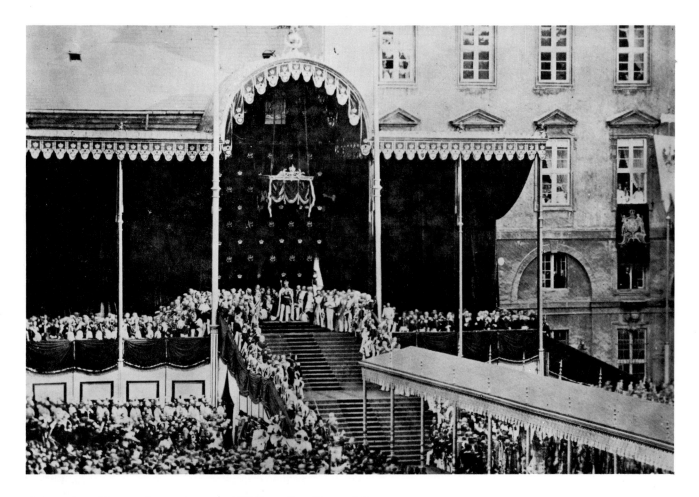

Coronation. Here is the crowning of William I as King of Prussia in 1861. Although he once described Otto von Bismarck's ideas as "school-boy's politics," it was William I who appointed him prime minister. Bismarck's founding of the German Reich after the Prussians successfully defeated the French in 1871 also included changing William's title of king to emperor or kaiser.

William's son was Crown Prince Frederick, and his daughter-in-law was Victoria, eldest child of Britain's Queen Victoria. Their son later became Kaiser William II, who took Germany into the First World War against the country of his maternal grandparents. Queen Victoria's children properly married into all the royal houses of Europe and they and their children created an extended family whose squabbles dominated international politics.

opposite:

Civil War. On April 12, 1861, the Confederate soldiers opened fire on Fort Sumter, and the American Civil War began. The rebel flag is seen hoisted in this photograph taken at the fort on April 14. The pictures of the American Civil War are considered by many people as the first great extended photo-documentary. Mathew Brady's name is always associated with these although most were taken by Alexander Gardner, Timothy O'Sullivan, George Barnard, and others. Among them are pictures of bridges and battlefields, soldiers alive and soldiers dead, generals and cooks, campsites and churches, cities in cinders, skulls and bones on empty fields, Abraham Lincoln and freed slaves.

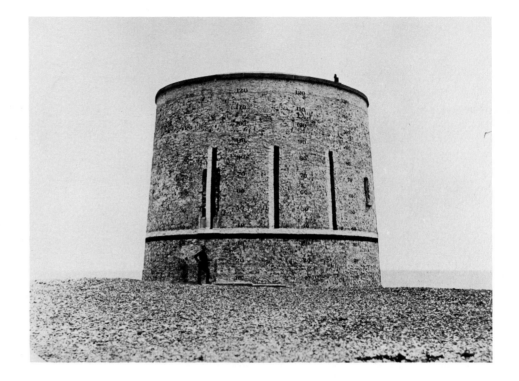

Cannon power. The English Royal Engineers was one of the first institutional groups to train photographers. These pictures suggest why: the generals could study the effectiveness of military action at their leisure, and records could be kept of both successful and unsuccessful techniques. The ladder was climbed probably for a look-see inside the Martello Tower, used in the target practice, on the coast at Eastbourne, after every few experimental shots from a 7-inch howitzer, a 6-inch cannon, and a 40-pounder cannon. This demolition took place about 1860.

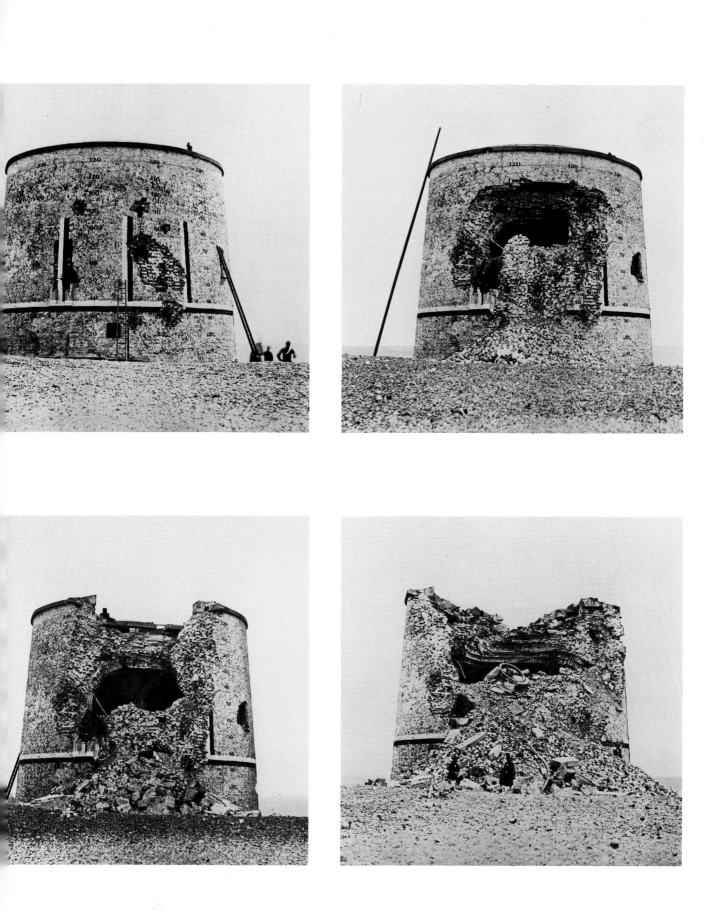

opposite:

Corpse.

When Death strikes down the innocent and young, for every fragile form from which he let the panting spirit free, a hundred virtues rise, in shapes of mercy, charity, and love, to walk the world, and bless it.

 —Charles Dickens, The Old Curiosity Shop, *1841*

For most of human history people were born and died without leaving a trace of their visage. Only royalty, the rich and the powerful, from ancient Egyptian times until the mid-nineteenth century, had portraits in pigment and stone, and death masks, made to perpetuate their earthly looks. One reason photography became a democratic art was precisely because people of all classes could now be immortalized pictorially.

In the first decades after it was invented, however, it was likely that many people never visited a photographer's studio and so most still died as their ancestors had, without leaving a portrait. But by 1840, postmortem photographs could remedy the oversight without the expense of gold and lapis lazuli.

Postmortem portraits of children, whose deaths were always unexpected, were most common. Sometimes the photographer came to the house of mourning; at other times the body was brought to his studio. This French daguerreotype was made about the time of the Dickens quote. It is not known whether it is a first, but it is a very early photograph of a dead child.

By Julia Margaret Cameron. Julia Margaret Cameron, who was born in Calcutta in 1815 and died in Ceylon in 1879, was one of the greatest nineteenth-century photographers. She made photographs of "famous men and fair women," a phrase used in the title of the book by her niece Virginia Woolf and Roger Fry. Her pictures create impressions of personalities emerging with great force from the surface of the prints.

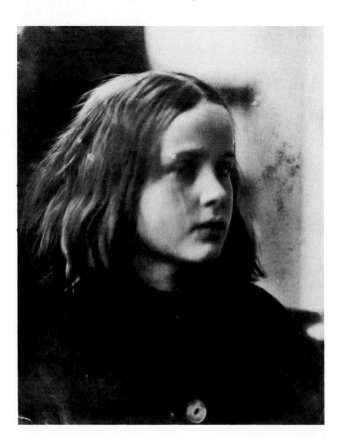

She did not start photographing until she was forty-eight, after she had moved from London to the Isle of Wight. Her children gave her a camera, saying, "It may amuse you, Mother, to try to photograph during your solitude at Freshwater Bay." And so she turned her coal house into a darkroom and her chicken house into a studio. In January 1864, she made a print of a little girl named Annie Philpot and labeled it "Annie—'My First Success.'"

In her usual exuberance Mrs. Cameron declared that Annie had "entirely made the picture." The photographer "ran all over the house to search for gifts for the child." She gave the photograph to Annie's father with an accompanying letter: "My first perfect success in the complete photograph owing greatly to the docility and sweetness of my best & fairest little sitter. This Photograph was taken by me at 1 PM Friday Jany 29th- Printed Toned . . . and framed all by me & given as it now is by 8 pm. this same day. . . ."

Ten years later she wrote in her biographical fragment "Annals of My Glass House":

I began with no knowledge of the art. I did not know where to place my dark box, how to focus my sitter, and my first picture I effaced to my consternation by rubbing my hand over the filmy side of the glass. It was a portrait of a farmer of Freshwater, who, to my fancy, resembled Bollingbroke.

I believe that what my youngest boy, Henry Herschel, who is now himself a very remarkable photographer, told me is quite true—that my first successes in my out-of-focus pictures were a fluke. That is to say, that when focusing and coming to something which, to my eye, was very beautiful, I stopped there instead of screwing on the lens to the more definite focus which all other photographers insist upon.

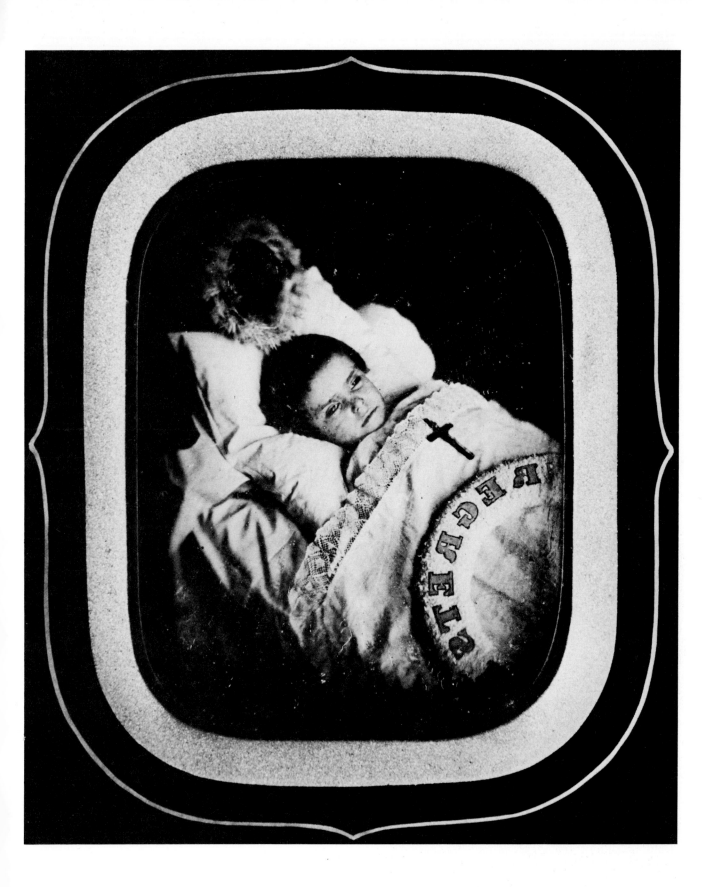

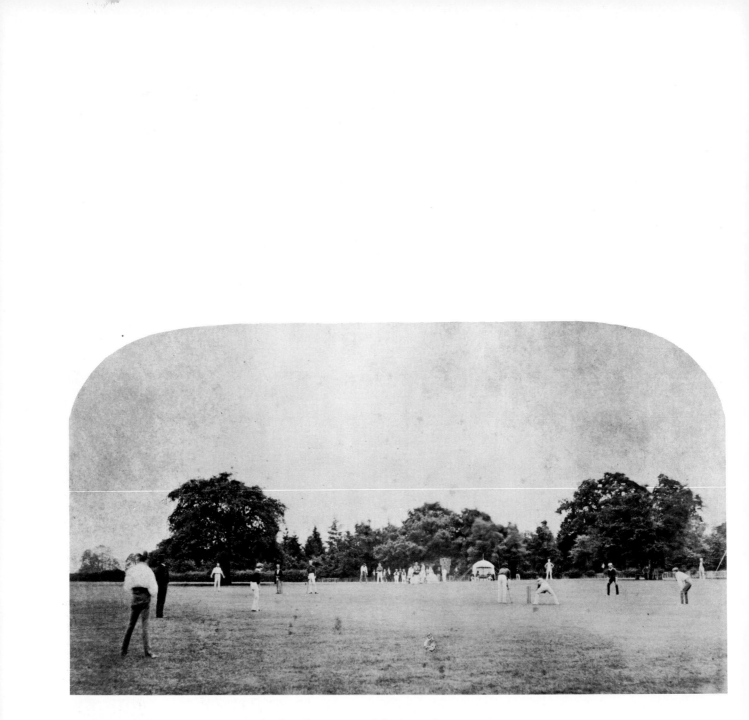

Cricket. A slow game at any time, with only occasional flurries of activity, cricket was the sport that lent itself best as a subject for the wet-collodion photographer. Roger Fenton knew when the players would be motionless for a few seconds of concentration and he uncovered his lens just then (1857).

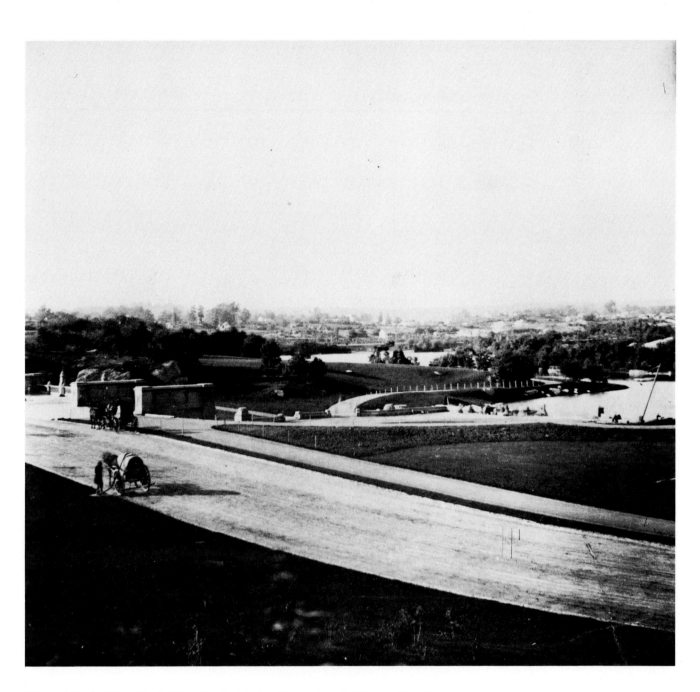

Central Park, New York City. Frederick L. Olmsted and Calvert Vaux's concept for New York's 840-acre park did not follow European models, with their straight alleys of trees, pools, and statuary all designed for formal strolling and dallying in a herbacious frame. One of their goals for Central Park was to create a rural atmosphere with open fields and woods in the heart of the city, but still it had touches of the Old World. In the picture, part of a larger group taken by Victor Prevost in 1862, the park is seen under construction at 72nd Street. One can only shudder at the thought of a New York City without its Central Park.

City traffic. In the earliest photographs of towns and cities, there is often a ghost-like air. No people are on the streets, no carts or cabs pass by. The improving technology of the camera, lenses, and emulsions is most apparent when one compares an 1840 or 1850 photograph of a busy city street at noon to one taken in the 1890s. In the former the city is devoid of life; in the latter there is movement everywhere.

This photograph of a shopping district in Bristol, England, was taken between 1851 and 1853 by Hugh Owen and is remarkable for its time. Extraordinary technical skill was required to achieve such a short exposure with the calotype process—perhaps less than a second—at a time when exposures were seconds and minutes long. The little glass house built on the roof of the building was the typical studio for photographers, who needed a flood of natural light.

Coca-Cola bottling plant. A self-proclaiming advertisement taken in 1906 of the bottling plant on West Main Street, Louisville, Kentucky. There are no photographs of the first plant, in Chattanooga, Tennessee. The earliest notices for the new drink appeared in 1884 in *The Daily Journal*, Atlanta, Georgia. Four years later Coca-Cola ads confidently read:

*The Wonderful Nerve
and Brain Tonic
and REMARKABLE
THERAPEUTIC AGENT*

*For Headache or
Tired Feeling,
Summer or Winter.*

Drink Coca-Cola

*It Relieves
Mental and Physical
Exhaustion.*

*Dispensed at the Principal
Soda Founts at 5 Cents per Glass,
and Sold by Druggists and Grocers,
in Bottles, at 25 Cents per Bottle.*

Today, The Coca-Cola Company is the largest consumer of granulated sugar in the world. People drink "Coke" in almost every country, and its retail sales force is the largest anywhere. Only the United States Post Office owns more trucks.

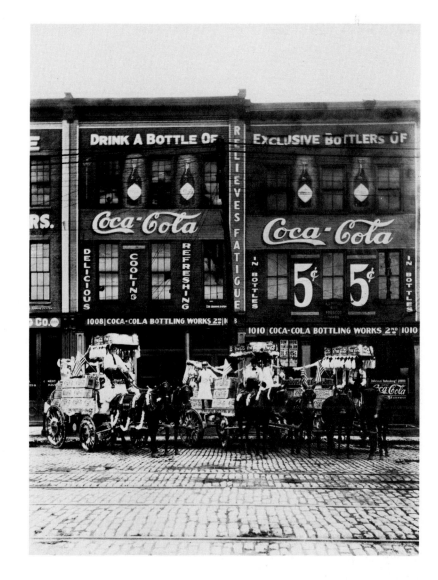

Cleveland, Ohio. This daguerreotype shows the Cleveland business district about 1840, with its livery stable, bathhouse, hotel, general store, ironmonger, wagons, and signs advertising oysters. Amazingly, apparently fresh oysters arrived daily from Baltimore, coming hundreds of miles across the Pennsylvania mountains—but shellfish at that time *was* one of the staples in the diet of the poor and the working class. Do photographs lie? Often. There were probably people on this street moving about too fast to leave an impression on the plate. Do advertising signs lie? Often.

Canadian prairies. H.L. Hime, photographer with the Assiniboine and Saskatchewan Exploring Expedition of 1858, included this symbolic skull in what was to be the first group of pictures taken in Canada west of the Great Lakes. A fire had swept the prairies before he arrived. Nearby were the Red River settlements of pioneer farmers recruited by the famous leader of two Canadian rebellions, Louis Riel. The area above the horizon line is completely white, as early photographic emulsions were overly sensitive to skies and a photographer could not expose for the landscape and expect to capture any clouds.

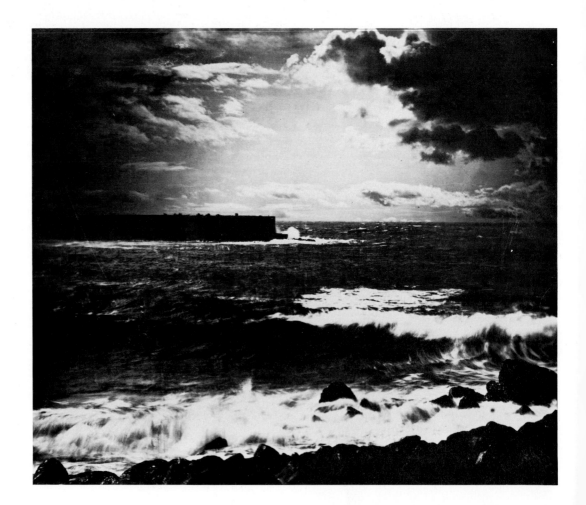

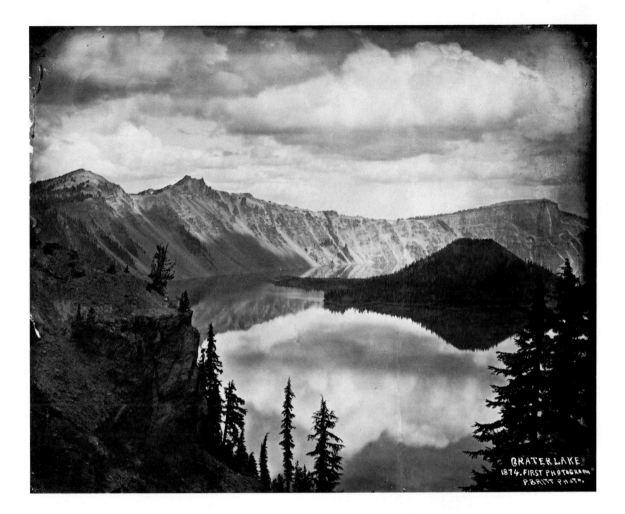

opposite:

Clouds. The French painter and photographer Gustave Le Gray made "Great Wave, Sète" in 1856. When it was exhibited that year at the Photographic Society of London it created a stir; people had never before seen photographs of sea and sky together.

Le Gray invented the waxed-paper process, an excellent means of making a paper negative. His seascapes with clouds, however, were made on wet-collodion plates. All early photographic emulsions were overly sensitive to skies in relation to the landscape, so skies invariably were over-exposed and appeared blank. Le Gray either very carefully made his exposure when the sky and the sea reflected the same amount of light, or he made two negatives, exposing one for the water and one for the clouds, and then printed them together. Most photographers in the 1850s through the 1880s who wanted cirrus, stratus, cumulus, or some other cloud form in their compositions had to make a special negative.

above:

Crater Lake, Oregon. In Europe, early photographers concentrated on buildings and other examples of civilized activity; American photographers, on the other hand, eulogized the scenic marvels of their unpopulated territories. Pictures such as this, taken by Peter Britt on August 13, 1874, had an enormous appeal not just to Americans in love with the national hymn to Manifest Destiny, but also to Europeans in their overcrowded cities. The vast open spaces and magnificent panoramas promised freedom to the adventurer, the romantic, the hustler, the renegade, the poet, the speculator, the loser, and the pious.

Twice before, in 1868 and 1869, Britt had hauled his wet-plate apparatus to Crater Lake, but bad weather and other factors had foiled him. Almost every scenic aspect of the American landscape has a "first photograph," and it is obviously impossible to include them all here. This one must therefore represent many delightful pictures of mountains, lakes, forests, and cloud-filled skies.

Children playing. Dolls, dollhouses, and make-believe are part of a little girl's world. The play of children is a universal theme—*The Family of Man* photography exhibition exploited it to the maximum. This small (2¾ by 2½ inches) daguerreotype—not in that collection—of two jeune filles playing house in France about 1845, probably helped remind their grandchildren that once grandma was young and playful, too.

opposite:

Crazy chair. Is it art? Obviously it is also a chair, because someone is sitting in it. It is grotesque enough by itself, but a nicely dressed, elderly Mr. Smith in the lap of this leather-covered dummy arouses all sorts of uneasy and macabre questions. Yet the chair, to be complete, must have a sitter in it. This was taken in 1905 by Dr. Benjamin Stone and obviously he, as photographer, is very much responsible for the way the final picture appears. Today, too, a lot of "happenings" and avant-garde art are created largely to be photographed because the event is transient; the camera is needed to make a permanent record.

Chemistry laboratory. This laboratory of 1855 belongs to chemist J.M. Taupenot, who in September of that year published his collodio-albumen process, the first practical dry collodion process. The picture is a self-portrait that shows Dr. Taupenot had a modest array of the current basic apparatus: a chart of crystal structures and some reagents—things that could be bought in supply houses. If this picture had been taken after 1869, Dimitri Mendeleev's Periodic Table of the Elements would have been prominently displayed. Unlike today's laboratories, there are no water taps for the sink or gas burners. The calculations on the board use formulas soon to become obsolete. The photograph is a peek into the history of science and scientific research, without which photography itself could never have developed.

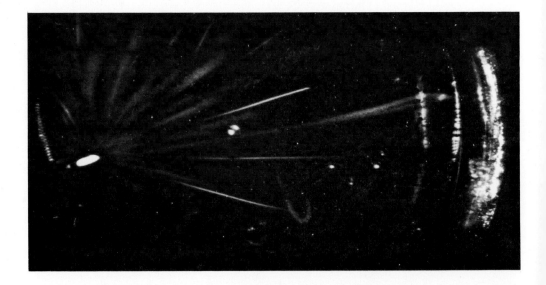

Charmed quark. Experiments with so-called atom smashers —particle accelerators—begun in the 1930s, isolated hundreds of subatomic particles that, thirty years later, were described by physicists as a zoo. Because all of them decayed (broke up or were transformed by energy changes) in fractions of a second into the familiar proton, neutron, electron, and neutrino, the nature of their relationship to one another and to the basic structure of matter/energy remained mysterious.

Several theories attempted to make sense out of the short streaks subatomic particles left in bubble chambers and cloud chambers, and it was postulated that if a certain kind of particle could exist, it would explain the zoo and reveal why matter exists in so many guises, however fleetingly. The search for this hypothetical particle, named the quark, has been successful. But it turned out that there were several kinds of quark; they are called up quark, down quark, strange quark, and charmed quark, and each comes in three different colors. There is also an antiquark for each kind of quark, and still other properties, such as flavor, have been added to the whimsical vocabulary.

Most recently, a fifth binful of "bottom" quarks have been detected—perhaps—and it seems that a sixth kind must also be sought. At any rate, indisputable evidence that charmed particles exist was found in October 1976, at Fermilab, Batavia, Illinois, in this photograph of what looks like weak chicken tracks in the dust. Because of the suspected extremely short life of charm, a specially prepared stack of photographic emulsions was used, the particle tunnelling through it to leave spots in its wake. After being developed, the individual layers in the stack were sorted into a mosaic and again photographed to produce this positive. The new particle's track begins at the top and turns into the V in the center of the picture.

opposite:

Cloud chamber tracks. To study radiation, Scottish scientist C.T.R. Wilson invented the cloud chamber in 1895. The same device and a similar one called the bubble chamber are still used in physics and astronomy.

When a speeding particle plunges into a cloud chamber, which contains a mixture of gases and water in what is called a supersaturated state, its collisions cause the water molecules to condense into tiny but visible droplets. Thus, the track of a moving particle is revealed by a fine line of droplets that lasts just long enough to be photographed at the same instant. Because electrical and magnetic fields can be generated around the cloud chamber, charged particles will be made to move differently than those

with no charge, heavier ones will butt their way further, and the movements of new fragments that result from collisions also become visible. Strictly speaking, it is meaningless to talk about the "size"— though not the mass—of a subatomic particle, but one can try to imagine trillions of them lined up along a straight line a quarter of an inch long.

In 1911, C.T.R. Wilson took the first published photographs of such tracks in the cloud chamber. This picture was made when an alpha particle (nucleus of a helium atom) plowed into the chamber. Even though there is not much to look at, it is included in this book because of the fundamental importance of this type of particle identification in physics and astronomy.

Cannibals. The two most powerful taboos—and the ones thought to be universal —are incest and cannibalism. In this picture, taken in 1912 by Martin Johnson on Malekula Island, largest of the New Hebrides, a supposed cannibal is curing the heads of his three victims, if one may use the term. The bones and heads were kept as relics in a sacred hut.

Johnson made movies as well as still photographs of these people. He showed the movies in the United States and when he returned to Malekula about four years later, he kindly screened them for his old friends, complete with the advertising used on Broadway. The scene of the "stars" of the film grouped in front of publicity pictures for the new movies proves that cannibals are as willing as other audiences to wait patiently for the show to start. When a man who had died appeared on the screen, the natives were in agreement that Johnson possessed magical powers.

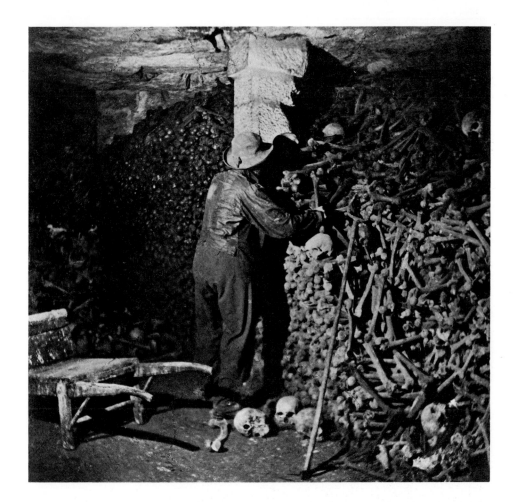

Catacombs. Nadar, the French photographer who made portraits of Baudelaire, Berlioz, Bernhardt, Corot, Courbet, Daumier, Delacroix, Doré, Dumas, Flaubert, Hugo, Offenbach, Liszt, Manet, Millet, Proudhon, Rossini, George Sand, Verdi, and other luminaries, also photographed in the dark, damp Paris sewers and catacombs. He first went down into the notorious sewers in 1861, connecting his arc lamps to Bunsen batteries on the street above by means of long cables. His friends helped him carry the considerable equipment.

Nadar's pictures were among the first made with electric light. Spurred on by his success, and always ready for more public attention, he again descended, this time into the catacombs, and photographed the bones of generations long gone. The figure in the picture is a mannequin as the long exposures required for the wet-collodion plates, sometimes lasting eighteen minutes, made it impossible to use a live model.

Nadar wrote of these experiences in *Quand j'étais photographe* (Paris, 1900):

The world underground offered an infinite field of activity no less interesting than that of the top surface. We were going into it, to reveal the mysteries of its deepest, most secret, caverns.

. . . I cannot tell you how many times our work was interrupted, held up for one reason or another. Must I spell out again how we were let down and angry when after several attempts at a tricky shot, at the moment when all precautions had been taken, all impediments removed or dealt with, the decisive moves being about to take place— all of a sudden, in the last seconds of the exposure, a mist arising from the waters would fog the plate—and what oaths were issued against the belle dame or bon monsieur above us, who without suspecting our presence, picked just that moment to renew their bath water!

Daguerreotype. Louis Jacques Mandé Daguerre started experimenting about 1824 to find a way to capture an image in the camera obscura. After 1826, he collaborated through correspondence with a fellow Frenchman, Joseph Nicéphore Niépce, whose name had been given to him by their mutual lens maker. By this time, Niépce was obtaining interesting results on the road to photography, using certain chemicals and metals including silvered copper plates and iodine. Daguerre, a painter and inventor of the Diorama, was not. In 1829, they formally became partners, but Niépce, who died in 1833, did not live long enough to see a practical result of his and Daguerre's labors.

By 1835, Daguerre realized that silver iodide was light-sensitive and he could get an image on his copper plates. Two years later, he discovered that a hot solution of common salt in water could keep his image from disappearing. Below is the first daguerreotype, made in 1837. It is of a corner of Daguerre's studio, light falling softly on his plaster casts. The announcement was made on January 7, 1839, and in August the details were revealed. The French government had purchased the invention from Daguerre (and Niépce's son) and gave it freely to the world (excluding England).

opposite:

In (total) darkness. Fox Talbot predicted in *The Pencil of Nature*, the first book ever published with photographs (1844-46), that someday, by means of differing wave lengths, a photograph could be taken in absolute darkness to reveal "the secrets of the darkened chamber." It was not, however, until 1930 that the first photograph made in complete darkness was successfully produced and published. It was possible because of the invention of a photographic emulsion sensitive to infrared radiation (heat). The subject—a bottle, a glass graduate, and a tin-can cover—was warmed with an electric heater. Dr. H.D. Babcock of the Mount Wilson Observatory exposed a plate sensitized with Neocyanine for forty-eight hours at f/2 to obtain this picture. Today, infrared films are used for geophysical mapping, medical diagnosis, locating underground springs and geysers, astronomical research and in many other fields.

By George Eastman. "The first negative taken by Geo. Eastman, amateur. Oct./77" is the inscription on the back of the original of this photograph. Later, "amateurs," when thinking of photography, would come to think of "Kodak" and the company name of Eastman. George Eastman's contributions to the medium include roll film and inexpensive snapshot cameras that anyone could use. As a result of his inventions, most people today do not remember their "first photograph."

In 1877, when Eastman was twenty-three years old and wanted to learn to take pictures, photography was not simple. He had to make an appointment with a professional, who, for a fee, agreed to teach him how to mix solutions, coat a glass plate in the dark, focus the large camera, and immediately develop the negative. Eastman was shown all these steps during his first lesson on October 22. He was not taught how to print; instead, he made what is called an ambrotype: the glass negative is backed with black so that it appears as a positive image, which is then matted and placed in a small case or frame. Eastman took this view in Rochester, New York—the city where George "You press the button, we do the rest" Eastman eventually founded his empire.

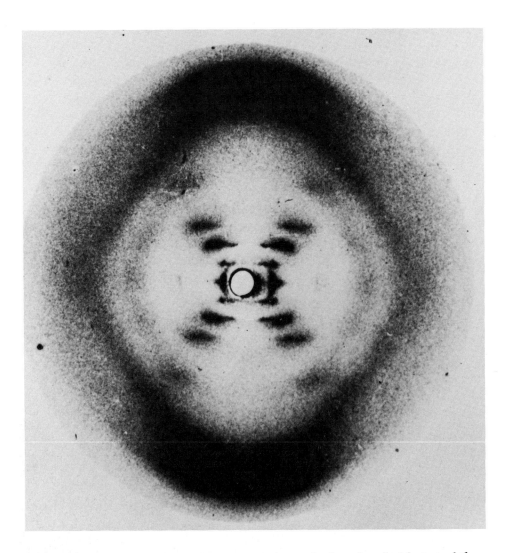

DNA structure. This was the key photograph involved in the elucidation of the DNA (deoxyribonucleic acid) structure in 1953. It contained a reservoir of information from which James Watson and Francis Crick deduced, using supporting evidence, that the DNA molecule found in chromosomes was double helical in structure. Knowing the structure and the chemical pairing of specific nucleotides (which make up DNA), they explained how DNA stores genetic information and how it is able to replicate itself. This understanding was the foundation for a new field of scientific research called molecular biology, one of the most active and exciting in present-day science. A recent breakthrough is the technique of gene splicing, also known as genetic engineering or recombinant DNA. A potential application of this is the manufacture of Interferon, an anti-viral agent which may be effective against certain forms of cancer.

The X-ray photograph was taken by Rosalind Franklin at Kings College, London, in the winter of 1952-53. She did not realize all the implications of the information contained in it, and although she was working in a rival group she allowed Watson and Crick to look at it. It was fortunate for them, and they went on to explain that the helical form is indicated by the patterns of X-ray reflections shown as dark areas in the center of the photograph. The black regions at the top and bottom indicate the individual components of the molecule and quantify the way in which these are stacked together, perpendicular to the helical axis.

Eclipse of the sun ("diamond ring"). Taking pictures of the blazing sun, the pale moon, and the pinpoints of stars fascinated astronomers from the beginning of photography. Prominent among them was Sir John Herschel, a friend of Fox Talbot who was also interested in photographing the heavens in 1839. The first successful daguerreotype of the sun was made on April 2, 1845, by Hippolyte Fizeau and J.-B.-Léon Foucault, who exposed for 1/60 of a second. The picture showed two sunspots.

Prior to this, G.A. Majocchi of Milan had made daguerreotypes of a solar eclipse in 1843. This was far easier than photographing the sun directly, because the face of the sun during an eclipse is hidden by the moon's body. Eclipse photographs show the sun's corona—the flames leaping far out that are visible as a ring of fire around the disc of the moon. This picture was taken during the Harvard eclipse expedition to Shelbyville, Kentucky, in 1869.

As the moon moves slowly between Earth and the sun, the last visible part of the sun seems to form a "diamond" in a ring that circles the moon; this photo is the first to show this effect. (The first photograph to show a solar eclipse without the "diamond ring" was a daguerreotype made in 1851.) Not until 1939 would scientists discover, in research inspired by Einstein's theory of relativity, that the sun's light and heat are produced by the fusion of hydrogen into helium.

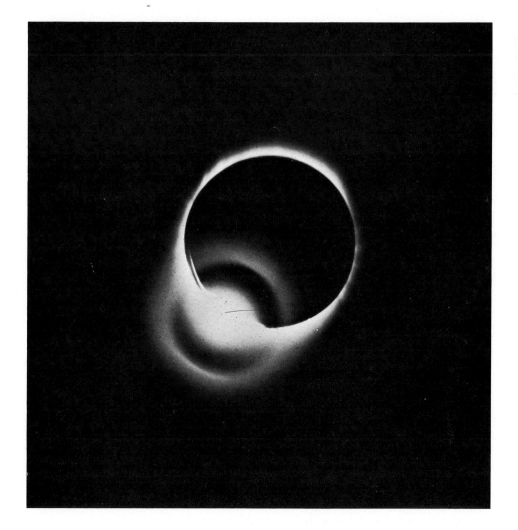

Night sky in color. This is not the night sky seen by an earthling when he gazes up at the heavens to count the stars, study the constellations, or contemplate his place in the universe. This is the full-color night sky of the astronomers, who can see ten billion light years beyond the limits of human vision with their instruments. Here is the Veil Nebula in the constellation Cygnus in 1959, taken through the 48-inch Schmidt telescope at the Hale Observatories in California. Although no photograph can capture the essence of what the astronomer sees, this advance in technology gives laymen some hint of the colors of the "floor of heaven."

On Mars in color. Before 1900, astronomers with increasingly powerful telescopes could study the details of Mars' terrain, the most obvious features of which were white polar caps that spread and shrank with the Martian seasons, and seasonal changes in color of the rest of the reddish surface. The network of dark lines that also became visible aroused the idea that perhaps intelligent beings had dug canals on the planet.

The question of whether we are alone in the universe probes religion and philosophy as well as science. One of the primary goals, in a sense, that technicians set themselves when they designed the first space probe to land on Mars, was to find evidence for or against the presence of life on our sister planet.

The caption released by NASA to accompany this photograph reads as follows: "First color picture taken on the surface of Mars today [July 21, 1976] by the *Viking I* Lander shows that the Martian soil consists mainly of reddish, fine grained material. However, small patches of black or blue-black soil are found deposited around many of the foreground rocks. . . . The horizon is about three kilometers (1.8 miles) from *Viking I*'s camera. The scene, covering about 67° from left to right, was scanned three times, each time with a different color filter. The color was reconstructed with computer processing." Remember—there was no man up there operating the camera. The mixture of light rays reflected by the image was collected by a "lens" for transmission to the receiver on Earth, which contained the film developed for publication. Truly, the camera was tens of millions of miles long.

Computer-enhanced Earth study. It was inevitable that Earth would become a primary target for photographs taken from space vehicles. But the awesome pictures that show planets and moons spinning in emptiness, kept on course by the invisible warp of gravity holding the solar system together, are not as important as the planned series of images of Earth's surface.

From the launching of *Gemini III* on March 23, 1965, to the present, thousands of colored photographs have been made to serve the public and private sectors of many nations. Techniques have been developed that transmit various wavelengths of radiation that the satellite camera equipment receives

from below, back to the Earth station, where a computer translates the information and produces colored images on film.

This picture is one of the first computer-enhanced LANDSAT scenes produced at the EROS Data Center. It shows southern Florida, Miami on the right, the Everglades in the center. It was transmitted March 3, 1975. The American LANDSAT program provides ongoing precise information on snow cover, water level, the state of vegetation, the emanations from cities and roads, ocean currents, meteorological data, and so on. Each satellite circles Earth every 103 minutes, 570 miles up, and repeats its path every eighteen days.

Baby in the womb. With a wide-angle lens built especially for this purpose, and a very small flash beam at the end of a surgical scope, Lennart Nilsson, the Swedish photographer, in 1964 took this first picture of a human 15-week-old embryo in the mother from only one inch away. A gynecologist remarked upon seeing it: "This is like the first look at the back side of the moon." Nilsson, known throughout the world for his astonishing studies of organic life in all its variety, spent ten years in preparation for this historic picture. Perhaps it should be noted that most of Nilsson's famous "baby in the womb" pictures are not of a baby in the womb at all, but rather of embryos that were surgically removed.

Space walk (by Americans) in color. Once around, twice around, three times around the world, then open the hatch and walk right out. In June 1965, astronaut Edward H. White II became the first American to leave the warmth and comfort of his space capsule while in outer space. Tethered by a 25-foot line and an umbilical cord, wrapped in gold tape, he remained outside looking around, fiddling with his gadgets, and feeling his weightlessness for twenty-one minutes, while command pilot James A. McDivitt in *Gemini 4* undoubtedly wished that he, too, could play outside.

Earth in color. This is our home as it looked to the satellite *ATS III* on November 10, 1967, 22,300 miles out in space. It is the first full-view photograph of our planet. Clouds hide the Antarctic, but portions of the other four continents are easy to recognize. The technology that gave us this picture, put men on the moon, and showed us close-ups of the sun, Mercury, Mars, Venus, Jupiter, Saturn, and Uranus, was undreamed of before the mid-twentieth century.

Yet the formulas needed to calculate the speed the satellite had to attain against the pull of Earth's gravitational field in order to take the path its inventors wanted had all been derived by Isaac Newton three hundred years ago. Even the calculations concerning the guidance system and the ratio of fuel to payload were made according to Newton's laws of motion. It is all a matter of force, mass, velocity, acceleration, and the inverse square law that determines the attraction between two bodies.

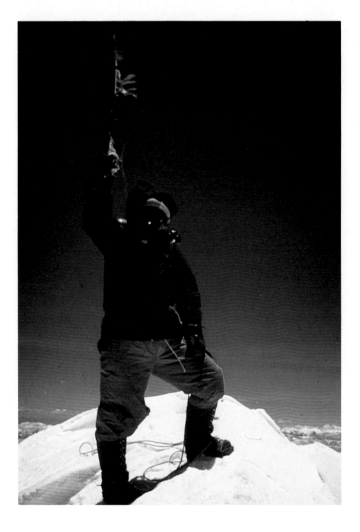

Top of Mount Everest. At 11:30 A.M. on May 29, 1953, New Zealander Edmund Hillary snapped this photograph of his friend Tensing Norkay on top of the world. When asked why there are no pictures of himself to mark the occasion of his becoming the first man to reach the summit of the tallest mountain, Hillary replied: "Tensing is no photographer, and Everest is no place to begin teaching him."

opposite:

Flash by a nuclear explosion. This extraordinary photograph is captioned in an official U.S. government publication as the "First successful photo made by the flash of an atomic bomb." The navy seamen are witnessing one of the atomic tests carried out in the Pacific Ocean at Bikini and Eniwetok atolls in 1948. Not everyone, however, chooses to look at the mushroom cloud, the symbol of man's power to annihilate himself, and some turn away from the monstrous idea in its eerie light.

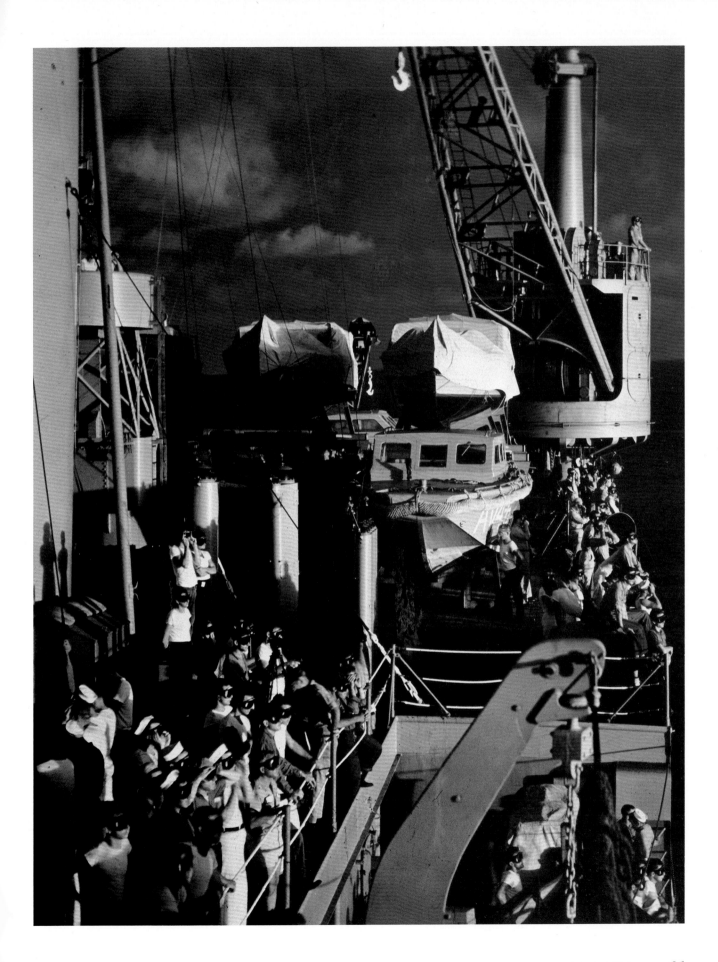

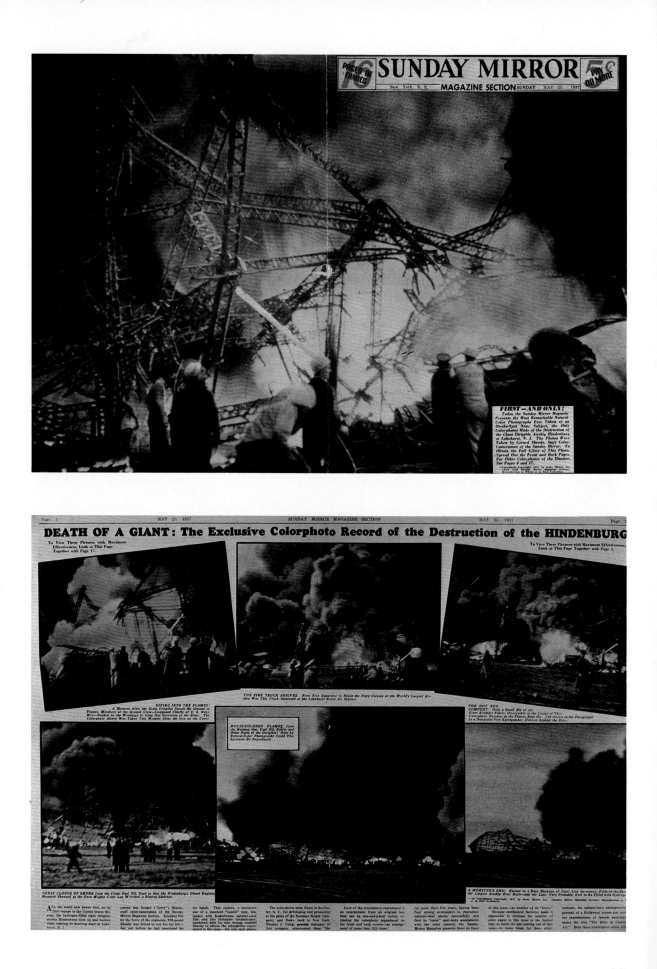

Hindenburg disaster in color. Many waited at Lakehurst, New Jersey, on May 6, 1937, to see the Hindenburg arrive for the tenth time from Friedrichshafen, Germany. When the dirigible was about to anchor, for reasons still not fully known, it exploded. The spectators scattered but two or three focused their cameras on the disaster and made some of the most famous pictures in the history of photojournalism.

One photographer had loaded his 35-mm camera with Kodachrome film, marketed for the first time only the year before, and produced what are probably the first spot news photographs in color. The *Sunday Mirror* (New York) ran them on May 23, 1937, with the following captions:

First—and Only!
Today the Sunday Mirror Magazine Presents the Most Remarkable Natural-Color Photographs Ever Taken of an On-the-Spot News Subject, the Only Colorphotos Made of the Destruction of the Giant Dirigible Airship Hindenburg at Lakehurst, N.J. The Photos Were Taken by Gerard Sheedy, Staff Color-Cameraman of the Sunday Mirror . . .

Multi-colored flames from the Burning Gas, Fuel Oil, Fabric and Other Parts of the Dirigible! Only by Natural-Color Photography Could This Spectacle Be Reproduced.

The colorphotos were flown to Rochester for developing & processing & flown back. Thomas J. Craig, process manager at Kodak said they were the "finest colorphotos ever made."

Each of the colorphotos reproduced is an enlargement from an original less than one by one-and-a half inches, including the colorphoto reproduced on the front and back covers—an enlargement of more than 225 times!

Having pioneered in colorphotography for more than five years, having been first among newspapers to reproduce natural-color photos successfully and first to "cover" spot news assignments with the color camera, the Sunday Mirror Magazine presents them on these pages and on the front and back covers of this issue—as another of its "firsts."

Because mechanical facilities made it impossible to increase the number of color pages in this issue in the limited time at hand, we are leaving out of this issue—to make room for these colorphotos—two of our regular weekly color features, the natural-color photographic portrait of a Hollywood screen star and the reproduction of famous paintings under the title "The Bible in Classic Art." Both these interrupted series will be resumed in our next issue.

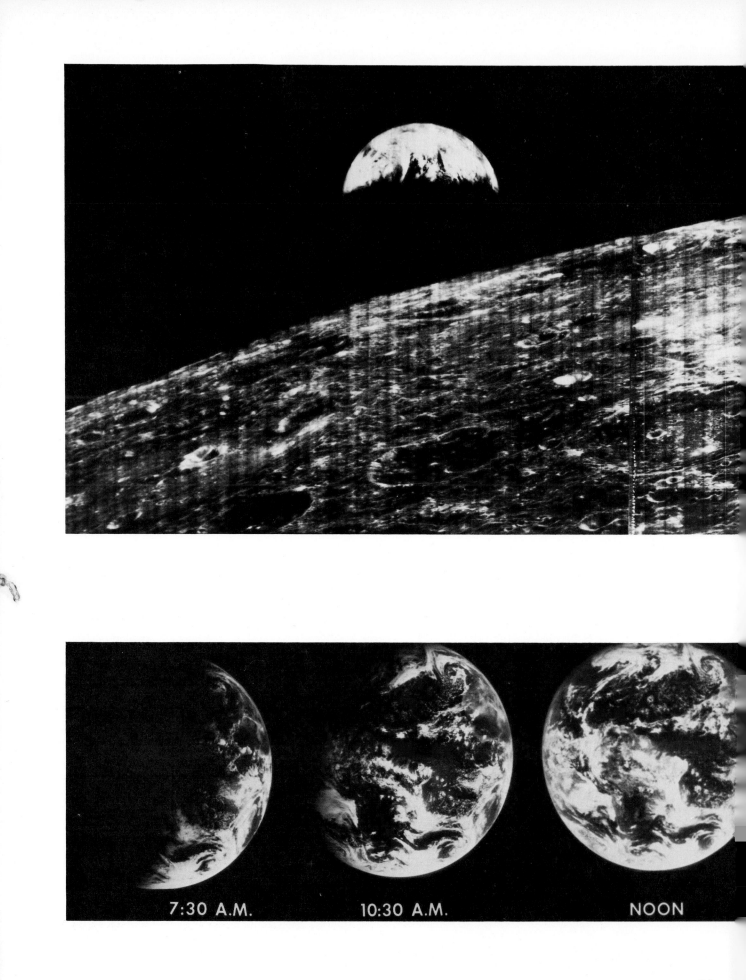

7:30 A.M. 10:30 A.M. NOON

Earthrise (Earth from the vicinity of the moon). This photograph of Earth rising above the moon—"Earthrise," as it is sometimes called— was taken by an unmanned piece of hardware controlled by Langley Research Center in Hampton, Virginia, on August 23, 1966. It not only gave pictorial proof that Earth is floating free in space, but it symbolizes a revolution in our view of the environment that began just about the time this picture was made. Clearly our planet is an eco-system that we cannot abuse without harming ourselves.

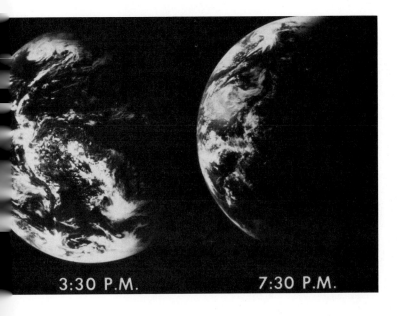

3:30 P.M. 7:30 P.M.

Day and night. Men and women have written, and always will write, poems about it, but an instrument controlled by a computer captured the essence of day and night in this set of photographs. On November 5, 1967, the ATS-III (Applications Technology Satellite) was launched by NASA to study methods of weather observation, navigation, and communication. It positioned itself 22,800 miles above the mouth of the Amazon on the equator, and held there, transmitting electronic impulses that on Earth were transformed into photographs. They show the Amazon directly below at three-hour intervals: during the day as the Earth turns from west to east, bringing the Amazon out of night into the sun's light; through high noon; and into twilight, just before the Amazon again looks up into the starry night.

9

23½

25½

Egg laying. An ocean of X-ray photographs have been taken of just about everything imaginable. Series depicting natural events from start to finish are not unusual, but the formation of an egg in a hen and its delivery has a special appeal due to the old question of which came first, the chicken or the egg?

Aristotle, reputedly the greatest intellect in history, included egg laying in his studies of nature during the fourth century B.C. Not for two thousand years were his findings questioned. About 1600 A.D., Hieronymous Fabricus of Aquapendente, professor of anatomy in Padua, wondered why the fat end of the egg came out first. "In a live hen," he wrote, "an egg provided with a hard shell may be easily palpated superficially. Housewives daily make this test when they try the hardness of an egg with their fingers from outside the body, in order to find out whether or not the hen is soon going to lay." (Whether or not to plan an omelette for supper was the question.)

Centuries passed before further light—this time X rays—was cast on the hen's travail. The egg is seen at 9, 23½ and 25½ hours. (Even the ancients knew that no hen could lay more than one egg every twenty-six hours.) These three pictures, part of a series, show clearly that the egg is turned around just before it is laid. The next step will be to find out exactly why it doesn't start off in the right direction in the first place. The photographs were made in 1946 by J.A. Fairfax Fozzard, formerly of the Department of Anatomy, University of Cambridge.

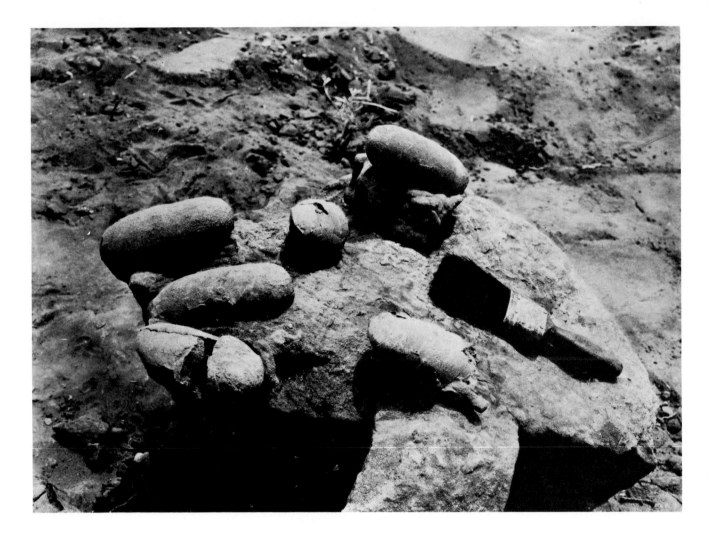

Dinosaur eggs and footprints. In the fossil record, the reptiles first appear 280 million years ago, become the dominant class of vertebrates everywhere on earth, and 65 million years ago vanish, except for the ancestors of turtles, crocodiles, snakes, and lizards. An enormous variety of dinosaurs flourished. They were found on every continent, but they became interesting only when notions of evolution began to develop, early in the nineteenth century. The question was: how long ago did they appear and why did they become extinct? The answer to the first was gradually worked out by reference to geological events and finally fixed by radioactive dating in the mid-twentieth century. The cause for their demise is still unknown; at least half a dozen theories have been proposed, one of the most charming being that just before the dinosaurs vanished the flowering plants evolved, and the flowers were poisonous to the vegetarians on whom the carnivores lived.

The highlight of children's trips to natural history museums is always the dinosaur exhibit. But, astounding though the size and shapes of these creatures are, and however mind-boggling the distance in time between then and now, their ossified eggs and stony tracks create a familiarity that the bones do not. These dinosaur eggs are the first ever found by scientists. The year was 1925, the expedition was led by Roy Chapman Andrews, and the place was Mongolia. The scholar who discovered them was George Olsen and the photographer, J.B. Shackelford. The footprints are also the first dinosaur footprints uncovered. The photographer was Charles L. Bernheimer, date 1927, place Niskla Nizzadi Canyon, Arizona.

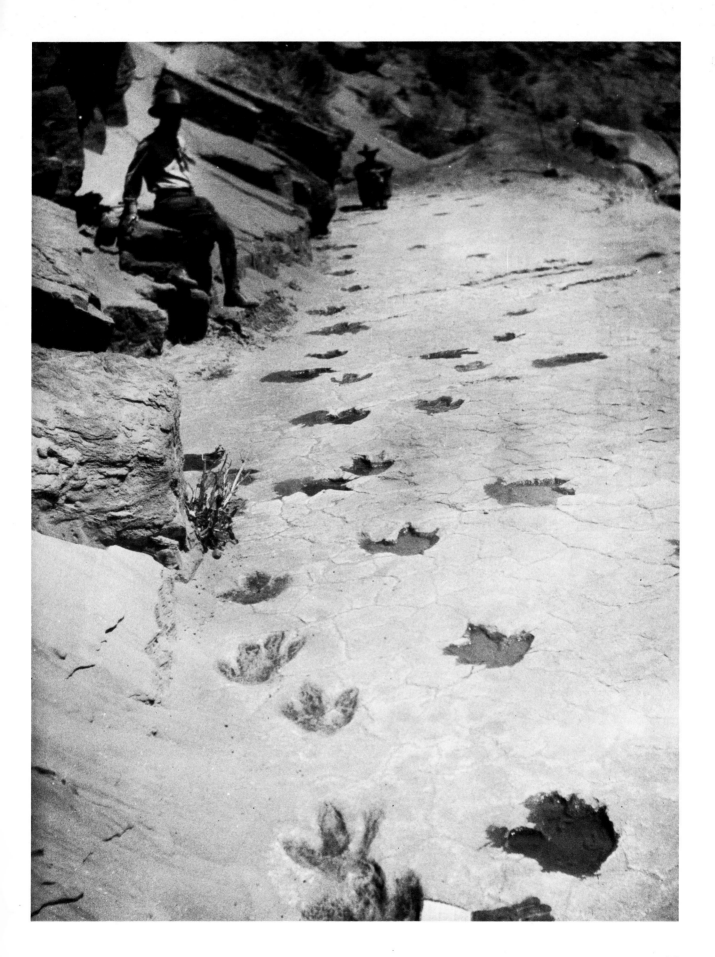

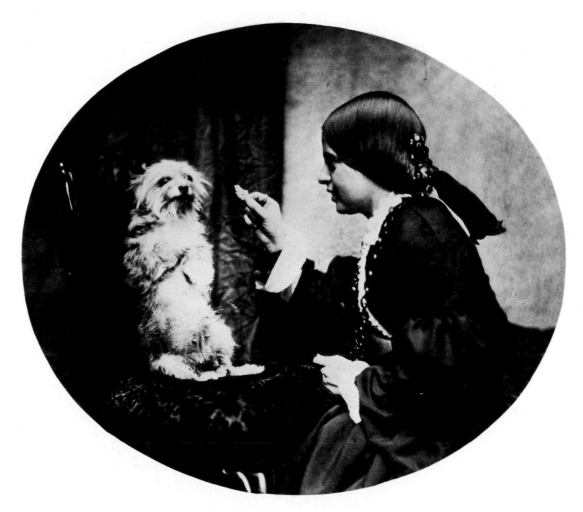

Dog begging. A cute little white dog held this pose for seven seconds in May 1856. Perhaps if the English weather had not been so cloudy—as recorded by the photographer W.G. Campbell in *The Photographic Album for the Year 1857* (a collection of photographs, text, and technical information that appeared only once before, in 1855)—his ordeal would have been reduced by one or two seconds. Although the title is "The Lesson," clearly the doggie is already a master at begging.

opposite:

Diving equipment. These English photographs, salted paper prints, date from about 1856. They are from albums relating to the activities of the Royal Engineers, including the period of the Crimean War. Diving suits were invented in the 1820s; by 1844 diving equipment had been greatly perfected. This particular air pump, hose, helmet, suit, and boots was made by the English firm of Heinke (later taken over by their rivals, Siebe, Gorman & Co.). Such equipment was familiar to moviegoers before scuba gear cast away the umbilical cord and gave the underwater adventurer a completely different image.

The Royal Engineers were active in the use and development of diving equipment from about 1839 because it was their job to find things dropped into harbors, raise wrecks, build underwater structures, and occasionally, perhaps, scuttle enemy ships. If the man at the pump stopped cranking, the diver tugging on his lifeline lived as long as he could hold his breath, for he could never escape from his suit. In the photograph (top) the diver is ready to descend with a saw. Actually, the ponderous weight of the suit and helmet helped the diver to twist wrenches, swing mallets, press drills, although it must have been exhausting labor. A scuba diver floating free cannot get the same leverage.

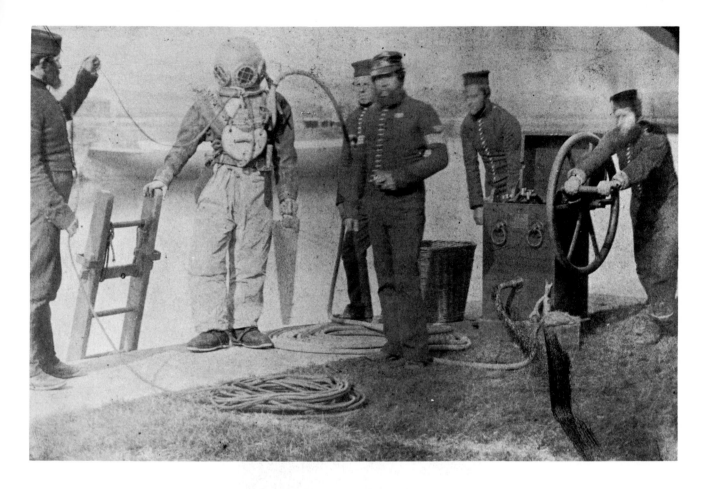

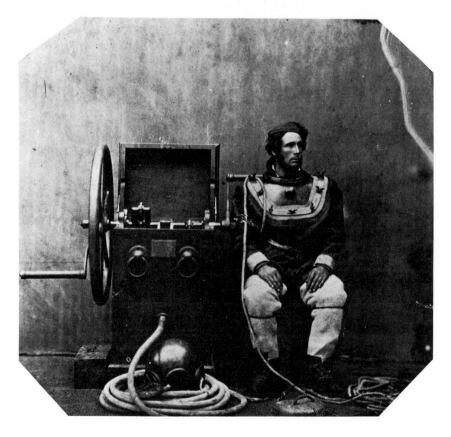

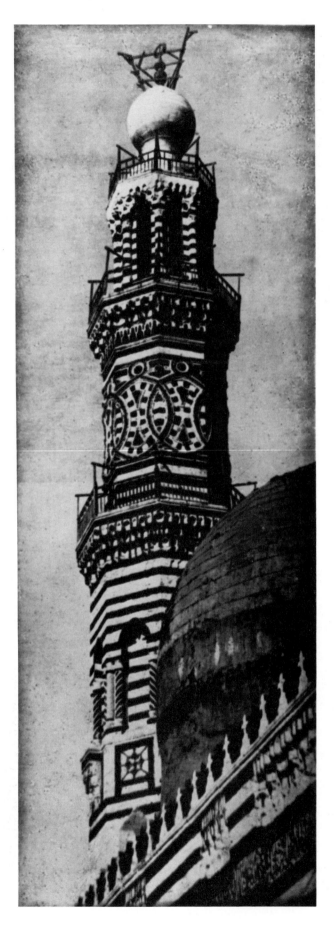

Egypt. An expert on Islamic architecture and an amateur photographer, Joseph-Philibert Girault de Prangey made the earliest extant photograph of Egypt in 1843. It is of the minaret of the Mosque of Lalaoun in Cairo.

The Land of the Nile, with its antiquities and romance, was one of the first places European photographers chose to visit. Jules Janin, editor of *L'Artiste*, wrote in 1839: "The daguerreotype will be the indispensable companion of the traveler who does not know how to draw and of the artist who does not have time to draw." On November 6, 1839, the French romantic painter Horace Vernet wrote from outside Cairo, "We have been daguerreotyping like lions." He was traveling with his nephew, Charles Bouton, and Frédéric Goupil-Fesquet, who handled the camera. Pasha Mehemet Ali, who of course had never seen a photograph when these three were working in Egypt, exclaimed upon looking at his first daguerreotype, "It's the work of the Devil!" And this devilish occupation was spreading. Already in the fall of 1839 there was a second cameraman heading up the Nile. His name was Joly de Lotbinière, and like Goupil-Fesquet he had many failures for each success.

The daguerreotypes of Egypt by Goupil-Fesquet and Joly de Lotbinière are not known to exist. Engravings based on some of them, however, appear among the 114 plates in *Excursions daguerriennes: Vues et monuments les plus remarquables du globe*, published in Paris by N.P. Lerebours from 1840 to 1842. Because tracings were made of the plates, the surfaces of which are fragile, the plates were destroyed.

opposite:

Eiffel Tower. We cannot identify the *first* photograph of the Eiffel Tower; while it was being built in the 1880s, hundreds of people snapped pictures. Monsieur Pierre Petit, who made this photograph about 1888, viewed the Eiffel Tower very differently than we do. He did not know what the final structure would look like, whereas we are familiar with it through photographs, whether or not we have visited Paris. The exact shape is so well known today that it is difficult to glance at this picture without completing it in our minds. This is because, when dealing with visual imagery, we tend to fall back on traditional reference points.

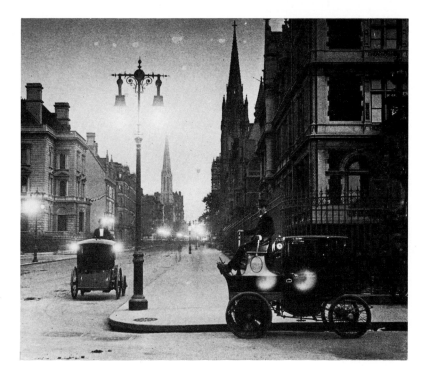

Electric taxis in New York. Although gasoline engines had been propelling automobiles for some time, the chauffeurs of these battery-run carriages sat as if they were still driving horses. This photograph of the taxis was taken by A. Radclyffe Dugmore in 1899, and it must be one of the first, as Dugmore reported that these electric taxis had just started to appear on the streets of New York. The rising price of gasoline and the pollution in the modern metropolises may yet revive the electric car—or horse and buggy.

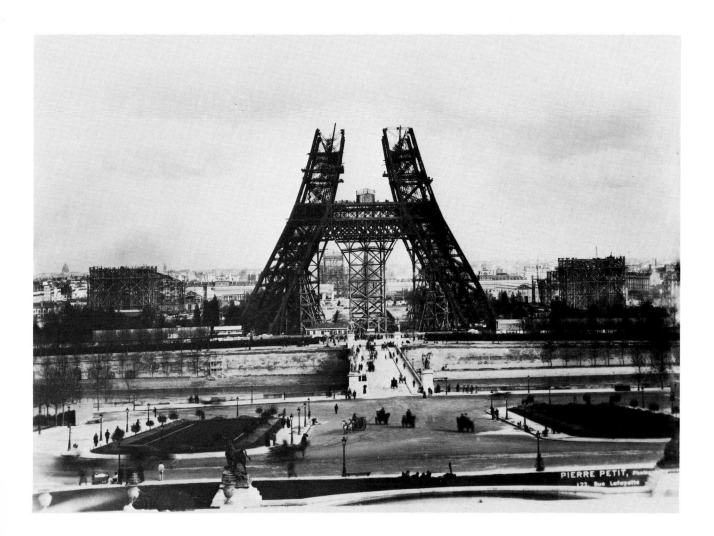

Camp de Châlons (1857)

Duel. Dueling was outlawed in Europe in the nineteenth century but it remained popular as an illegal way of revenging personal insults in gambling, politics, and love. The rules were strict and varied from country to country. The weapons, especially pistols, were deliberately made less lethal than they could have been, as duelers really did not want to die or be convicted of murder. Seconds did their best to bring about amicable settlements before the combatants faced each other. On the Camp de Chalons in 1857 an unknown photographer with a stereoscopic camera captured the start or finish of a pistol duel. The man on the left has either already fired his one shot or is waiting for his enemy to fire first. Which man had the advantage all depended on the complicated rules.

Effigy. Effigies have been burned, hanged, trampled, dismembered, drowned, and defiled from time immemorial. During the Modoc War of 1872-73 between this northwest American tribe and the United States government, Secretary of the Interior Columbus Delano was hanged in effigy on the main street of Yreka, California, on April 13, 1872. The Californian settlers did not feel that he was providing them with enough protection against the Indians, whose grievances against the government caused the uprising. Louis Heller took the picture.

RUTH SNYDER'S DEATH PICTURED!—This is perhaps the most remarkable exclusive picture in the history of criminology. It shows the actual scene in the Sing Sing death house as the lethal current surged through Ruth Snyder's body at 11:06 last night. Her helmeted head is stiffened in death, her face masked and an electrode strapped to her bare right leg. The autopsy table on which her body was removed is beside her. Judd Gray, mumbling a prayer, followed her down the

Electrocution. Ruth Snyder, convicted of murdering her husband, was executed on January 12, 1928. Strangely, no photographers were allowed among the journalists and witnesses. The *New York Daily News*, however, knowing of the public's avid desire to have a visual record, outfitted Tom Howard, a photojournalist from Chicago, and hence unknown in the New York area, with a hidden, pre-focused camera, which he strapped to his ankle. The camera held only one small glass plate. He aimed his shoe and released the shutter (by means of a cable that ran up his leg) as Snyder was dying. The picture, blurred by her convulsions, had a five-second exposure. It appeared the next day— Friday the thirteenth—full-page, and the way it was used is still controversial.

The human need to see everything from the sublime to the tragic to the most depraved or terrifying spectacle is constantly satisfied by photography, and cameramen have often been accused of pandering to salacious voyeurism. Who is to blame? Photographer, publisher, subject, public, or advertisers, who subsidize the press? Throughout history, executions have always been public spectacles, and in many countries they still are.

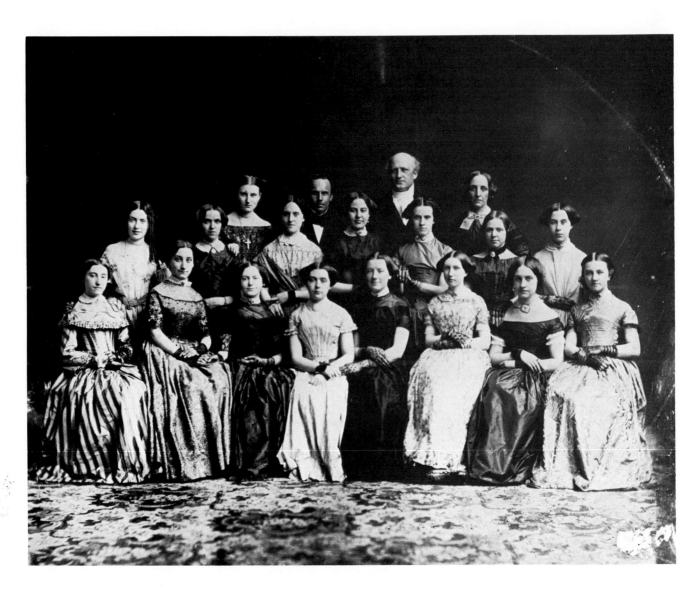

Graduation picture (in U.S.A.). A mammoth plate (11 by 14 inches) daguerreotype made in 1851 is the first group graduation picture taken in the United States. Dressed in their best, hands gracefully placed, the class of Rutger's Female Institute, Fifth Avenue and 42nd Street (now the site of the New York Public Library), sat before an anonymous photographer to commemorate their years together.

This single image of the girls and their tutors was more like a trophy than a typical class portrait of the present day. Only one person could keep it, so probably it stayed at the school. These women had what was considered one of the most liberal educations of their day; they studied chemistry in the laboratory, astronomy, higher mathematics, and the principles of daguerreotypy and telegraphy. But still they all parted their hair in the middle, and all but one had buns over their ears. The earliest extant class picture anywhere seems to be a daguerreotype made of a group of boys in a school in Lubeck, Germany, on February 15, 1850.

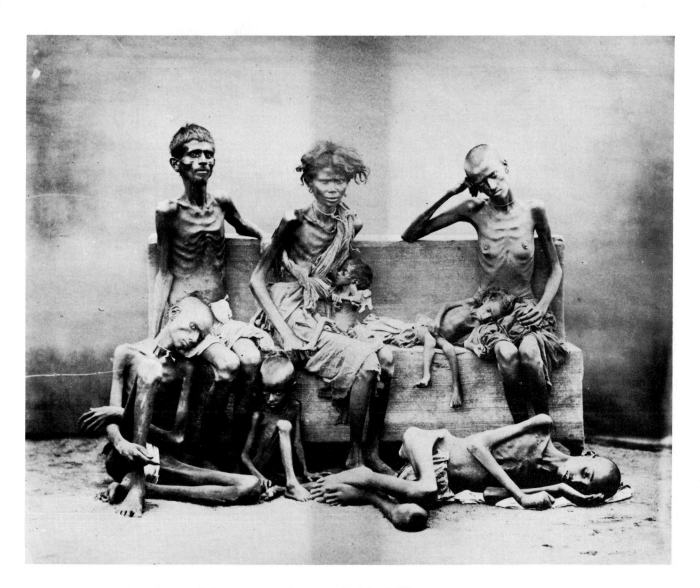

Famine victims. These living skeletons were photographed by William Willoughby Hooper about 1876 in Madras, India, during a famine. Modern technology may be able to save people from the ravages of droughts and floods in the industrialized West, but elsewhere the same old picture is still being repeated.

Gliding. The amazing German Otto Lilenthal kept jumping off high places, hanging from a variety of rigid wings that he designed along principles drawn from experiments with kites. In 1894, a photographer recorded this glide from an artificial hill near Lichterfelde, Germany. The ancient dream of flying, so often described in legends and myths, and depicted by painters, was now a reality. Although this modern Icarus crashed to his death in another leap, his success inspired all the other aerial crazies to redouble their efforts. Nine years after these mosquito-like wings were used by Lilenthal, the Wright brothers triumphed.

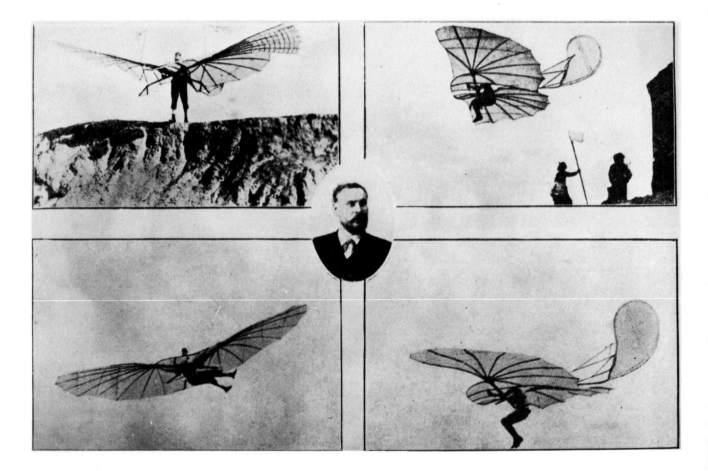

opposite:

Fly landing on ceiling. Stephen Dalton had a dream—to photograph insects on the wing. No one had ever photographed them before in free flight, which, as he said, "made it an Everest I wanted to conquer." No camera or electronic flash equipment was fast enough in 1969 to capture clearly the motions of a dragonfly, grasshopper, bee, or beetle. Dalton had to work with an electronics scientist, Ronald Perkins, who helped him design a system that allowed a shutter to open in 1/450 of a second instead of the usual 1/20 of a second, and had a sufficiently powerful flash of 1/20,000 of a second instead of the conventional electronic flash of 1/400 to 1/1000 of a second duration.

The first objective was achieved by clamping a special rapid-opening shutter in front of the lens; the focal-plane shutter of Dalton's 35-mm Leicaflex was left permanently opened. The ultra high-speed flash that was eventually designed after many months was triggered by the insect itself moving past an electric eye multiplied by a series of reflecting mirrors so that even an insect with the most erratic flight pattern could not miss setting off the flash.

Eventually, a device was designed to fire a sequence of three flashes so that a series of images could be recorded on the same frame. Because the technique shows different wing positions within a very short time, takeoff and landing of insects could be studied. The picture, made in 1974, shows the superb acrobatics of a common housefly when it wants to take a stroll across a ceiling.

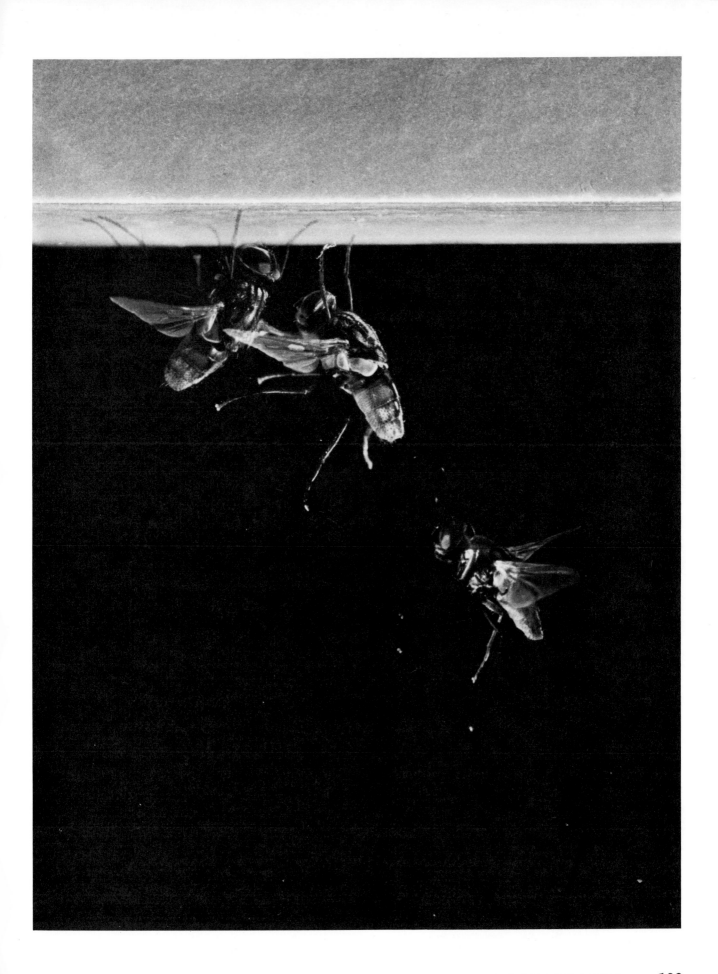

Ghosts. Ghosts started appearing in photographs in 1839—quite unintentionally. While the long exposure necessary then was taking place, a person would sometimes walk through the scene on which the camera lens was focused, stop for a moment, and then move on. The figure would appear more or less as transparent and be called a ghost, but was of a purely photographic origin.

Sir David Brewster, in *The Stereoscope—Its History, Theory, and Construction* (1856), was the first to explain how photographers could have greater control over ghost production:

For the purpose of amusement, the photographer might carry us even into the regions of the supernatural. His art, as I have elsewhere shewn, enables him to give a spiritual appearance to one or more of his figures, and to exhibit them as "thin air" amid the solid realities of the stereoscopic picture. While a party is engaged with their whist or their gossip, a female figure appears in the midst of them with all the attributes of the supernatural. Her form is transparent, every object or person beyond her being seen in shadowy but distinct outline. She may occupy more than one place in the scene, and different portions of the group might be made to gaze upon one or other of the visions before them. In order to produce such a scene, the parties which are to compose the group must

have their portraits nearly finished in the binocular camera, in the attitude which they may be supposed to take, and with the expression which they may be supposed to assume, if the vision were real. When the party have nearly sat the proper length of time, the female figure, suitably attired, walks quickly into the place assigned her, and after standing a few seconds in the proper attitude retires quickly, or takes as quickly a second or even third place in the picture if it is required, in each of which she remains a few seconds, so that her picture in these different positions may be taken with sufficient distinctness in the negative photograph. If this operation has been well performed, all the objects immediately behind the female figure, having been previous to her introduction, impressed upon the negative surface, will be seen through her, and she will have the appearance of an aerial personage, unlike the other figures in the picture.

The title of the photograph below is "The Orphan's Dream" (c. 1857). The picture was used by Brewster as an illustration of capturing "ghosts" or "spirits."

The first time ghosts appeared on photographic plates without an explanation was in 1862. An amateur American photographer with an interest in the occult, William H. Mumler, seemed to be able to attract spirits and take their pictures. He found them appearing with greater frequency on his

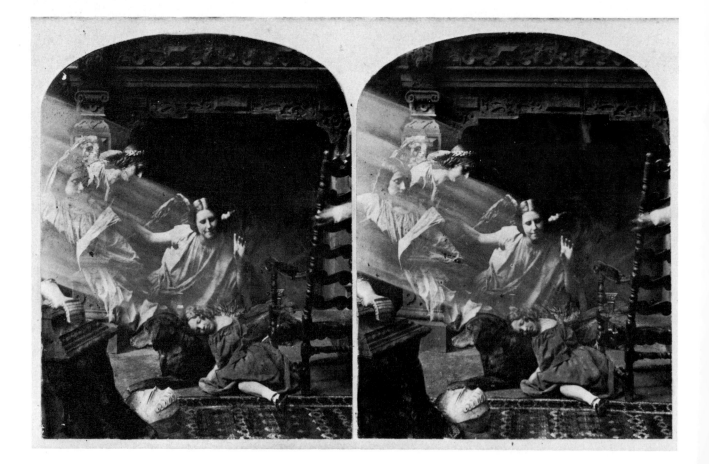

glass-plate negatives, and even individuals who scrutinized his procedure could not state that the ghosts were fabricated by Mumler.

Mumler set up a business in New York and became successful photographing the living with their dearly departed. He was known as a "spirit portrait photographer," but not everyone was convinced. He was arrested for having "by means of what he termed spiritual photographs, swindled many credulous people." A trial was held, but so many people, including a judge, testified that they had received "genuine psychic portraits" of dead friends and relatives that Mumler was acquitted. His most famous picture was of Mrs. Abraham Lincoln with her late husband standing beside her.

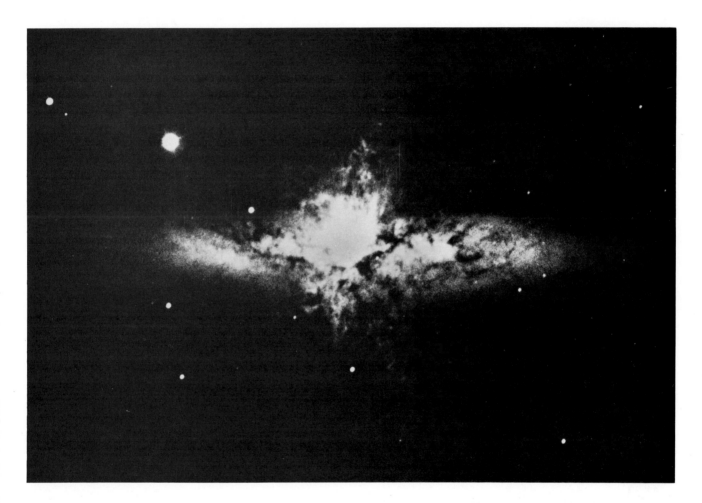

Galactic explosion. Until the 1920s, astronomers believed that only one galaxy of stars existed—the Milky Way. That, in effect, was our entire universe. They had listed, among the various components in the Milky Way, fuzzy, irregular patches of light, which they called nebulae, because these were not pinpoints of light, like stars. By the 1930s, new telescopes proved that some of these nebulae were far, far beyond the limits of the Milky Way.

It is now estimated that the observable universe consists of tens of billions of galaxies, each with about 100 billion stars. The light from all these galaxies has a characteristic called the red shift, suggesting that they are racing away from us and one another, at speeds that, for the farthest from us, approach the speed of light itself.

This and other observations led to the theory that the universe began with a cosmic explosion—the Big Bang—and that it is still expanding. There is a sound theory for the formation of individual stars but not for galaxies, and for the explosions of stars but not for the explosions of galaxies. This picture of what was listed as the nebula Messier 82 is interpreted as an image of the galaxy exploding. It was taken with the 200-inch telescope at Mt. Palomar in the early 1960s.

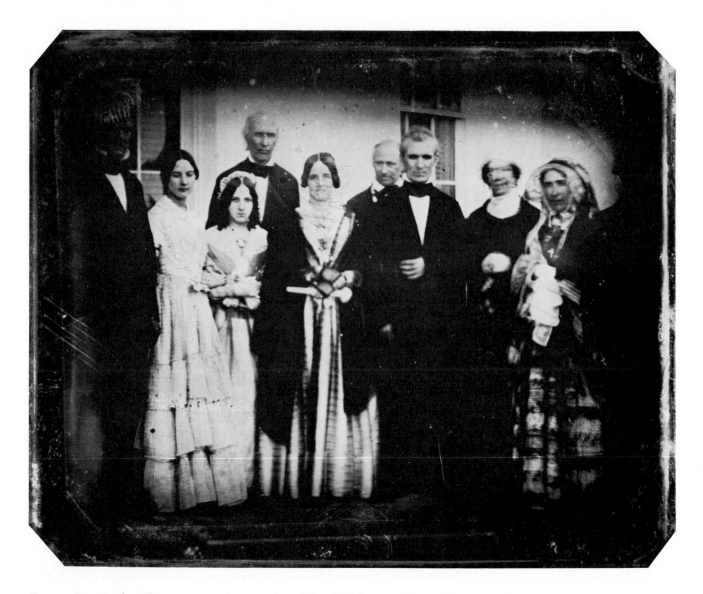

Former First Lady. There are no photographs of the fourth president of the United States, but his First Lady lived long enough to turn up on a group daguerreotype. Dolley Madison, wife of James, is the second woman from the right. Dolley was known both during the Madison presidency (1809-17) and afterward as a congenial hostess, permitting and indulging in wine-drinking, card-playing, and snuff-taking, even if others highly disapproved.

In contrast, one of the most austere first ladies was Sarah Childress Polk, standing in the center of the photograph next to her husband, President James Polk. They did not allow wine in the White House and so guests often left official functions in a beeline for Dolley's house. Others shown are Secretary of State James Buchanan (on the extreme left), later to be the fifteenth U.S. president, standing with his niece Harriet Lane next to him; Postmaster General Cave Johnson (fourth from left); and Secretary of the Treasury Robert Walker (between President and Mrs. Polk). The photograph is thought to have been taken by G.P.A. Healy, on June 16, 1846.

Girl Scout troop. This is the first Girl Scout troop in the United States: the White Rose Patrol, formed in 1912. One of the girls, Page Anderson, tells the story of how it all began:

My home was on Lafayette Square [Savannah, Georgia]—next to that of Juliette Low, My Cousin "Daisy." She was devoted to my Father and Mother and in 1912 on her return from England [where she got the idea to form the Girl Scouts] she asked my Mother, Page Wilder Anderson, to become the first Captain or "Leader," and have me and my friends—8 of us to begin with—form the First Troop. . . .

Mother was interested and inspired by Daisy Low's enthusiasm and energy—and so were we, but we certainly did not realize that we were "Making History!" However, when we met in the stable house—now called the First Headquarters—in Mrs. Low's yard—she solemnly lined us up and asked us to raise our right hands and take the oath of allegiance. We felt we were in on "Something Big" especially as she said many times —"This will be for all girls in America."

We studied first aid; homemaking; nature craft; and cooking (mostly making fudge —to begin with) and we would meet once a week for supper and games.

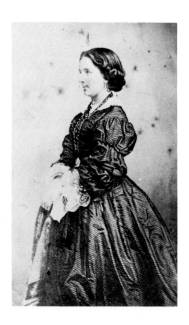

Flash—by magnesium light. The use of burning magnesium wire literally opened closed doors, permitting photographers to photograph indoors and at night. The frightening flash explosion became part of the photographer's image in the days before floods, bulbs, cubes, and strobes.

In February 1864, Professor Henry Roscoe, who had previously published papers on the brilliance of burning magnesium wire, gave a lecture to the Manchester Literary and Philosophical Society, Manchester, England. Alfred Brothers, a Manchester photographer, heard the lecture and was afterward given a small lump of the metal. He experimented with the magnesium and succeeded in making this photograph. He wrote: "The result of an experiment I have just made is that in 50 seconds with magnesium light I have obtained a good negative copy of an engraving, the copy being made in a darkened room." The picture, the *carte-de-visite* of Madame Nantier-Didiée, is inscribed on the back: "Copy of an engraving. The first copy ever made by the magnesium light."

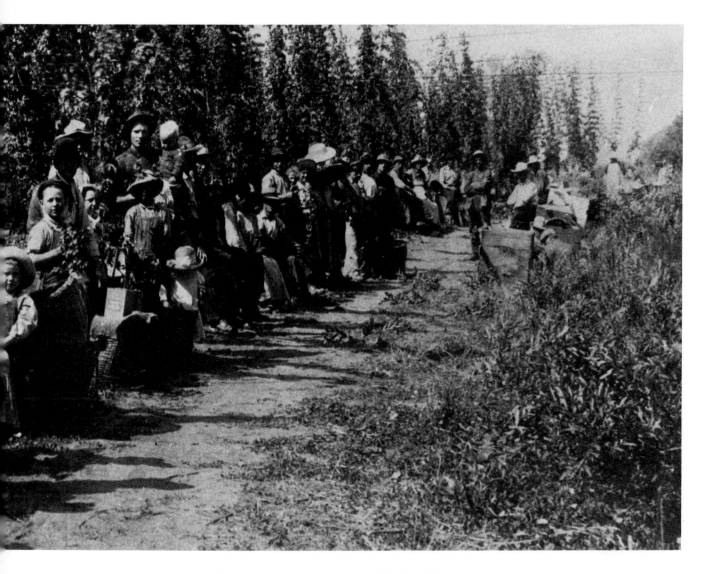

Farm workers on strike (in U.S.A.). This is the earliest known photograph of agricultural laborers on strike in America. They are hop-pickers in California, and they seem to be organized into nonviolent protest, with even a tot here and there. The picture was made in August 1913.

Germany. The earliest photographs taken in Germany date from March/April 1839 and are three views of Munich. The men responsible for these pictures, Carl August von Steinheil (1801-70) and Franz von Kobell (1803-75), were professors at the University of Munich. Steinheil was an astronomer, physicist, mathematician, and lens-maker; Kobell, a mineralogist interested in the graphic arts. There is evidence that they might have been independent inventors of photography, but their experiments do not predate those of Talbot or Daguerre.

The exposures for these pictures, made on paper treated with silver nitrate solution and fixed with either caustic ammonia or potassium hyposulphite, were at least half an hour long. The negatives are about 2¼ inches square. They show, above left to right, The Glyptothek, towers of the Munich cathedral, and a building in the Odeonsplatz (left).

The Forum, Rome. A man leans on a railing, contemplating the ruins around him. The Temple of Saturn, the Temple of Vesta, the Arch of Titus, the Arch of Septimius Severus, the Temple of Castor and Pollux, and the Deified Caesar all had a greater reality to the classically educated nineteenth-century gentleman than they do to the average twentieth-century man or woman. The Victorian had read in Latin about the events that had taken place in the great Roman Forum: the public meetings; the gladiatorial combats; the many rulers who had passed through it. To visit Rome was part of his education. To photograph it, however, was to capture antiquity with the tools of the machine age. This anonymous daguerreotype was taken in 1839 or 1840.

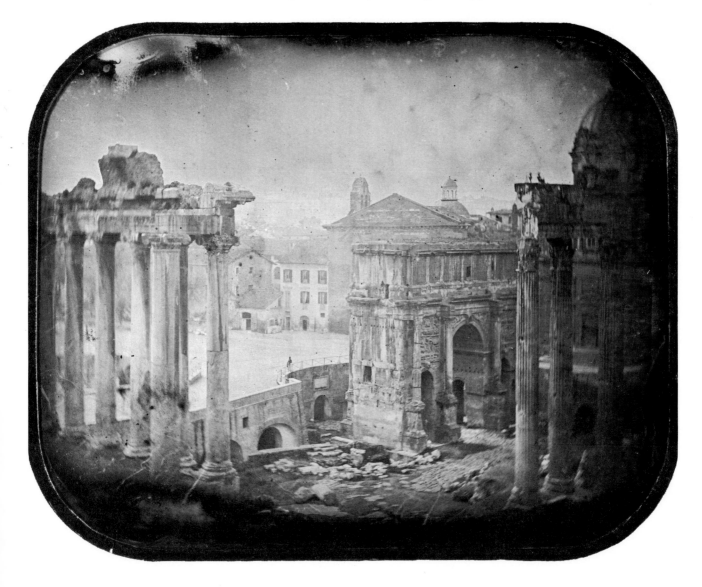

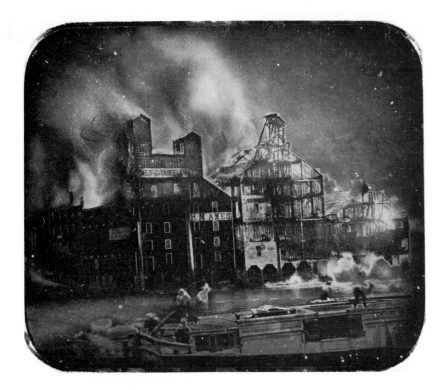

A fire. George N. Barnard captured the destructive force of a raging fire as mills in Oswego, New York, burned on July 5, 1853. More recent photographers at the scene of a fire generally try to focus on the faces of those directly affected by the fearful loss of life and property. Barnard's daguerreotype apparatus did not permit this type of documentary; his picture deals with the burning of the buildings themselves. Four figures can be seen on a barge on Barnard's side of the river, but because they were not completely still during the entire exposure, they too appear as if consumed in flames, and are quite indistinct.

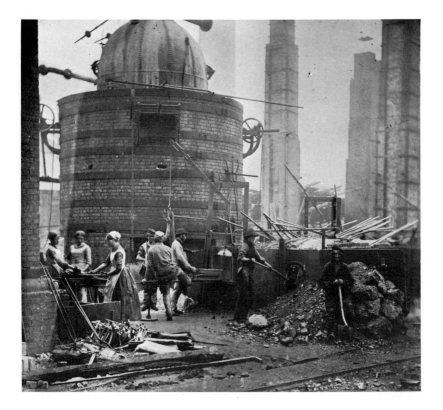

Forge. The Industrial Revolution had become the sinew of Western civilization by 1857, when this photograph by G.B. Gething of a forge in Great Britain was probably taken. Female labor was clearly commonplace in this, one of the most dramatically frightening technologies to outsiders (because of its dirt, heat, and dangers). Forging iron, that is, giving it shape while it is hot, is a craft discovered by the Hittites in 2,000 B.C. With iron swords they conquered the bronze civilizations. The British made the first iron bridges, iron rails for trains, and iron-bottomed ships, with which they created their worldwide empire.

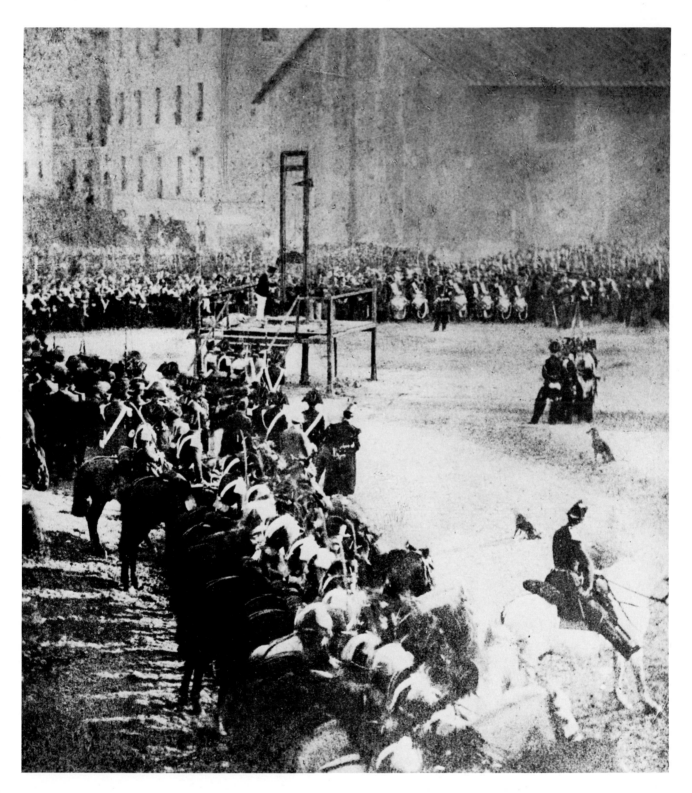

Guillotine. In 1867, the revolutionary Giuseppe Garibaldi led an army to liberate Rome from papal rule as the final stage in his pursuit of a unified Italy. Two rebels planted a bomb in the papal barracks, but they were caught and arrested and on November 24, 1868, at 7:00 A.M. they were guillotined in the Via del Cerchi.

Garibaldi's previous efforts, especially the capture of Naples (September 7, 1860), helped unite Italy under King Victor Emmanuel II of Sardinia-Piedmont. Once Rome was established as the Italian capital, Garibaldi retired to Caprera, near Sardinia, disillusioned with the political maneuvering that seemed to have little to do with his revolutionary ideals.

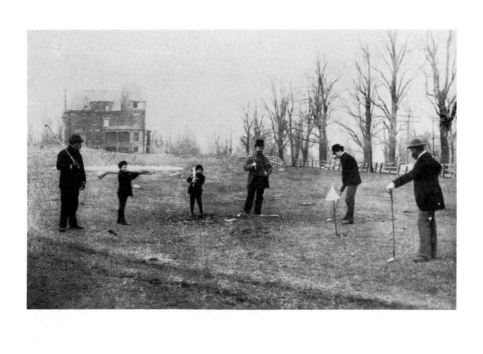

Golf in the United States. John Shotts, a butcher in Yonkers, New York, opened 30 acres of his land to golf players in 1888. A Scotsman, John Reid, with friends, founded on those acres St. Andrews, the first golf club in the United States. The picture was taken in that year and shows Reid at the far right, leaning on his putter in traditional style. Even small caddies, lugging driver, brassie, spoon, cleek, sand iron, and putter, are present.

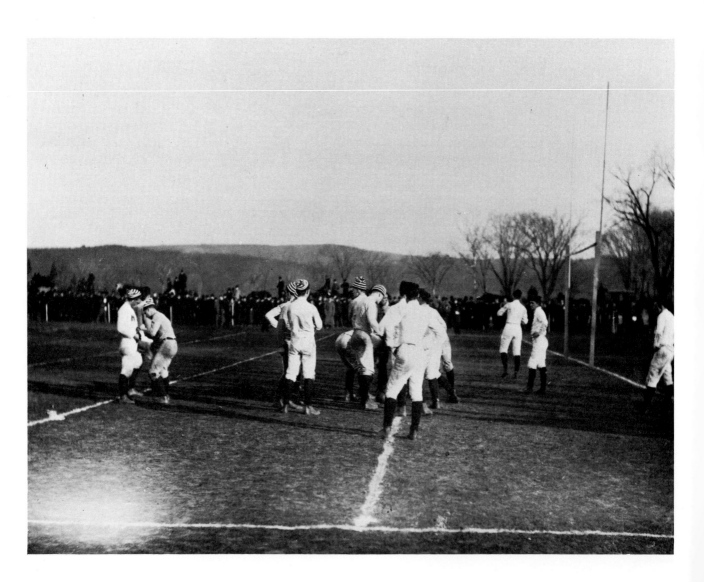

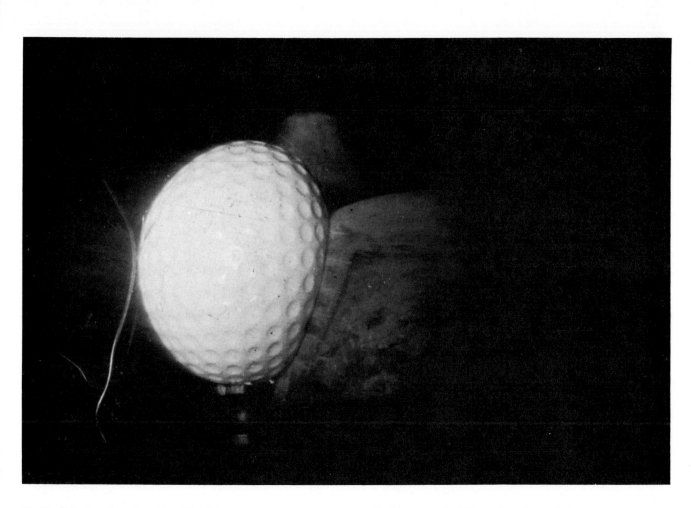

Golfball being hit. Dr. Harold Edgerton is a master problem solver. In 1931, he developed what has come to be known as the strobe, a lamp that produces a brilliant light with less than 1/1,000,000 of a second duration. He is best known, perhaps, for his sharp photographs of objects traveling at thousands of miles an hour. He has also developed techniques to photograph nuclear test explosions and sea life at unprecedented depths. Dr. Edgerton has said: "I have followed the work of Fox Talbot and have looked at Boys' original articles on bullets in flight. I have studied Professor Worthington's book on splashes. . . ." Although acknowledging inspiration and information from many sources, Edgerton has initiated and developed countless techniques and has made thousands of "first" photographs.

One of Dr. Edgerton's earliest stroboscopic photographs is this one of a golf stroke taken at a 10-microsecond exposure, made in the early 1930s. It had to be timed within about 1/5,000 of a second, because the ball and the club are in contact for only that length of time. They travel together for about a quarter of an inch.

opposite:

Football game, Army-Navy. This picture of 1890 shows the first time Army played Navy in what was to become a famous annual rivalry. Navy won, 24-0, on a frozen field.

Legend has it that the first time someone picked up the ball in a soccer game and ran with it was in 1823, at Rugby School, Warwickshire, England. American football is a descendant of the English game of Rugby. The first intercollegiate match in America was between Princeton and Rutgers in 1869; in the 1870s and 1880s one college after another formed football teams and sought opponents.

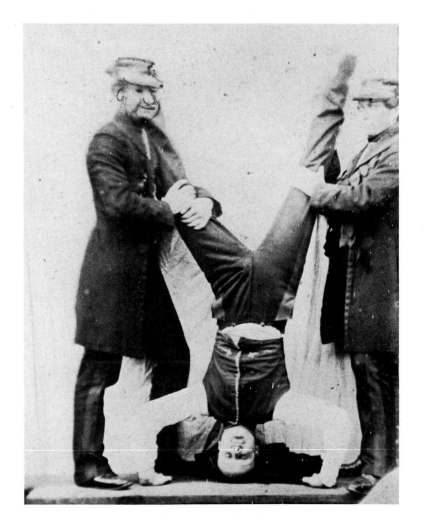

opposite:

Hippopotamus. A present to Queen Victoria in 1850 from the pasha of Egypt, this peaceful beast was the first of its species to put up with Sunday crowds at the Regent's Park Zoo in London. Count de Montizon arranged his camera in 1854 to make it look as if the children were the ones locked behind bars, while a free hippo dreamed of the White Nile.

Head stand. A remarkable first (with retouching) by Corp. Dukes, R.E., taken about 1852. Right side up, left to right: Ens. Moore, Ens. Manson. Upside down, center: Ens. Luard. Exposure time unknown.

opposite:

Hide (Blind). Richard and Cherry Kearton were two of the first true nature photographers. When they decided in the early 1890s to photograph birds, a few trials resulted in their observation that birds fly away from men. They noticed, however, something perhaps these Yorkshire lads had always known: birds don't fly away from cows. So they made a dummy bullock and one day, Richard, the older brother, climbed inside and focused his camera on a bird's nest through a tiny peephole. As it was not the most comfortable or well ventilated of waiting rooms, eventually Richard got dizzy and toppled over. He struggled for an hour to escape before Cherry came along and straightened him out—after fits of laughter and a single (camera) shot. Of the five legs in the photograph, the two with the shoes belong to Richard.

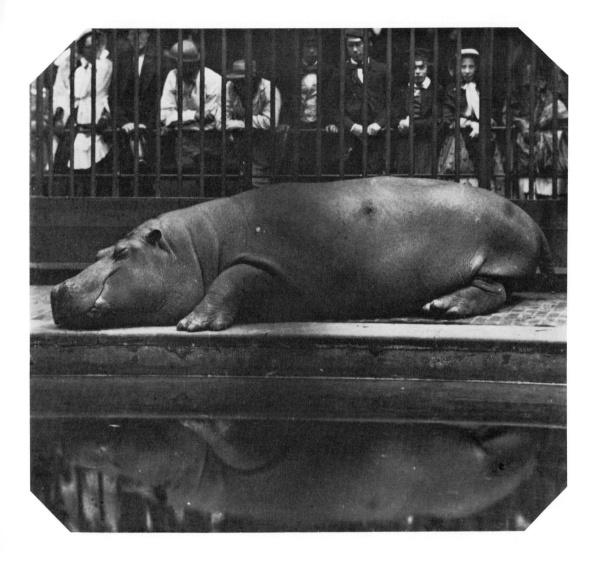

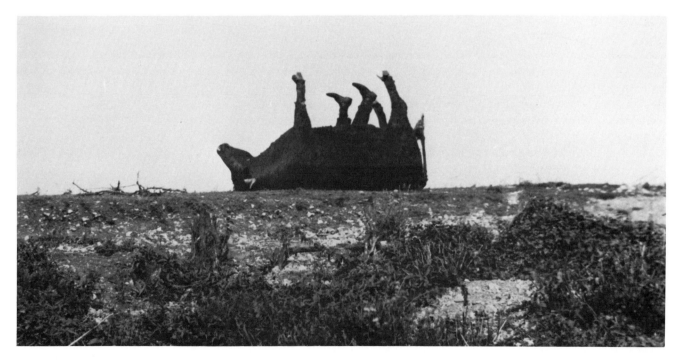

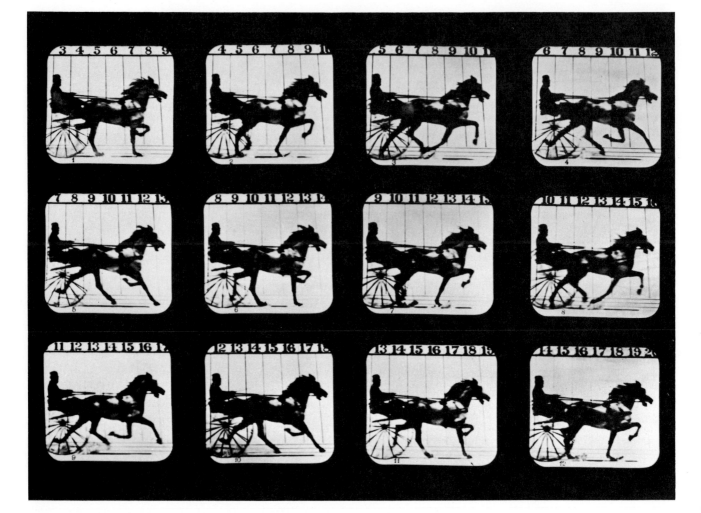

Horse in motion. Eadweard Muybridge invented a way of photographing a horse in motion by setting up a series of cameras with trip shutters along the horse's route. Each camera was triggered by its own string when the horse was directly before it. This series of "Abe Edgington" trotting at 2:24 gait was taken June 15, 1878, at the Palo Alto Track in California and is the first of Muybridge's studies that were not retouched. The clarity of the horse's moving legs makes a marvelous sight even today. It was important in its day in settling the question, once and for all, that at some point, all four of a galloping horse's hoofs leave the ground at the same time. Muybridge's pictures brought an end to rocking-horse horses in painting.

Muybridge's nude human models photographed with more sophisticated camera equipment in 1884-85 show all sorts of acrobatic exercises and are famous. They were avidly bought by painters, sculptors, doctors, and others who, for the first time in history, could examine the muscles and bones of the body in motion.

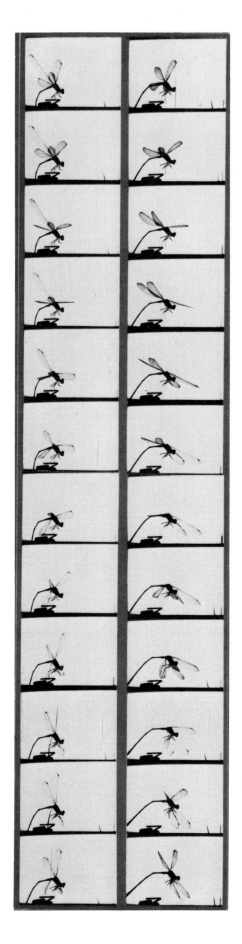

Insect in flight (dragonfly). Dr. Lucien G. Bull was one of several men who invented various techniques and equipment for high-speed photography. William Henry Fox Talbot was the first, in 1851, to design a method using a spark, from a battery of Leyden jars, that lasted 1/100,000 of a second, and though photographic emulsions were slow the brilliance of the flash triggered sufficient chemical reactions to obtain a photograph of a fast-moving object.

Dr. Bull's invention of 1903 was a rotating drum three feet in circumference with 35-mm film wound on it. The drum was spun by an electric motor at forty revolutions per second, which moved two thousand frames past the lens every second. A special hookup between the drum and the light source synchronized the illumination of the subject. Bull was the first to photograph insects in flight and soap bubbles bursting. In this series, taken 1905-1906, a dragonfly is about to exit from a tube where it has been imprisoned; as it takes off it kicks a little switch that starts the camera.

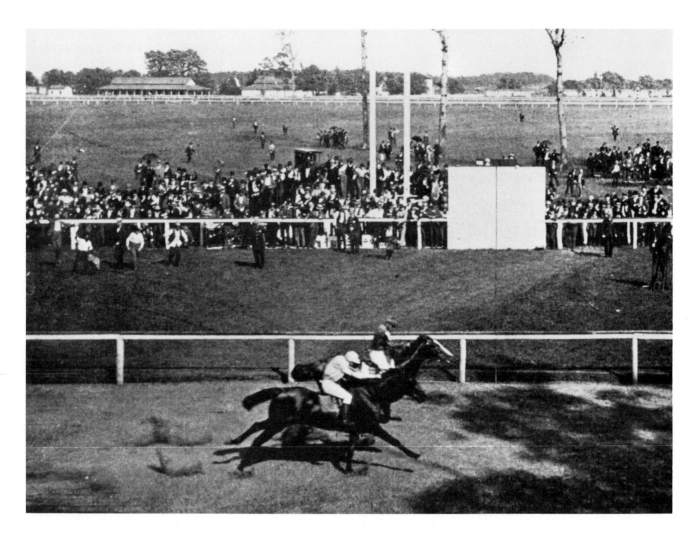

Horse race finish. The photograph shows the last second of a race run on June 25, 1890, at Sheepshead Bay, New York, and described in the June 28 *Spirit of the Times* "Post and Paddock" column as "a race such as but very few if any of us had seen before and none of us may ever see again. Winners and losers together lost sight of money in signifying their delirious pleasure in seeing such a magnificent and grandly contested race." Nevertheless, those who had put their money on Salvator were happier than those who had bet on Tenny. As the writer of the article explained, "the chestnut held him, just held him, and that's all, and as the pair passed before the judges he still had the advantage of a 'short head'—a few inches indeed to decide the disposition of such vast sums of money."

Both of the stallions were stars, and each had a long obituary in the *Thoroughbred Record* when he died. On November 20, 1909, Tenny's began: "Tenny, one of the greatest of American race horses, is reported dead. The death of Tenny, following within a brief time the passing away of his greatest

rival, Salvator, is being discussed by turfmen as a coincident that revives interest in the sensational match races that Tenny ran against Salvator. . . ." After the usual discussion of where he lived, who his parents were, his major accomplishments, the obituary ended as would only be proper for a horse: "Then came his retirement to the stud, where he achieved a moderate measure of success as a sire. His total winnings during his five years on the turf amounted to $87,025."

The first reference to using a camera at the finish line of a horse race appeared in *Photo News* in 1884. A correspondent suggested that a camera would help the judge "to justify his verdict of a short neck, a short head, or possibly a dead heat, by producing a negative on which the actual position of the first two or three horses was clearly shown." By 1888, Ernest Marks of Plainfield, New Jersey, was an official photographer to a racing association and could hand the judges a negative three minutes after the end of the race. No pictures by Mr. Marks are known, and the earliest extant of this type appears to be this one made by J.C. Hemment.

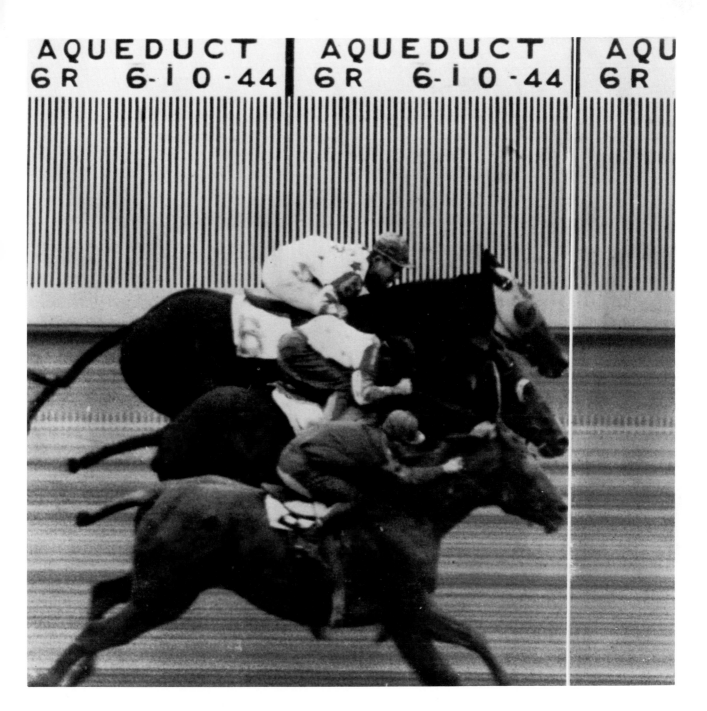

Horse race, triple dead heat. On June 10, 1944, this triple dead heat was snapped at Aqueduct Race Track in New York. The horses were Brownie, Bossuet, and Wait-a-Bit, and they paid $4.30, $2.40, and $3.50 to win in this race called The Carter Handicap.

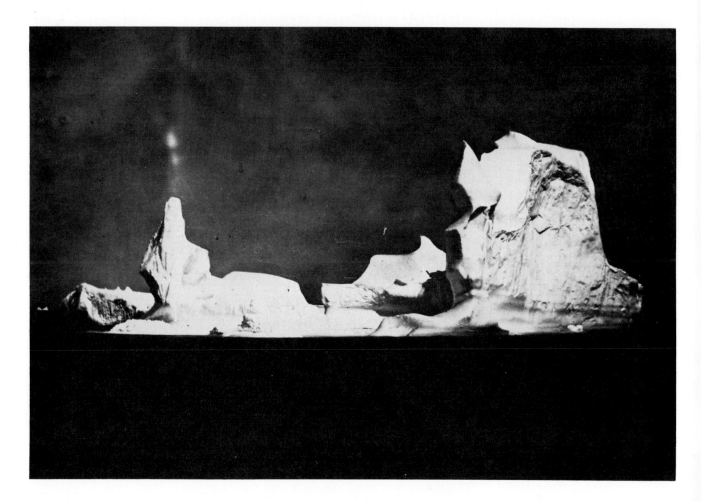

Iceberg. In 1869, William Bradford, a Boston artist, organized a group of people for a 5,000-mile journey to the Arctic regions on the 350-ton steamer *Panther*. Dunmore and Critcherson were the photographers, although there is some evidence that Bradford, too, made pictures. "This view," wrote the leader of the expedition in his book *The Arctic Regions*, illustrated with original photographs, published in 1873, "shows the beautiful forms in varied shapes which the Berg assumes. On this Berg we found a Lake of Fresh Water, covering an acre in extent." Pictures of natural forms such as this, collected from all over the world, had a deep influence upon painters and sculptors of the time, who were trying to break from the classical tradition.

Himalayas. Samuel Bourne was one of the most adventurous photographers of the nineteenth century. Between 1863 and 1866, he made three trips to the Himalayas, traversing some of the most difficult terrain imaginable. Sometimes he had as many as sixty coolies carrying his provisions and equipment; once he was in the mountains for ten months. The first European to photograph in the area, he wrote:

Everything wore an air of the wildest solitude and the most profound desolation, and while I looked upon it I almost shuddered with awe at the terrific dreariness of the scene. But the cold was too intense to permit me to look long upon its stern and desolate grandeur, and while at this elevation I was anxious, if possible, to try a picture; but to attempt it required all the courage and resolution I was *possessed of. In the first place, having no water I had to make a fire on the glacier and melt some snow. In the next place, the hands of my assistants were so benumbed with cold that they could render me no service in erecting the tent, and my own were nearly as bad. These obstacles having at length been overcome, on going to fix the camera I was greatly disappointed after much trouble to find that half the sky had become obscured, and that a snow storm was fast approaching.*

Altogether, Bourne made more than fifteen hundred wet-collodion negatives, some large, 10-by-12-inch plates and some of smaller size, many of them magnificent technically and aesthetically. He worked at a higher altitude than anyone else until 1880. This picture of the Manirung Pass was made at 18,600 feet.

Hollywood Bowl concert. One pianist and one singer were served in the Bowl on a barn door, circa 1920. Symphony concerts began at the Hollywood Bowl on a more substantial stage in 1922.

Jury. This is the jury that heard the famous Tichborne case of 1873-74. It was a case, as Helmut Gernsheim, the photographic historian, has noted, that proved photographs alone are not sufficient evidence to establish a person's identity. Roger Tichborne, heir to an English fortune, had been lost at sea in 1854, but his mother refused to believe him dead and advertised for him in 1865. A missing persons agency informed her that an English butcher working in Wagga Wagga, Australia, said he was Lord Tichborne; when this man returned to Britain in 1867, Lady Tichborne acknowledged him as her son.

The family was outraged and called the man an imposter. He, in turn, took the family to court in 1871, charging that they were preventing him from receiving his rightful inheritance. During two trials, old photographs of Tichborne and of the claimant were studied and physiognomists had their say, often with differing conclusions.

One hundred fifty people testified, one hundred stating definitely the man was not Tichborne, fifty swearing the claimant was he. Eventually it was concluded that the man was Arthur Orton, a butcher's son from Wapping, England, who had jumped ship in South America in 1849. He was sentenced to fourteen years of hard labor for perjury and forgery. Released ten years later, he nevertheless continued to state he was Tichborne and many people continued to believe him. In 1895, three years before his death, Orton, penniless, revealed that he was an imposter in a sensational magazine article.

These men of the jury, each with whiskers of a different style, look unwilling to put up with nonsense. The participants in the case—the steward on one of the ships, the judge, the barristers, the jury, witnesses, policemen, the claimant—were also photographed and their portraits sold. It is strange that no earlier picture of a jury has been found, but perhaps no earlier trial demanded the same visual media coverage.

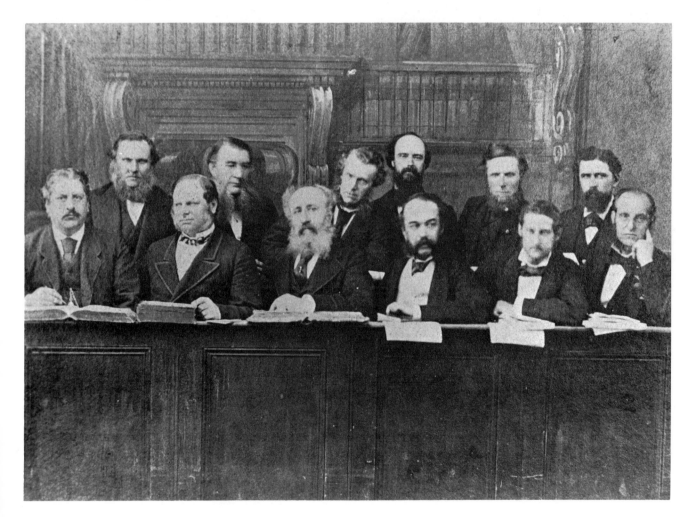

Interview. On August 31, 1886, the 100th birthday of the French scientist Marie Eugène Chevreul, a photo-interview was carried out and the series of pictures that resulted succeeded in capturing the expressions—inquisitive, thoughtful, argumentative —and character of the famous old man. Questions were asked by Nadar, another well-known Frenchman, while Paul Nadar, his son, made the pictures. "I had thought," wrote Paul Nadar, "of adding to the camera a phonograph . . . but as Edison had not made the phonograph commercially available, I engaged a stenographer to take down the spoken words." The pictures were published in the *Journal Illustré* under the title "The Art of Living for 100 Years." Each photograph was captioned with Chevreul's words at the time of exposure. Nothing like this, which aimed at revealing greater insight into a person's character than could be achieved by a single portrait, had been done before, and the public was delighted to see how lively a 100-year-old man could look and how bright his answers could be. Some of the translated captions to the photographs reproduced are: "That's the trouble with this philosophy of rhetors, of fancy idle talkers. We are content with words, and with empty phrases. . . . M. Hersent, who had become somewhat excited by our conversation, answered me: 'If anyone other than M. Chevreul told me that, I would say he had lied, but since it's M. Chevreul who is saying it, I want to see it in order to believe it.'—Whereupon I proposed that he come to my laboratory at the Gobelins where I would show him the proof. . . . I see Pasteur's name on this page. It is under his name that I shall put my own. M. Pasteur is one of the greatest minds of our time, because whereas our scientists had until then always started from known phenomena in order to arrive at the unknown, he proceeded in the opposite direction: I must confess to you that the scientific school to which I belong had made me consider this novelty as nonsensical . . . I am going to write down for you my primary philosophical principle. I'm not the one who formulated it, it was Malebranche. I have searched hard, but haven't found a better one. . . . One must strive to be infallible without claiming to be. (Malebranche). Paris, August 31, 1886."

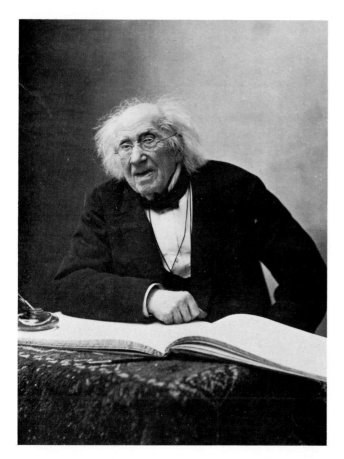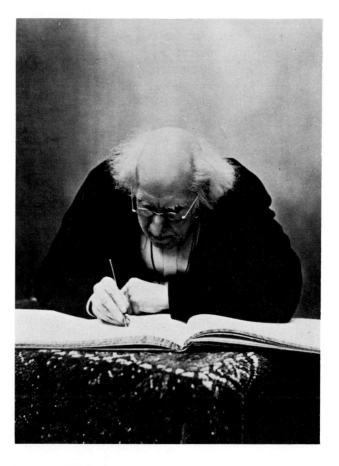

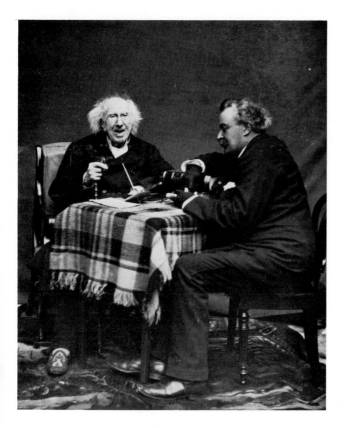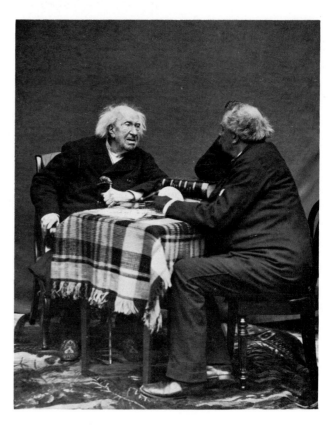

opposite:

Iwo Jima flag-raising. A Navy photographer, Louis R. Lowery, took this picture of U.S. Marines planting the American flag on the summit of Mt. Suribachi, Iwo Jima, in 1945. Several hours later, when things had quieted down, Joe Rosenthal requested a reenactment of the event, and it is his photograph that became immortalized. But this one was the first.

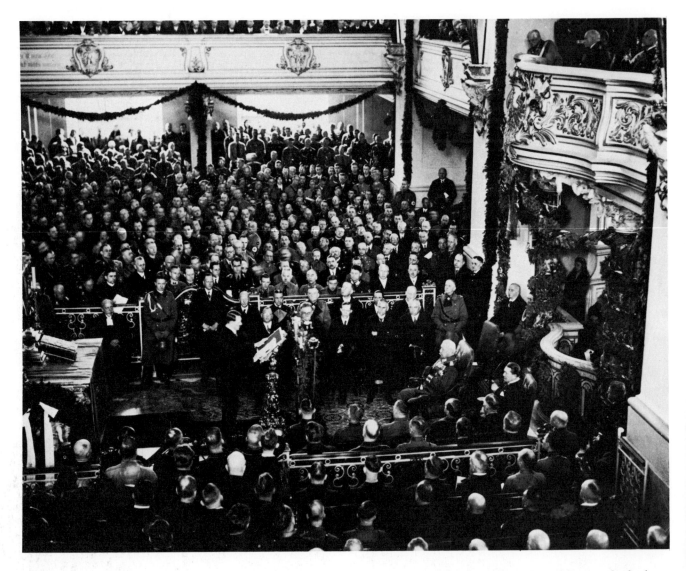

Hitler as Chancellor. In a photograph that apparently was never published, Hitler is shown just after being sworn in as chancellor of the Third Reich. This event, which led to so much horror and to World War II, took place on January 30, 1933, in the Garrison Church, Potsdam; the Bible on which the führer had placed his hand rests behind him. He is addressing President Hindenberg, Hermann Göring, Rudolf Hess, Heinrich Himmler, and others who became infamous with him.

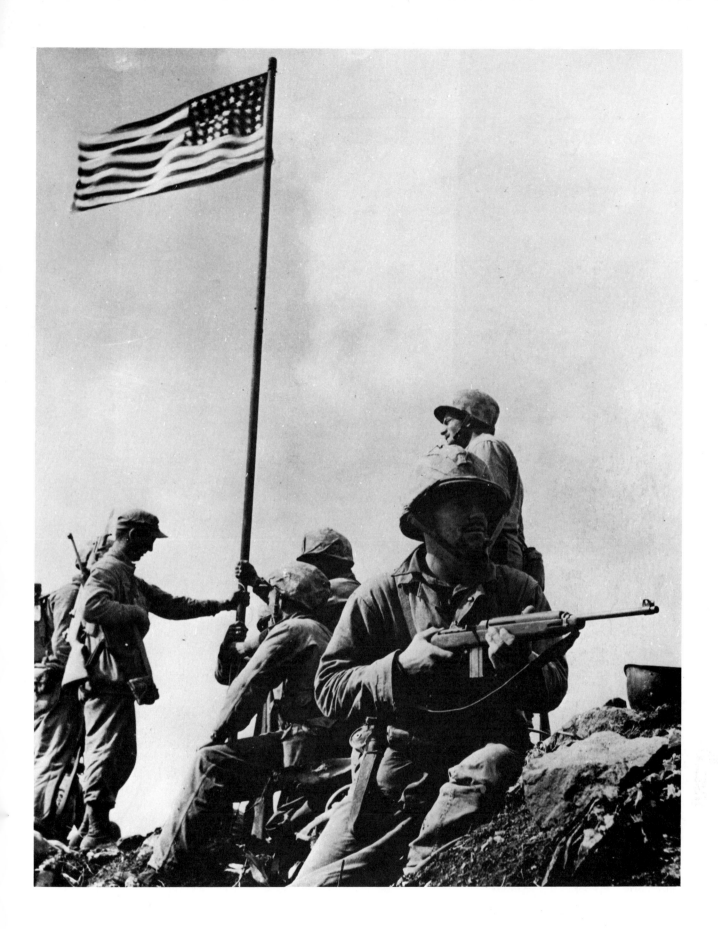

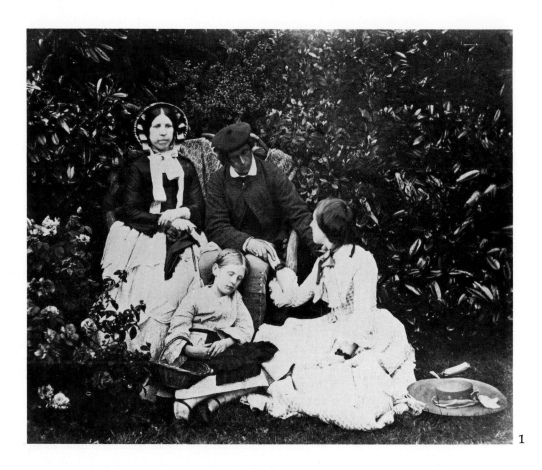

2

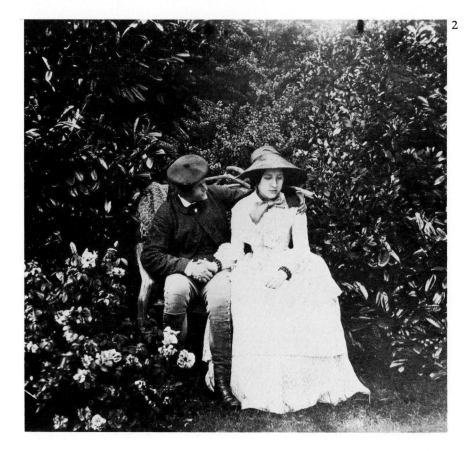

1

Love story. Although pictures loaded with story elements, for example, tableaux, were popular from the beginning of photography, it was not until 1854 that the idea occurred to Roger Fenton to string together a series of images to tell a more detailed story. Here, in four acts, is a Victorian romance: No. 1. Strong flirtation of which one Spectator highly disapproves. No. 2. Popping the Question. No. 3. Sealing the Covenant. No. 4. The Honeymoon. Number 3 may also be the first photograph of a kiss.

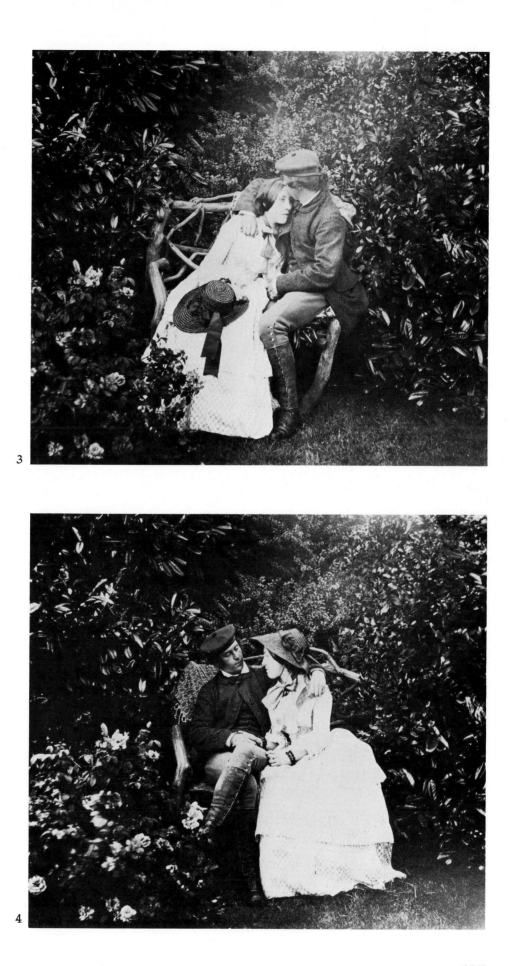

3

4

Karnak. Maxime DuCamp, who accompanied the novelist Gustave Flaubert on a trip to Egypt from 1849 to 1851, took two hundred calotypes, many of which became famous because they were the first Near Eastern photographs to be published in a book. Earlier daguerreotypes had been made of many of the same sites, but most were destroyed when artists made etchings from them for printers. Here is one of the first group of views of Karnak made in 1849 near Luxor, and occupying part of the site of Thebes. Such pictures became hugely popular in Europe and America and deeply influenced not just artists but architects as well.

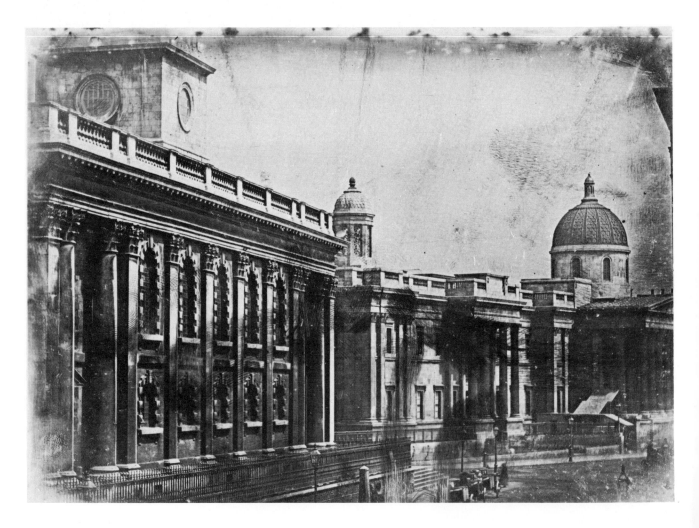

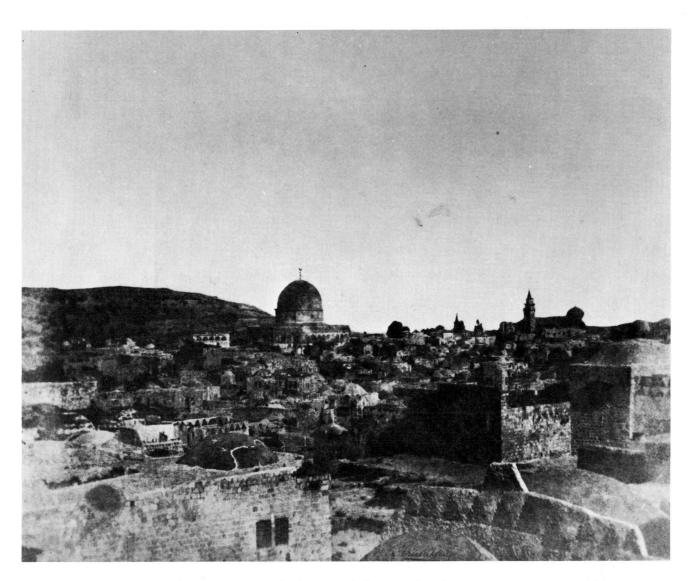

Jerusalem. One of the least-known figures in the history of photography, the Englishman C.G. Wheelhouse made the earliest extant pictures of Jerusalem in 1849 or 1850. Ten years previously Frédéric Goupil-Fesquet made daguerreotypes there, but none are known to exist today. Holy city for Jews, Christians, and Moslems, Jerusalem quickly became one of the most popular of subjects. In the 1850s, the very nooks and crannies of the streets and antiquities were carefully preserved on paper negatives by the Frenchman August Salzmann. By the 1860s, middle-class Victorians who cherished culture and religion had many stereoscopic slides of the city in their collections.

opposite:

London, England. Ironically, the two earliest extant photographs of London (taken August or September 1839) are daguerreotypes, the French process that rivaled the English photogenic drawing or paper negative. Both were taken at Trafalgar Square, one of the National Gallery, reproduced here, and the other of the steeple of St. Martin-in-the-Fields. It was the French who later mastered the paper negative and the Americans who exploited the daguerreotype best.

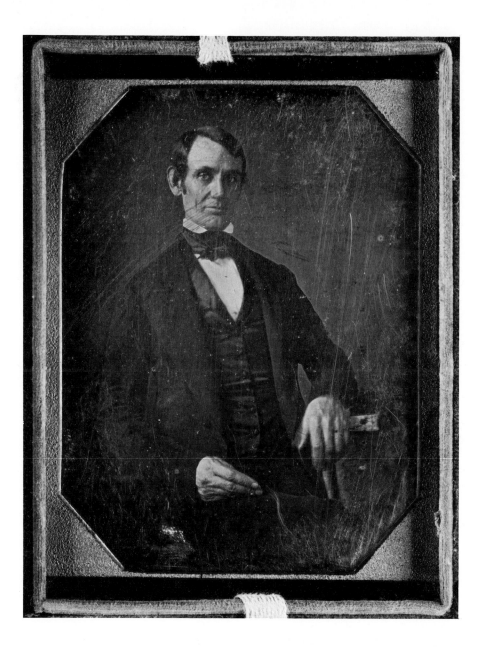

Lincoln. Thirty-seven-year-old
Abe, as he looked to
N.H. Shepherd in 1846.

opposite:

Lynching in the United States. Obviously, no one was ashamed of attending a
lynching (always illegal) in 1882, photographed here by H.R. Farr. The hanging
man was Macmanus—white or black, crime forgotten, perhaps never
committed. The movies have relied on the threat of lynching for suspense in
innumerable Western films. It would be difficult to argue that the threat still lurks
in American society. Mob action, on the other hand, is always a possibility.

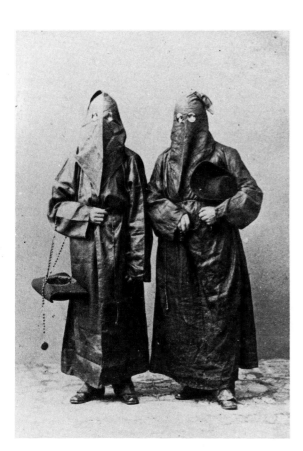

Ku Klux Klan. In May 1866, in Pulaski, Tennessee, various small resistance groups in the defeated Confederacy formed a secret organization to fight Reconstruction and to maintain white supremacy. The first Grand Wizard of the "Empire" was elected in Nashville the following year. He was assisted by ten Genii; the participating states were called Realms and obeyed Grand Dragons, who had staffs of eight Hydras. The hierarchies of power included names such as Grand Titan, Fury, Grand Giant, Nighthawk, Grand Cyclops. Each member was a Ghoul. Whoever was responsible for this nomenclature succeeded in generating fear, and with the same intention, the men wore sheets and hoods and rode horses, also sheeted, whose hoofs were muffled. These two members of the Ku Klux Klan posed about the time of its founding. The place and photographer are unknown. The photograph was discovered, however, in New Orleans.

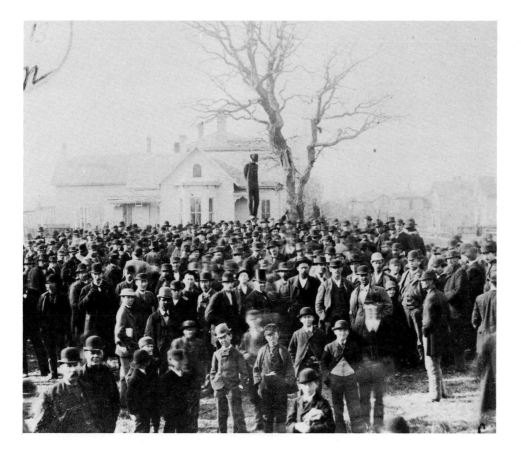

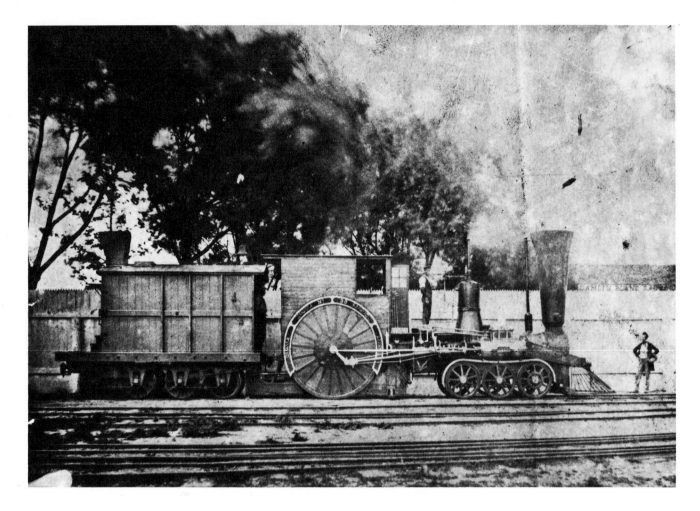

Locomotive. Although there is a French daguerreotype circa 1850 of a locomotive at the International Museum of Photography at George Eastman House, this calotype made by W. & F. Langenheim in 1850 of the Eight Feet Driver locomotive is the earliest dated one. Trains were one of the great symbols of the Victorian age, but photographers were slow to record them. It is possible to imagine many types of photographs being discarded by later generations, but who, upon finding a picture of an early locomotive, could have destroyed it? And yet, where are they all? Nineteenth-century cameramen seemed to avoid photographing machines. The demand for the picturesque and the portrait took precedence.

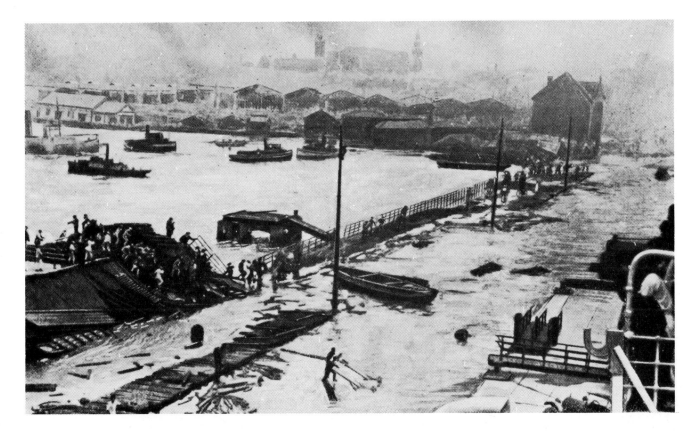

Japanese earthquake (published in London newspaper). On September 1, 1923, there was an earthquake in Japan. On September 27, the London *Daily Mirror* proudly published the photographs of the event. They startled their readers by being so remarkably quick with their pictorial coverage! The story of how the *Daily Mirror* was able to obtain photographs from 11,000 miles away in only three weeks was related by an editor as follows:

When the news of the disaster reached London, the Daily Mirror *immediately made arrangements by cable with a Far East correspondent. He flew 750 miles from Shanghai to Japan; took photographs in Tokio and Yokohama, flew on to Kobe and put his pictures on board a ship bound for Victoria, Vancouver. Vancouver was reached on September 15th, a fortnight after the earthquake. Thence, the pictures were flown via Seattle, and Chicago, to Cleveland, Ohio, where the aeroplane developed engine trouble. So the precious pictures were transferred to an express train and rushed to New York where a member of the* Daily Mirror *staff had been sent to meet them.*

He caught the French liner La France, bound for Havre. At Havre, an aeroplane awaited him and with the photographs he flew to Croydon direct in 2¼ hours, and thus the Daily Mirror *was able to publish on September 27th, 1923 . . . that amazing series of pictures which must still be fresh in the minds of readers, of the catastrophe that occurred less than four weeks previously, on the other side of the world.*

Lightning. The original daguerreotype made by Thomas Easterly in 1847 of a bolt of lightning was fortunately photographed by Cramer, Gross, and Company, St. Louis, in 1870, after which the daguerreotype was lost. Lightning, rather strange-looking here, was not understood until the structure of atoms and the interplay between them and electromagnetic radiation had been worked out in the twentieth century. All the same, from the beginning of history lightning was postulated to be the primary weapon of gods who wished to terrify or fry disobedient mankind. Benjamin Franklin was the first, as far as it is known, to attempt an analysis of Jove's thunderbolt, by flying a kite to which a large iron key was attached, up toward the blinding flashes. No one can understand today, when we know all about lightning, why *he* wasn't fried for his impertinence.

Lesson. This daguerreotype taken by Robert Cornelius in 1843 is the first attempt to teach directly through photographs. It was copied by an engraver and used as a book illustration. The lesson happens to be the procedure for filtering sediment from a solution. One wonders whether the hand-worked cloth was the photographer's idea to embellish the stark lab equipment, or whether he and Professor Martin Boyé simply forgot to remove it before settling down to poses that probably lasted a minute or more.

Kodak snapshot. This photograph, one of the earliest Kodak snapshots, was taken by George Eastman himself while he was on vacation in Egypt. The round picture was the standard format for the No. 1 Kodak. (The snappy name Eastman gave his invention was easily pronounceable in any language.) Some inventors designed clever cameras, others, excellent emulsions, but George Eastman gave the public everything it needed for simple photography. "You press the button," he promised in 1888, "we do the rest."

The No. 1 Kodak was marketed that year at twenty-five dollars, and it was sold loaded with a roll of treated paper (roll film, which came later, was also an Eastman invention) for taking one hundred exposures, the cost of processing being included in the purchase price. Anyone, without training or fear of failure, could press the button one hundred times and then pack up the camera and send the whole contraption back to Rochester, New York, where the negatives were developed, printed and mounted on gilt-edged, dark brown boards. The camera was then sent back to the photographer with the prints. For an additional ten dollars, it was reloaded (processing included).

Just ten years before, only the dedicated and the skilled could make photographs. Intrepid individuals would carry around their dark tents, chemicals, glass plates and preparing emulsions before each exposure, then develop them immediately after. George Eastman's idea—that anyone could make pictures—was a worldwide success.

Jesus (?). For four hundred years the fourteen-foot piece of linen shown here, believed to be the burial cloth of Jesus, has been kept in a Roman Catholic chapel in Turin, Italy. Only five times has the shroud been removed from its red silk wrapping in a silver box for public display. The last time, in 1978, a team of scientists was given ninety-six hours in which to examine the shroud for authenticity. "We can show mathematically the image was formed by a body shape underneath the cloth," said one. Another, a chemist at the Los Alamos Scientific Laboratory, said, "Every way we can think of for hoaxing it that would be credible, we can't prove."

The shroud shows a front and back image of a man, hands crossed. Marks on the hands and feet and on the right side of the chest are visible. The face is that of a bearded man with bruises. How the image got there is the puzzling question. The researchers say that it could not have been painted because the fibers of the cloth have not absorbed any pigment. It could not have been produced by ordinary heat because such a process would have scorched the cloth.

The image on the left is a positive print of the shroud as it appears to the naked eye, showing that it resembles a photographic negative. The picture on the right is an actual photographic negative taken of the shroud and it appears to be positive.

So far there is no answer to the mystery of the Turin shroud. If it is authentic, however, then this is the first photograph of a man who lived almost two thousand years ago. The photographs of the shroud were made in 1978 by Barrie M. Schwortz, a member of the international research team of scientists.

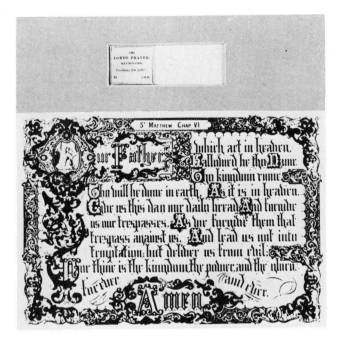

Microphotograph. John Benjamin Dancer (1812-87), an optical instrument maker and the inventor of the calcium spotlight (limelight) and a rapid-action electrical contact (the modern door buzzer), was also one of the first photographers in Great Britain and the maker of the earliest microphotographs.

Late in 1839, Dancer began experimenting with a microscope lens of 1.5-inch focal length fitted onto a camera and photographed a document 20 inches long, producing an image only ⅛ inch in length. This daguerreotype was the first microphotograph. He then used eyeballs of freshly killed animals instead of the glass lens and was again successful in making these very tiny pictures.

Daguerreotype microphotographs were not practical, as the image could not be magnified more than about twenty times because of the coarse granulation of the silver deposit. In 1851, Frederick Scott Archer announced his discovery of the wet-collodion process, which proved an excellent means of microphotography. The fine detail on the glass plates meant the picture could be blown up to any size.

In 1852, Dancer resumed experiments using the microscope but this time projected the image onto wet-collodion plates. His earliest surviving work in this medium dates from 1853 and is of his family and also of a monumental stone tablet carved in memory of Mr. William Sturgeon. Another early Dancer microphotograph is the dot on the inch-long slide, barely visible, which enlarges to the curlicued Lord's Prayer below it. Today, Dancer's invention is called microfilm or microfiche.

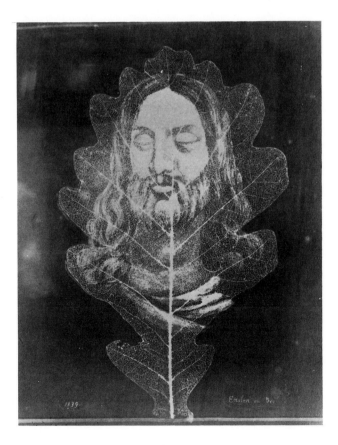

Montage. A montage is a composite picture made by combining several separate pictures. It is a term most frequently used in connection with photography and cinematography.

The first time a montage was made on photographic paper was in 1839. William Henry Fox Talbot superimposed an oak leaf over the face of Jesus Christ and produced this picture. In the nineteenth century, the best-known practitioners of the art were O.G. Rejlander and H.P. Robinson. Today, Jerry Uelsmann dazzles his audience with his expert skill in combining negatives to make surrealistic prints.

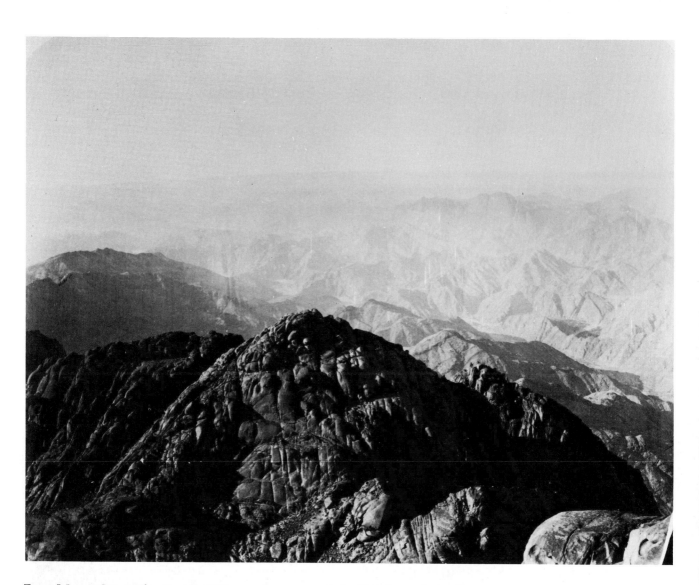

From Mount Sinai. The Captain Wilson who surveyed the U.S./Canada border was sent in 1868 by the Ordnance Survey with a new team of Royal Engineers, including an excellent photographer, Sergeant-Major McDonald, to map the Sinai. The real purpose included the needs of military intelligence, as Great Britain was trying to consolidate her position along the Nile and the Suez Canal, which had been started in 1859. The reason given, however, is partially summed up in the following words of Sir Henry James, Director of the Ordnance Survey:

This map is especially required by Biblical scholars and the public, to illustrate the Bible history, and to enable them, if possible, to trace the routes which were taken by the Israelites in their wanderings through the wilderness of Sinai, and to identify the mountain from which the Law was given, some writers contending that the mountain called Jebel Musa on the existing maps was the Mount Sinai of the Bible, whilst others contend that it was Jebel Serbal . . .

The view above is from the top of Jebel Serbal, the view on the right from Jebel Musa, each looking toward the Promised Land. Sgt. McDonald climbed both mountains with his wet-plate apparatus and took these pictures in an attempt to identify the spot where Moses might have stood when he received the Ten Commandments. Jebel Musa was eventually declared the winner for many reasons, but still not all authorities are in agreement.

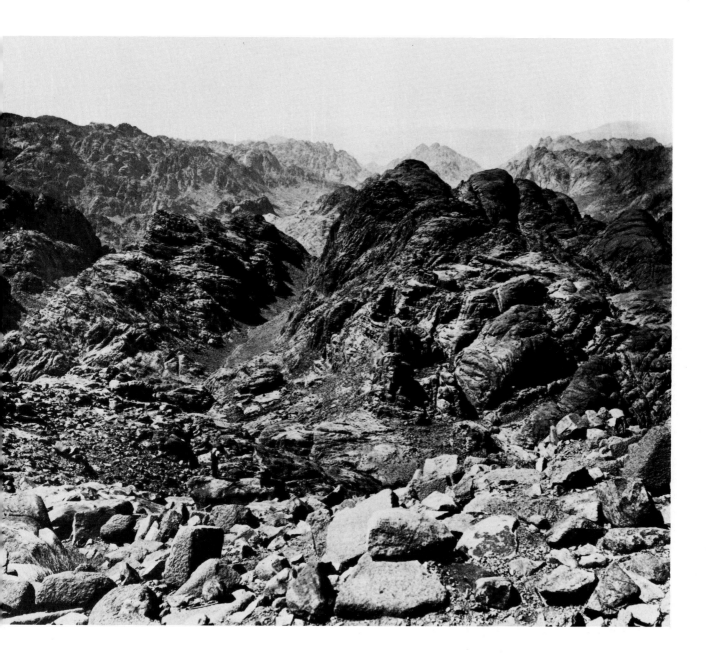

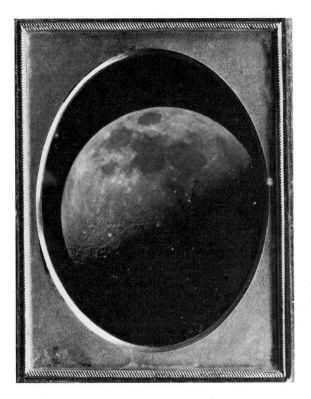

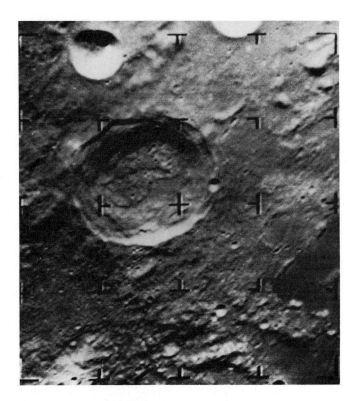

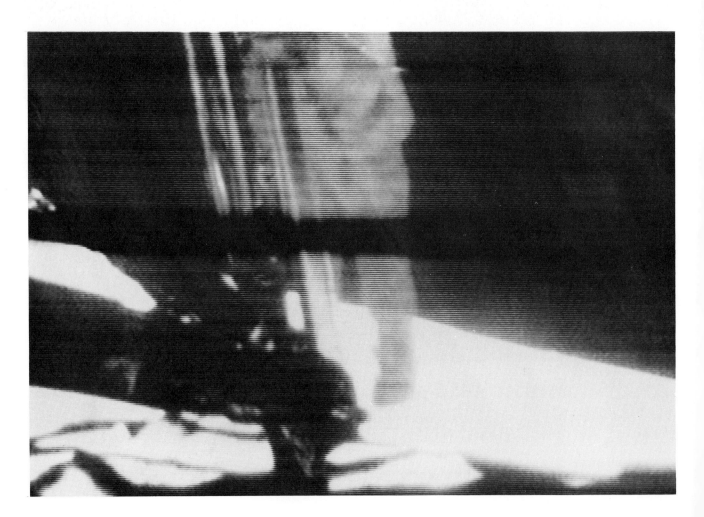

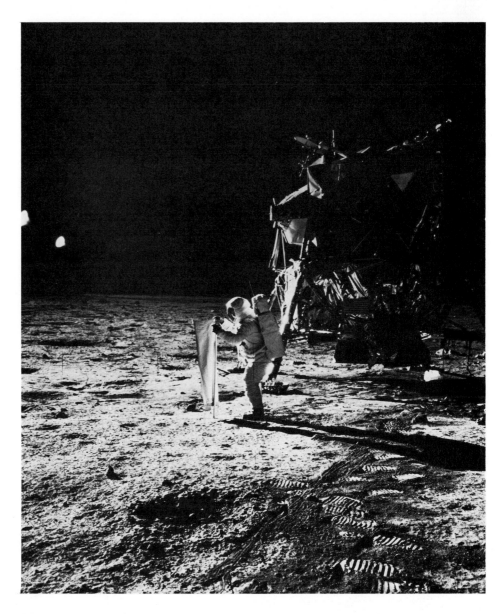

Moon—From Earth (opposite, top left). John Adams Whipple of Boston, Massachusetts, made this first detailed daguerreotype of the moon in March 1851.

Moon—Prior to impact (opposite, top right). NASA's *Ranger VIII* on February 20, 1965, sent this close-up from 970 miles above the surface of the moon back to Earth, seven minutes before crashing.

Moon—First man landing (opposite, bottom). *Apollo 11* landed July 20, 1969, four days after leaving Earth. Astronaut Neil A. Armstrong is seen here coming down the ladder to make his first step on the moon—"for mankind." This shadowy image is the only moon photograph showing Armstrong.

Moon—Man on (above). All those pictures in which the now familiar space-suited astronaut is performing various tasks are of Edwin Aldrin, Armstrong's companion. NASA had meticulously delegated every job and Armstrong had been appointed photographer. The TV cameras, however, showed both men gambolling democratically on the cheek of the smiling Man in the Moon. Armstrong might have been first on the moon, but the first photographs of a man on the moon are of Aldrin, and that, in its way, is democratic, too.

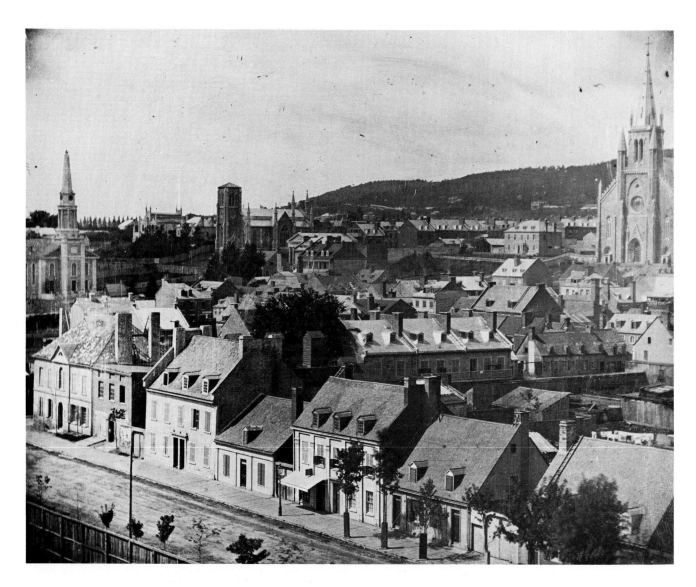

Montreal, Quebec. Colonial houses on Craig Street, Montreal (which later became the city's banking center), are seen in the foreground of this daguerreotype, circa 1852.

opposite:

Miami, Florida, hotel. Peacock Inn, seen here in 1883, with bananas hanging from the roof of the porch and with the guests, including one strumming a banjo, lazing about, was the first hotel on the southern Florida mainland. The Peacock soon spread its wings, so to speak, and the tourist industry grew and grew. The picture below was taken at Christmas time, 1886. The owners of the inn held a party for their guests and invited everyone living in the Greater Miami area. Here they are—men, women, and children—posing for the first photograph of a community gathering in Miami. The photographs were taken by Ralph Middleton Munroe, the area's first cameraman.

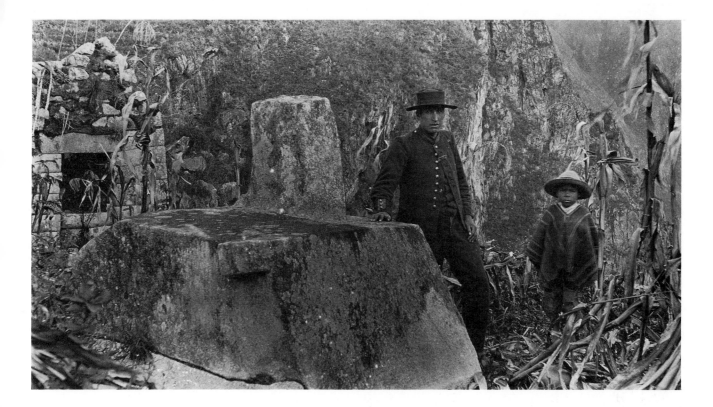

Machu Picchu, Peru. Until explorers could carry cameras and film easily, the world usually had to rely on their literary talents to learn about their discoveries. In 1911, Hiram Bingham, like all adventurers by then, relied on photographs to verify his tales. On July 24, he was the first Westerner to see the ancient Inca city, overgrown and partially buried, of Machu Picchu, in Peru. He took about twenty pictures on this first trip. Here are his two companions, a Peruvian soldier and a boy guide who led him to the spot, on the day of the discovery. When Bingham returned to America, these photographs, published in *National Geographic Magazine*, helped him raise enough money to return to Peru and excavate Machu Picchu.

opposite:

Mining. The mining of ores, other than the gathering of pure gold and silver nuggets on the surface of the earth, and the smelting of ores were the first true professions in the evolution of civilization. The working of copper and tin mines to make the alloy bronze began about 3,500 B.C. The methods, just as today, required men to follow veins of ore wherever they led underground. Timothy O'Sullivan in 1867 made the first photographs in an American mine, using a magnesium flare, introduced by Charles Waldack the year before when he used it to photograph inside the Mammoth Cave in Kentucky. The photograph on the opposite page shows a miner at the Comstock Mine, Virginia City, Nevada, 900 feet underground, pick in hand, a candle burning dimly behind him. The one to the left is the first photograph of a cave-in and gives the outsider a vivid image of the kind of industrial accident that one has often read about.

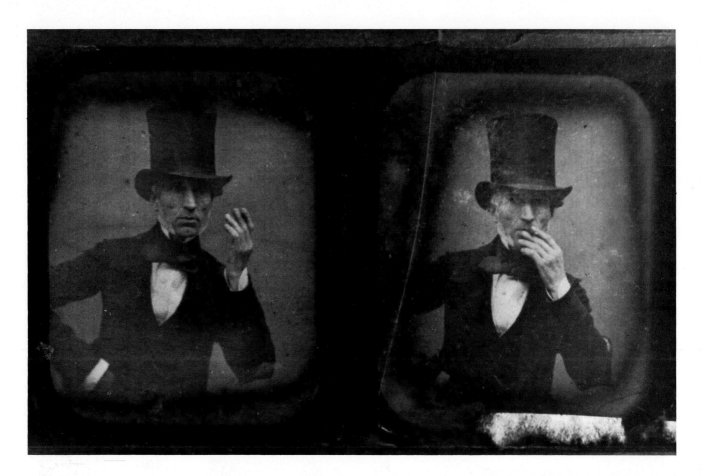

Movement. As soon as men could stop action with the camera, they wanted to make it move again. As early as 1853, the French photographer Antoine Claudet, working in England, patented a device for giving photographs the illusion of movement. His device had an eyepiece that one moved and if the two pictures on the card showed a person performing consecutive actions, the viewer, by moving the eyepiece, would have the impression he was witnessing actual motion. The man in the top hat—Claudet himself—appears to be puffing on a cigarette. Previously, an apparatus had been designed to give the appearance of motion to hand-painted lantern slides and drawings, but Claudet's viewer was built especially for photographs—"moving pictures." This is the first. Others followed with various systems leading up to today's movie cameras.

opposite:

Man running. The model for this picture wore a black coverall and hood with white stripes and dots down the side turned to the photographer, Etienne Marey. Marey exposed a single plate according to one of his own techniques, called chronophotography, as the man ran past. The picture, taken about 1884, proved that it was possible to analyze motion, and that the human torso and limbs, straining for speed, followed an amazingly precise, cyclical pattern. No one could guess that the lovely geometric shape is a running man.

Motion picture show. At an amazingly early date, 1870, an audience sat in the dark and watched a couple waltz—two people dancing who were not there in person. We know all about this thing called moving pictures, but back then, fifteen hundred people in one evening paid good money just to see if it really was possible. The *Scientific American* of June 5, 1915, in an article highlighting great events in the history of photography, described what happened:

To Henry Heyl of Philadelphia must be assigned the credit of having given the first motion-picture exhibition in the modern sense of the term. That was in 1870. His invention, the "Phasmatrope" was first exhibited in Philadelphia at the American Academy of Music, February 5, 1870 before an audience of more than 1500 persons. [Previously, if pictures were made to 'move', only one person could view them at a time.] The related photos were small glass plate positives of selected subjects reduced from wet plate negatives, taken from successive poses, by an ordinary camera. The "phasmatrope," was a revolving skeleton disk around the periphery of which the glass positives were removably placed to register accurately as they intermittently came into the lantern rays. During the intervals between the rests of the disk a vibrating shutter cut off the light. The rotation of the disk was in absolute control by the operator so that the movements of the figures (two waltzers) were kept in perfect synchronism with an orchestra of 40 musicians. Hence, we have not only motion pictures but the correlation of sound with motion. Mr. Heyl went even further. He threw upon the screen a figure of a gesticulating "Brother Jonathan" [Uncle Sam]. The pantomimic gestures and lip movements of the moving photographs coincided with the voice of a reader who supplied the audible words.

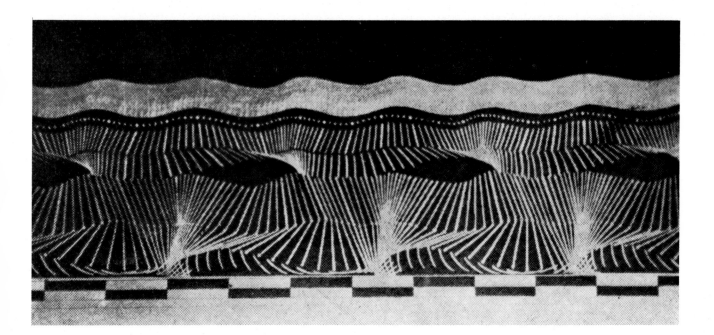

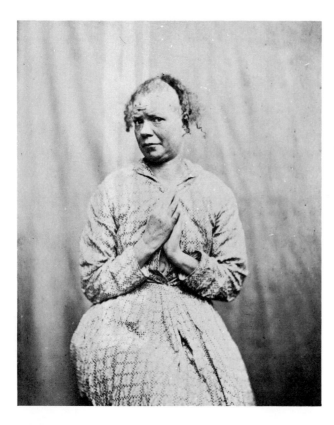

Mental patient. One of the earliest applications of photography to medicine was in the area of mental illness. This is probably due to the fact that one of the first people to learn photography in England was Dr. Hugh Welch Diamond, the resident superintendent of the women patients at the Surrey County Asylum. Between 1848 and 1858, he made calotype portraits of these charges of the state, but he stopped when he went into private practice.

In addition to noting the occasionally powerful therapeutic effect that looking at their own portraits had on the patients (especially when they could witness their own physical improvement), Dr. Diamond observed in 1856 that "the photographer catches in a moment the permanent cloud, or the passing storm of sunshine of the soul, and thus enables the metaphysician to witness and trace out the connexion between the visible and the invisible in one important branch of his researches into the philosophy of the human mind."

Medical subject. Hospitals have almost bottomless files of photographs and continue to add to them daily, as photography is one of the tools of modern medicine in diagnosis, teaching, and record keeping. This picture of a woman's goiter, taken by D.O. Hill and Robert Adamson in September 1844, is the first photograph of a medical problem. It is notable that disfigurations, when preserved for therapeutic reasons, do not betray the humanity of the afflicted. This is in contrast to other photographs of unnaturally or monstrously distorted bodies and faces, which often excite a voyeuristic fascination in the viewer.

opposite:

Miss America. The first Miss America contest was held in 1921, and the first Miss America was Margaret Gorman, of Washington, D.C. She was only 5'1" and her measurements, as the papers reported, were 30-25-32. She is wearing a bathing suit!

Mug shots. The police in Brussels, Belgium, were the first to take mug shots of their criminals, beginning in 1843. These four, the earliest extant daguerreotypes, have a note on the back warning the viewer that the picture is reversed. This meant that although the likeness was precise, if the thief parted his hair on one side, it would appear on the other side in the daguerreotype.

The first mention of mug shots, was in the *Philadelphia Public Ledger* for November 30, 1841. The article said that when any suspicious person or criminal is arrested in France he is immediately photographed and the daguerreotype is put in a cabinet for future reference. It went on to say "The rogues, to defeat this object, resort to contortions of the visage and horrible grimaces."

According to Harris B. Tuttle, Sr., in his article "History of Photography in Law Enforcement" (*Finger Print and Indentification Magazine*, Vol. 43, No. 4, Oct. 1961), the first U.S. city to start photographing criminals was San Francisco (1854). The oldest extant mug shot in the United States is dated April 1867 and belonged to the Cleveland Police Department. These were made in professional photographers' studios. It was not until 1874 that the first special police photographic studio was set up in Paris.

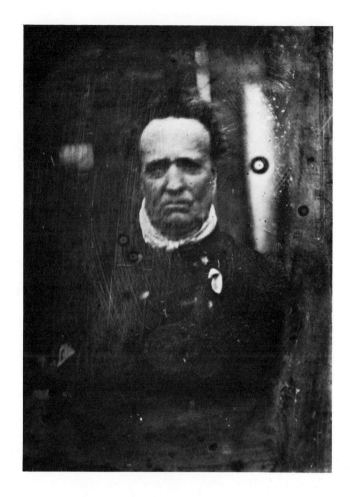

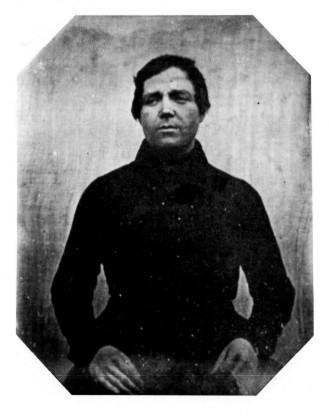

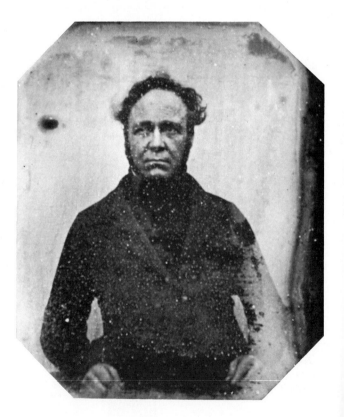

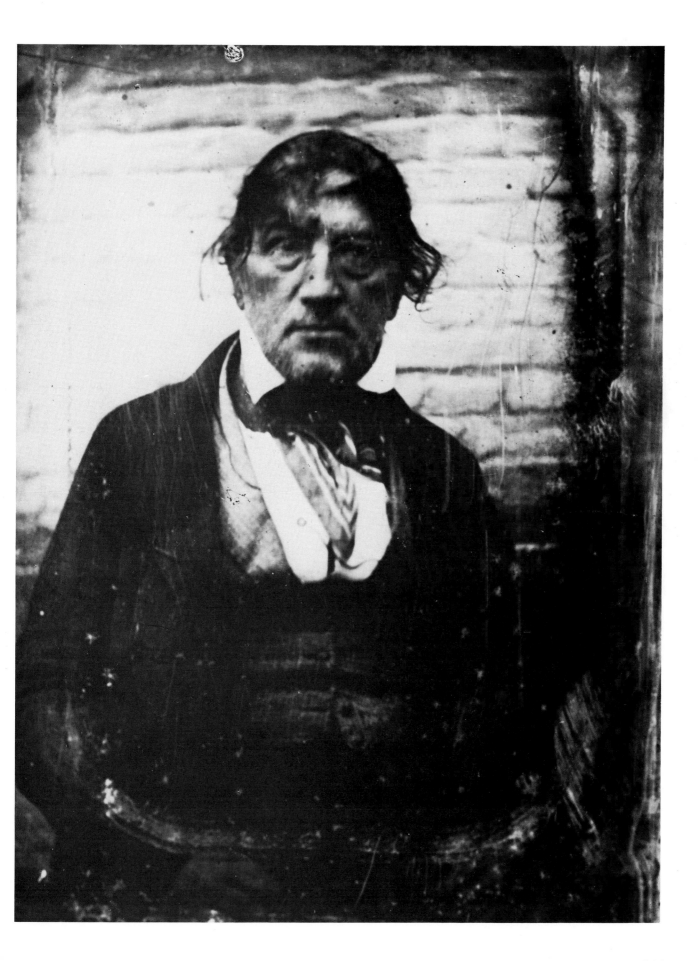

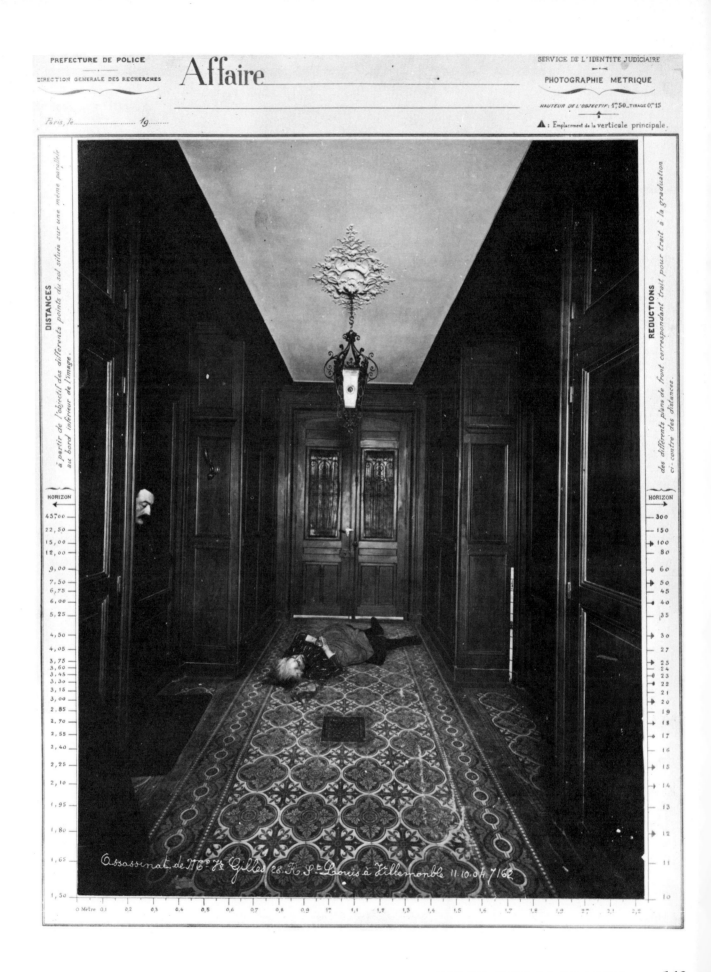

Assassinat de M.e Jte Gilles 28 R. St Louis à Villemomble 11.10.04 7/62

Murder victim. Alphonse Bertillon (1853-1914) was chief of criminal identification for the Paris police beginning in 1880, and his name was given to the entire system of identification that he introduced two years later. *Bertillonage*, or anthropometry, relied on precise bodily measurements, physical description, and photographs. It was he who advocated a front and side view portrait of every suspect, made under standardized conditions of lighting and scale. Called "the Father of Scientific Detection," Bertillon wrote *La Photographie judiciare* in 1890. These three photographs are examples of the type of records he required for a homocide. Although taken in 1904 and not his first, they are, however, excellent examples of this early and precise tool of criminal investigation.

Dr. Erich Stenger, in *The History of Photography; Its Relation to Civilization and Practice* (Leipzig, 1938; translated into English by Edward Epstean, 1939), states that the earliest suggestion to photograph the scene of a crime was in 1859, and in that year photographs were used in a court in California. He also mentions that by 1867 a photograph of a scene of a crime could invalidate the testimony of a witness. Berlin Privy Judicial Councillor Karl Theodor Odebrecht in 1864 advocated in his book (its translated title is *On the Use of Photography in the Penal Process*) the following: photography of corpses discovered, scenes of crimes, documents, articles found, disputed objects, identification portraits for passports and I.D. cards.

One of the strangest beliefs relating to photography and criminology began in the late 1850s and lasted for a few decades. It was quite simply the contention that the retina of the deceased retains the image of the last person it has seen. A lawyer arguing a case in 1871 maintained:

Every object seen with the natural eye is only seen because photographed on the retina. In life the impression is transitory; it is only when death is at hand that it remains permanently fixed on the retina . . . Take the case of a murder committed on the highway: on the eye of the victim is fixed the perfect likeness of a human face . . . We submit that the eye of the dead man would furnish the best evidence that the accused was there when the deed was committed, for it would bear a fact, needing no effort of memory to preserve it . . . the handwriting of nature, preserved by nature's camera. (Quoted by Andre A. Moenssens in "The Origin of Legal Photography," Finger Print and Identification Magazine, Jan. 1962.)

Lattieed Window (with the Camera Obscura) August 1835

When first made, the squares of glass about 200 in number could be counted, with help of a lens.

Negative. Modern photography developed from two discoveries made by the Englishman William Henry Fox Talbot (1800-77). The first is that a material (generally paper, glass, or film) coated with light-sensitive chemicals, placed in a camera and exposed to light produces a negative image that, if fixed, can be used to make numerous positive copies.

The lilac-tinted "Lattice Window" negative was made in August 1835, with a small wooden camera producing a negative roughly one inch square. The ordinary writing paper that Talbot placed in this camera was treated with silver chloride; the exposure time was perhaps two hours. When Talbot removed the negative from the camera he stabilized it (made it no longer sensitive to the action of light) with a solution of common salt.

Unlike some experimenters, both before him and after, who could not find a way of preventing the paper from going completely black or who saw a "negative" image as no more significant than a smudged piece of paper, Talbot discovered how to fix the image so that it could be "printed" to yield a new picture—the positive. This negative was made by Talbot two years before the Frenchman Louis Jacques Mandé Daguerre made his first daguerreotype.

Talbot's second great breakthrough did not take place until September 1840. He discovered that even a short exposure can have an effect on a photographic emulsion, even though there might not be anything visible. This "latent image" could be brought out or "developed" at a later date with chemicals.

THE FAR EAST.

AN ILLUSTRATED FORTNIGHTLY NEWSPAPER,

[VOL. I, No. I.] YOKOHAMA, MONDAY, MAY, 30TH, 1870. [SINGLE COPY $1.00]

ASIA, with its numerous races and shades of character, although tritely and truly honoured with the title of the "cradle of civilization," present at this day so many varieties of this great principle, and generally so different from everything that now obtains in Europe, that it continues to command the engrossing interest of more advanced peoples. It contains almost every state of civil polity within the two extremes. It does not possess the wild savage as found in Australia and portions of the American Continent, nor has it the amount of learning and scientific attainment, which places Europe and the United States on so high a pinnacle; but between these extremes, all degrees of progress may be observed; each with its own title to attention.

The characteristics of Asiatics, too, are as various as their civilization. The Bengalee meek, submissive and even cringing. The Malay hot-blooded and revengeful. The Chinaman quiet, plodding and mercenary. The Japanese quick, high-spirited and chivalrous. All have their own degree of bravery. But the Indian requires a leader, the Japanese would lead. The Chinaman imagines there is no learning, no science in the world that can improve his condition, or equal that of his country; the Japanese sees promptly how far he has been in the background, and is nervously eager to be taught. But the China-man who consents to learn goes in for mastering his subject, whilst the Japanese, directly he has "an inkling of knowledge," is impatient of restraint and fancies he has all. Thus although there is much in the Japanese character that is captivating, there is also much that may, and often does, lead him into difficulties. Yet among all the races of the Far East, there is none approaching so nearly to the most civilized; nor any who will so rapidly acquire an equality with them, as the Japanese.

But there are points about them which still more impress the foreigner in Japan. The fact, that what we found them in 1859 the Portuguese Missionaries described them to be in 1550 and in all probability they had been for centuries preceding, evidences the anti-progressive nature of feudalism when left to itself; and those who carry back their reminiscences of them, even in Yokohama, only some five or six years, saw them as to dress and habits as they may have been before the days of

KANAGAWA.—THE TEA HOUSE.

In a newspaper. The first time a photograph appeared in a newspaper was in 1870, and it was pasted in by hand. *The Far East,* published in Yokohama, delighted the English-speaking residents each fortnight with another selection of camera-made illustrations describing the life and customs, architecture, and landscape of Japan, even if the albumen prints were not always of the subjects being discussed in the articles. The newspaper was published until 1875 and then again during 1876 and 1877.

New York City. It is strange that although there are photographs taken of London, Paris, Rome, Athens, and even Philadelphia in 1839, there is not one extant of New York City made before 1851, although many were done. Daguerrean portraits were made in New York studios after 1840, but this photograph (one of three views of this building taken on the same day) is the earliest of some aspect of the city itself. It is the warehouse of Reed & Sturges on the east side of Front Street, between Wall and Pine Streets, just west of the East River.

The man who made the photograph was an immigrant from France, Victor Prevost, who had arrived in America in 1848. In Paris he had studied painting with Paul Delaroche and photography with Gustave Le Gray, from whom he learned the waxed-paper process. The New York directories listed Prevost as an artist in 1850-51-52-53, a photographer in 1853-54, and a chemist in 1855-56-57. After that he became a teacher of drawing, painting, and physics and a school principal.

In 1853, Prevost formed a partnership with another Frenchman, P.C. Duchochois, to make photographs on paper. It lasted only two years, as there was little market for the pictures they produced. As Duchochois stated: "Our studio was in Broadway, between Houston and Bleecker streets, pretty far up town then, but we did not succeed to make it pay; the time for photographers (those making negatives and positive prints) was not yet come, the beauty of Daguerreotype was reigning supreme."

Newspaper (halftone). On the last page of New York's *Daily Graphic* for December 2, 1873, there appeared something that had never been seen before, a halftone reproduction, startling thousands of readers. An announcement on another page read, "On the last page will be found a picture of Steinway Hall. . . . It is worthy of inspection, too, as being the first picture ever printed in a newspaper directly from a photograph. There has been here no intervention of artist or engraver, but the picture is transferred directly from a negative by means of our own patented process of 'granulated photography'." Practically every source states mistakenly that the first halftone in a newspaper was a picture of "Shantytown," New York, published in the *Daily Graphic*, March 4, 1880. In any case, it was not until the turn of the century that newspapers started using photographs regularly.

Niagara Falls. These daguerreotypes of the Falls by W. & F. Langenheim made in July 1845 are the earliest extant and already have the carnival style that has made Niagara Falls an extension, as it were, of private enterprise. The very first views were made either in 1839 or 1840 by an Englishman, H.L. Pattinson, and were copied for *Excursions Daguerriennes*. As early as 1853, Mr. Babbitt had a monopoly on making daguerreotypes on the United States side. He set up a pavilion to photograph lovers with the thundering Horseshoe Falls as a backdrop. Fifty years later, many visitors began to take their own pictures with Kodaks, and today flashbulbs still pop nightly needlessly to capture the already illuminated distant cascade.

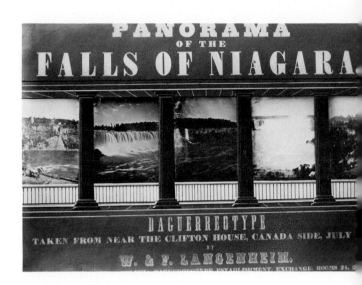

Nebula in Orion. The objects observed in the night sky at the end of the eighteenth century included stars, comets, planets, and fuzzy patches of light that were called nebulae: Several thousand nebulae had been counted and all were considered to be in the Milky Way, which at that time was thought to be the whole universe. Various types of nebula were distinguished; one of the brightest is in the constellation of Orion. This is the first photograph of that nebula and the earliest extant of any nebula. It was taken by Professor Henry Draper, M.D., on September 30, 1880. Exposure time was 51 minutes, during which time the earth rolled almost $\frac{1}{24}$ of its way around its axis, so that the telescope and camera had to be turned smoothly against this spin in order to keep the nebula stationary on the plate. The large bright objects are stars, overexposed. Not until the 1920s was it clear that many nebulae are not just cloudy patches of illumination associated with clusters of stars or with an exploding star, but are whole galaxies containing billions of stars at enormous distances outside the Milky Way, the galaxy to which we belong. Many of the advances made in modern astronomy could not have been possible without photography.

Old Faithful. The old geyser continues to gush on schedule, and tourists can organize their visits as precisely as they do for the changing of the guard at Buckingham Palace. William Henry Jackson was the first photographer to see Old Faithful and take its picture (1872) and many others of what is now called Yellowstone National Park. Partially on the basis of his work, Congress declared the region a national park and named Jackson Hole after him. He was called the Grand Old Man of the national parks and he lived to the age of ninety-eight. At ninety-two he was still working—the oldest government employee on record—painting murals in government buildings.

hooked. Nineteenth-century studies revealed that life thins out as one goes deeper into the sea, due to increasing pressure, cold, and fading light; it was believed no life could exist much more than a mile down. Then, in 1932, William Beebe descended in his Bathysphere to 3,000 feet—and there was life, though unfamiliar in many ways.

Jacques Cousteau, the inventor (with colleagues) of the aqualung and the world's pioneer oceanographer, and Dr. Harold Edgerton, an electrical engineer who developed the stroboscopic flash and known for his ultra-high-speed photography, collaborated in designing a camera that could take pressures of 5½ tons per square inch. They also worked out a technique in 1956 for lowering the camera to 24,600 feet—four and a half miles. There was life in that silent and seemingly motionless stygian darkness and for the first time, the tiny, stalked creatures and their footprints were the subject of the camera's gaze. This photograph, taken in the Roman Trench in the Atlantic Ocean, off the Ivory Coast of Africa, is one of the first taken at such an incredible depth and of life so far down. The electronic flash revealed about a nine-square-foot area; the dark blotches were caused by mud clots on the camera window.

In 1960, Jacques Piccard, the noted Swiss marine scientist, and Don Walsh, an American navy lieutenant, sank to 35,810 feet in Piccard's bathyscaphe and still there was life in the form of a flatfish, a medusa and a shrimp. Unfortunately, there was no room for the camera Dr. Edgerton had sent them.

Ocean bottom. Life began in the sea 3½ billion years ago, and the sea, transformed chemically by the plants and living organisms that evolved, still contains more life than the land. From time immemorial, fishermen have brought up weird animals, and the early mapmakers included pictures of the kinds of monsters that sailors claimed they'd

opposite:

Oil well in the United States. Oil Creek, near Titusville, Pennsylvania, had been seeping oil for centuries. In 1859, Col. E.L. Drake (the rank was not official) supervised the drilling of a well there, adapting known techniques, and 70 feet down they tapped the source. A pump began to draw twenty to thirty barrels of oil daily, except Sunday. In 1861, John Mather took this photograph of Colonel Drake in top hat before his oil well, the first in America. Four years later Mather took this picture of a forest of derricks in the same field.

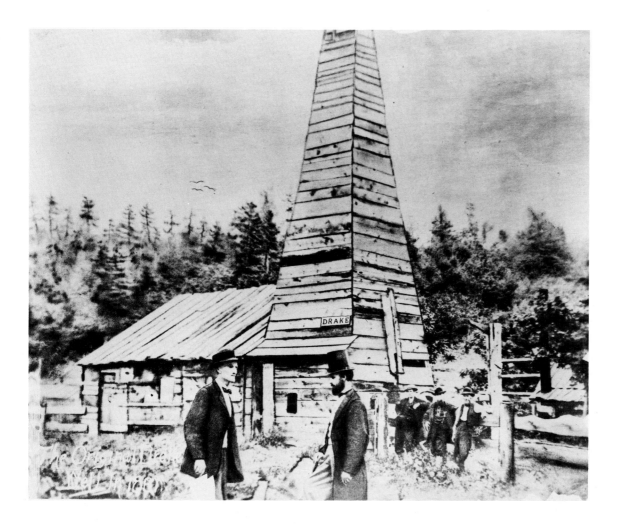

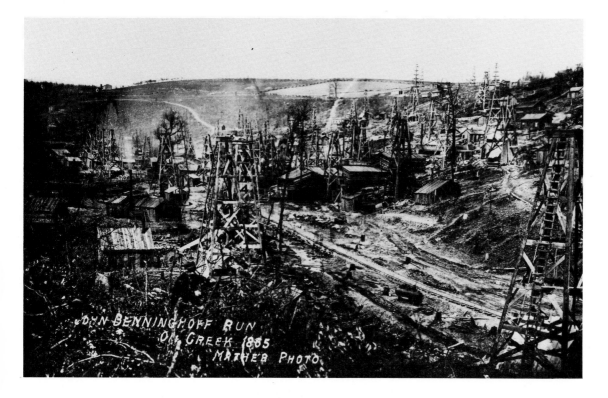

Oregon (State of, nearly). The photograph shows the band, the fire department, and the people of Portland celebrating news of the admission of Oregon to the Union. The date is June 22, 1858. The news turned out to be a false rumor, and Oregon became a state on February 14, 1859.

Oregon Trail. In the late 1850s, a daguerreotype was made of the Rock Creek Station in Jefferson County, Nebraska, on the Oregon Trail. The station serviced the Overland Stage Company. Although the picture is faint, there are details of American history—the stage coach, a cowboy on his horse, a corral and barns, log cabins. Here Wild Bill Hickok, "the fastest gun in the West," fought the McCanles gang single-handedly, killing three of the outlaws.

The Oregon Trail ran from the Missouri River, the most popular starting points being Independence and Kansas City, Missouri, to the Columbia River. It was not one road; the wagons wandered widely and fell into each other's tracks only at fords and mountain passes. John Bidwell guided the first train in 1841; most trains took about six months to make the 2,000-mile journey.

Nursing mother. Taken about the late 1840s, this daguerreotype is one of the earliest of a nursing mother. Even if the woman were a South Sea Islander, normally bare-breasted, it would still be a rare image for this date. She is, however, a lace-collared American.

Perhaps the woman was the photographer's wife, and this is the image he most wanted. Perhaps the woman's lover abandoned her and his child and she planned to send him a reminder, accusingly. Or perhaps the photographer was thinking of one of the most prominent subjects in the arts—breast feeding. The Virgin Mary and the queens of Europe have long been depicted revealing their milk-swollen breasts. It is believed that this hand-tinted, sixth-plate (2¾ by 3¼ inches) daguerreotype comes from the Midwest.

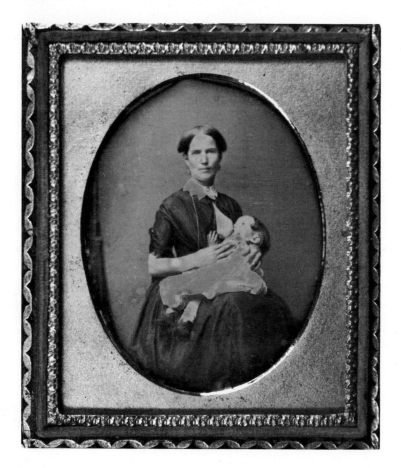

opposite:

Nude. Photographs of nudes have many fans. The Frenchman Lerebours opened a studio in Paris in 1841 and advertised that he took "Acadèmies"— or nudes—and sold them to artists and tourists. The first photograph of a nude was probably made as soon as the model could hold steady for the length of the exposure, in other words, a few months after Daguerre had released details of his process, but it is impossible to determine the earliest one. Daguerreotypes of nudes are rarely dated. But because a photography book needs at least one naked body, and in order to emphasize the French contribution to the world of art, this daguerreotype by an unknown Frenchman was selected. Whether or not it is the first, this picture is beautiful and worthy of representing the entire genre.

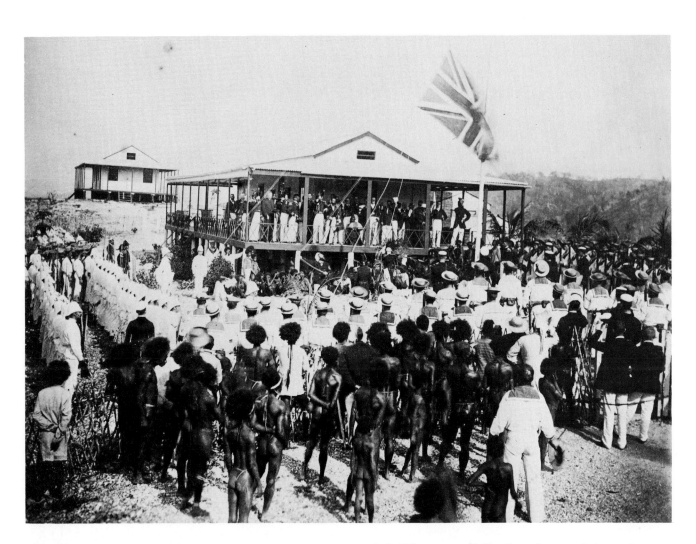

New Guinea. In 1884, Southeast New Guinea was declared a protectorate of the British government, with the Australian colonies paying the cost of administration. The picture "Hoysting Flag at Port Moresby, N.W." is a simple, coherent statement about colonialism. The British were able to make it seem so orderly and natural. It is from an album titled "Narrative of the Expedition of Australian Squadron to the South-Sea coast of New Guinea Oct. to Dec., 1884," the illustrations of which are the first set of photographs made on this wildly mysterious island, the subject of so much anthropological research.

New Guinea, the Highlands. The surprisingly late date of this picture taken in the interior of New Guinea is 1931, although knowledge of the coastal areas of this second largest island in the world (Greenland is the largest) is centuries old. These are Middle Wahgi River warriors; the picture is one of a group taken by M.J. Leahy. The first foreigners to penetrate the highlands had come only the year before to search for commercially profitable resources—plants, woods, metals, skins, and so on. A year later, the first anthropologists arrived with their modern cameras as standard equipment.

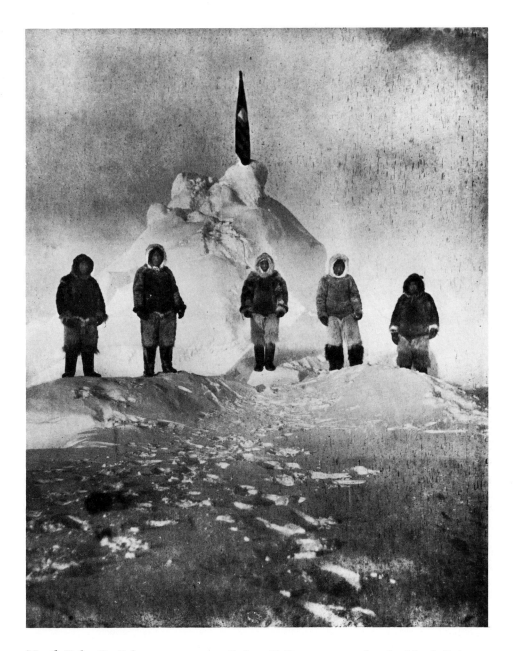

North Pole. On February 22, 1909, Robert E. Peary set out for the North Pole. With him were 23 men (17 of whom were Eskimos), 19 sleds, and 133 dogs. As they came closer and as the supplies were used up, men were sent back to base camp until only Peary, Matt Henson (a black who was Peary's constant companion), and four Eskimos proceeded to and reached the North Pole— according to their navigational calculations—on April 6, 1909. The expedition was sponsored by the National Geographic Society, the U.S. Navy, and the U.S. Government. To this day, Peary's claim is disputed by some historians, who feel that the honor should have gone to Dr. Frederick Cook, who claimed to have reached the North Pole in 1908, or to Richard Byrd, who with more sophisticated navigational instruments *definitely* flew over it in 1926.

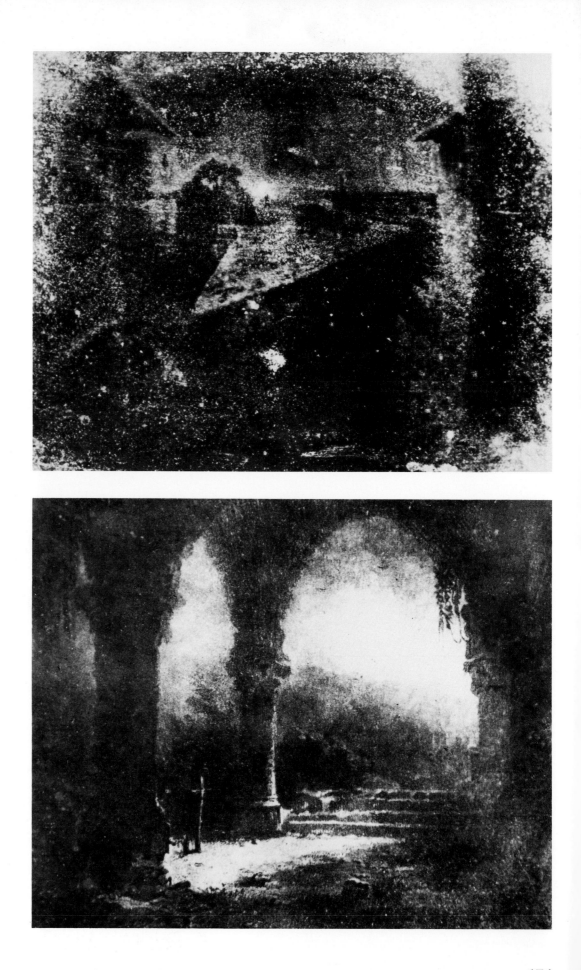

Portrait. Compare this with any photographic portrait today. Except for the scratch and tarnish marks, does it not compare favorably with the best? Yet it is the earliest surviving camera portrait of a human being, made by Robert Cornelius, probably in November 1839, in the yard of his Philadelphia home. The sitter is Cornelius himself, and he stares at the camera lens staring at him. The actual daguerreotype is only 2¾ by 3½ inches.

Potato, over 7 pounds. A giant spud, 7½ pounds heavy, was dug out of the California soil in the 1850s and carried reverently to a daguerreotypist's studio for its portrait. During the early years of the camera, everyone had a private idea of its usefulness. But the first priority for most was to have portraits made of their loved ones. Later, many wanted keepsakes of celebrities. Others loved landscapes and often felt that industrialization was threatening the beauty of nature and of the architecture of their cities and they wanted pictures of these before they changed. But for a farmer, the portrait of such a potato was worth the price.

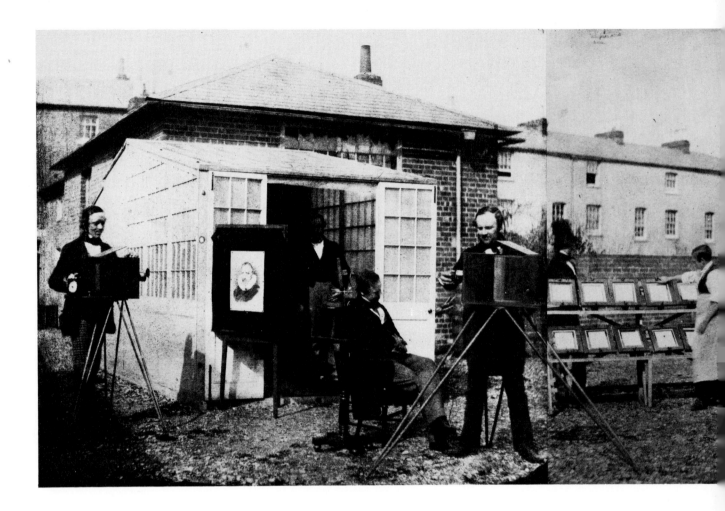

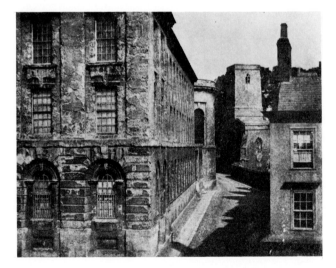

Photographic book. Photographs are supremely well suited to being reproduced in books. If the book is expertly printed, the enjoyment of looking at the pictures can closely approximate the joy of seeing the originals. The honor of making the first photographic book, *The Pencil of Nature*, goes to William Henry Fox Talbot, inventor of negative/positive photography. And in this case there was no difference between the original and the reproduction, as they were one and the same—each illustration was an actual photograph pasted into the book by hand.

Talbot's book was published in parts between 1844 and 1846, and brilliantly explains the possible uses for his invention. "Part of Queen's College, Oxford," shown here, is the first photograph in it. *The Pencil of Nature* is a genuine collection of fascinating photographs and text—a true photographic book, with the pictures important for themselves.

opposite:

Photograph. The Frenchman Nicéphore Niépce (1765-1833) made the world's first photograph. In the 1820s, he coated a polished pewter plate with the asphalt bitumen of Judea, put it in a camera obscura, exposed it, and then washed it with a mixture of oil of lavender and white petroleum until an image appeared and remained fixed. The illustration opposite (top) is referred to in almost every publication on the history of photography as "The first photograph." It is a view from a window of Niépce's house in Châlon-sur-Saône, France, believed to have been taken in 1826 with a camera obscura pointing at the scene for eight hours. On the back of the photograph, in the handwriting of Francis Bauer, Fellow of the Royal Society, is the following:

L'Heliographie.

Les premiéres résultats
obtenus *Spontenément*
par l'action de la lumière.
Par Monsieur Niépce
De Chalon sur Saône.
1827

Monsieur Niépce's first successful
experiment of fixing permanently
the Image from *Nature.*

[Signed] Francis Bauer

Although this picture is claimed by Helmut Gernsheim, the photographic historian, as the only extant camera view by Niépce, there is a picture in the Royal Photographic Society Collection that is a contender for the title "The World's First Photograph."

The illustration opposite (bottom) was also made possibly in 1826 but certainly before August 1827, when Niépce prepared to leave for England. On the back of it is written:

L'Héliographie.
Les premieres résultats
obtenus *Spontenément*
par l'action de la lumière.
Par Monsier N=Niépse [sic]
De Châlon-sur Saône.
1827

from a print about 2½ feet long
F. Bauer, Kew Gardens

If the note that the print was 2½ feet long had not been included, it would be assumed that Niépce had laid a small drawing (waxed or oiled to make it transparent) directly on the coated pewter plate. But since the original is large, and the Niépce plate is only about 4 by 5 inches, it seems likely that he copied the drawing with his camera. "Elodie," the title of the picture, coincidentally, is a drawing by Daguerre for a stage set of a play by the same name.

Niépce's original goal was to produce lithographic plates, but he also had become interested in using the camera obscura. His few pewter plates that still exist show a faint and difficult to decipher positive image, the actual plate representing the dark parts of the picture, the bitumen showing the light areas. When he etched the plates, as he often did, his discovery was a means of photoengraving. Although Niépce made the first photographs, he died before he could give the world a practical method of using the camera.

Person. The apparently empty Paris boulevards are the setting for this first photograph to show a human being. While city life was going on—but far too quickly for Daguerre's camera to depict—a man stood still with one leg raised, having his shoe shined. The exposure for this haunting picture, taken in 1839, the year that photography was publicly announced, was minutes long. But what other artist could draw so delicately, so faithfully, a detailed scene such as this, in minutes? None, obviously, and the king of Bavaria, when he received this plate as a gift from Daguerre, must have thought it miraculous. Everyone who saw Daguerre's achievement marvelled at it.

Philanthropic. Dr. Thomas John Barnardo, born in Dublin, established several "homes" in England for waifs and orphans without regard to their race, creed, sex, or health. These were the first founded on such a universal principle. In order to maintain them, Barnardo invented new tactics for raising money. One was to make photographs that aroused the pity and compassion of prospective donors.

Starting about 1870, Barnardo commissioned a photographer to take a picture of each child at the time he or she entered the home and another after the child had been there awhile or was about to leave. In 1874, he allocated more than a fifth of his annual budget to build and run a photographic studio. His photographer continued to make pictures for record-keeping purposes and also for distribution with an appeal. Other charitable organizations, such as the National Children's Home, also in England, occasionally used photographs in the 1870s, but Dr. Barnardo's reliance on them was most extensive. He was attacked by a Baptist minister, the Rev. George Reynolds, in 1876:

The system of taking, and making capital of, the children's photographs is not only dishonest, but has a tendency to destroy the better feelings of the children. Barnardo's method is to take the children as they are supposed to enter the Home, and then after they have been in the Home some time. He is not satisfied with taking them as they really are, but he tears their clothes, so as to make them appear worse than they really are. They are also taken in purely fictitious positions. A lad named Fletcher is taken with a shoeblack's box upon his back, although he never was a shoeblack. . . . [Quoted by Valerie Lloyd in the exhibition catalogue The Camera and Dr. Barnardo, *1974.]*

Dr. Barnardo went to Arbitration Court to protect his reputation. He explained that he often found

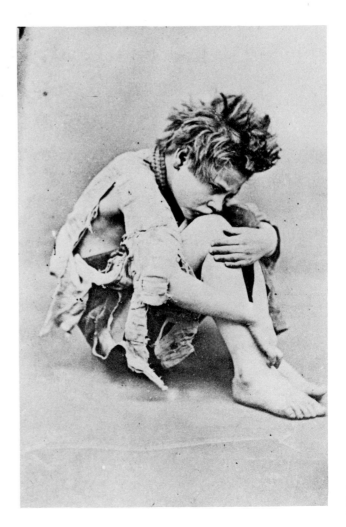

children sleeping in the streets at night when there was not enough light to use a camera. The wet-plate process did not allow quick shooting even under good conditions, and it was nearly impossible to be unnoticed while photographing. He said that the children were infested with vermin and he had to scrub them and dress them in new clothes, which immediately altered their appearance. Dr. Barnardo convinced the court that the pictures his photographers made for fund-raising purposes were not meant to be portraits of individuals but representations of a class of children for whom his homes had been designed.

Dr. Barnardo continued to use photography until his death in 1905, and his homes still maintain a photographic studio. This picture was titled "Lost" when it was used in a pamphlet in 1871.

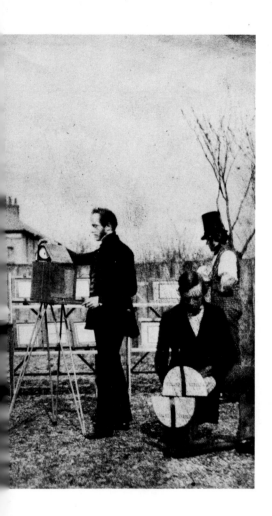

Photographic establishment. This two-part panorama shows the Reading Establishment, the first photographic printing works. It was set up by Fox Talbot during the winter of 1843-44, principally in order to print the photographs for his book *The Pencil of Nature* and those to follow. Other activities were carried out there as well, and some of these can be seen in the picture: copying paintings and sculptures and making portraits. The printing of the negatives had to take place outdoors on the days when it was not raining or too overcast. There was no enlarging (except by rephotographing the picture with a larger camera) and the negatives were contact-printed in frames as seen in the picture. Talbot himself is taking the lens cap off the camera in the center of the panorama; Henneman, his chief assistant, is holding a timer on the right while he photographs *The Three Graces*. Calotypes were also produced to be sold individually in stationers' shops and people came to the Reading Establishment to learn photography. The Reading residents knew that behind this converted schoolhouse (seen in the picture) mysterious operations went on with chemicals and paper, and since no one had ever heard of a photographic printing establishment, the consensus was that Talbot and his gang were counterfeiting money.

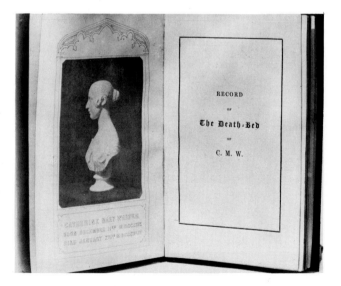

Photograph in a book. One of the advantages of Talbot's calotype over the photographic process of Daguerre was that it produced a negative that was printed on paper as a positive. The suitability for book illustration was immediately apparent. The illustration is a photographic frontispiece of a privately printed book written early in 1844.

The father of "C.M.W.," John Walter II, met Talbot and learned firsthand about some of the uses and possibilities of paper photography. When Catherine Walter died, Walter, chief proprietor of *The Times* (of London) had a memorial written about her and asked Talbot to have a marble bust of her photographed. The Reading Establishment had just been set up (see Photographic establishment) and Nicholaas Henneman and an assistant went to Walter's home to take this picture. Back at Reading they made the prints.

As this slim volume was completed about January 1844, it predates the first photographic book *The Pencil of Nature*, which was published in April. Typically Victorian in style, *Record of The Death-Bed of C.M.W.* was made "in order that the memory of one so dearly loved by us might be the more effectively cherished; and that the edifying example she had left us of Christian patience, humility, and resignation, might never be forgotten."

Phototypesetting. Johannes Gutenberg's invention of the printing press and movable lead type around 1450 inaugurated the method by which all books were printed for more than 400 years. In the latter part of the nineteenth and the early years of the twentieth century, other methods were developed and employed, such as offset and lithography, but perhaps the most revolutionary innovation has been the introduction in recent years of photocomposition machines. William Henry Fox Talbot envisioned the usefulness of photography in printing and included a description of his method in an 1842 patent. As typewriters did not exist in his day, he cut out individual letters, pasted them together to form the words of his poem, photographed them, and printed the whole from his negative.

Photocopy. When Fox Talbot published in *The Pencil of Nature* (1844-46) the first photocopy, called "Facsimile of an Old Printed Page," seen here, he wrote: "To the Antiquarian this application of the photographic art seems destined to be of great advantage." The page was from a book in Talbot's library containing the statutes of Richard the Second, written in Norman French. Talbot had no idea so many non-historians would eventually be grateful for modern photocopying machines.

One of the marks of an advanced technological society seems to be the number of photocopiers. Tourists discover this when they leave the industrialized West.

The photocopying business is booming for the same reason that insurance companies always make profits: people get nervous. With loss of faith in institutions, people make copies like crazy. One feels very insecure mailing, say, a manuscript, without knowing that an exact copy is tucked in the desk at home. College students are afraid their professors will lose papers, so they, too, make photocopies. Verbal communication is no longer sufficient in the office, so memoranda made on photocopiers fly into "In" trays and then into wastebaskets like leaves falling from the trees in autumn.

Polaroid. Edwin Herbert Land, born in Connecticut in 1909, and the inventor of the plastic polarizer called the Polaroid J sheet, decided that twentieth-century photographers should have the same advantage nineteenth-century ones had enjoyed —that of seeing their pictures immediately after they were taken. After World War II Land began work, in part on the instigation of his young daughter, who complained about having to wait before she could see Daddy's pictures. By 1946, he reproduced the above, the first published Polaroid

picture in the first paper on one-step photography. Three years later, he commented on the significance of the new medium at a meeting of the Royal Photographic Society in London:

The aesthetic purpose is to make available a new medium of expression to the numerous individuals who have an artistic interest in the world around them, but who are not given to drawing, sculpture, or painting. For most people photography cannot compete with these arts, partly because of the intricacies of photographic manipulations and partly because of an important fundamental difference in the approach to the creative problem. In the earlier arts the artist initiates his activity by observing his subject matter and then responds, as he proceeds, to a two-fold stimulus: the original subject matter and his own growing but uncompleted work. With photography, except for those who combine long training, high technical ability, and splendid imagination, this important kind of double stimulus—original subject and partly finished work— cannot exist. Consequently, for most people it has been of limited and sporadic interest and has not been a source of deep artistic satisfaction, and there has arisen the gulf between the majority who make snapshots as a record and as a gamble, and the minority who can reveal beauty in this medium. [The Photographic Journal, Jan. 1950, quoted in the Beaumont Newhall's The History of Photography.]

Photography exhibition. Photography galleries are proliferating today and museums collect and exhibit photographs regularly. But putting photographs up on the walls and letting in the crowds is nothing new. The Photographic Society of London (now the Royal Photographic Society) has held annual exhibitions since the year 1854, when 1,500 pictures were on view. This illustration is the installation shot of the society's 1858 show. Every print is framed and matted, but unlike exhibitions today, here they are crammed together, from floor up and stereo viewers are available. Prizes were awarded for the best in many different categories. Prints were usually for sale, often at quite respectable prices.

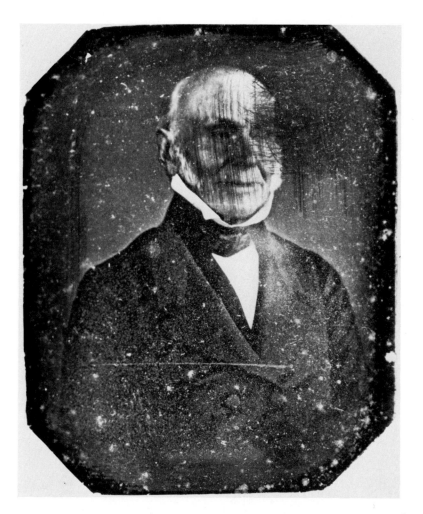

President (former) of the United States. The first American president for whom there is an extant photograph is John Quincy Adams. But the daguerreotype by Bishop and Gray could not have been made of the sixth president during his term of office (1825-29). It was in 1843, five years before his death, that this was taken. At some time, someone carelessly touched the fragile surface of the plate and nearly obliterated J.Q.A., the only son of a president to become president himself. Coming through the scratches, however, is the man who, as secretary of state under President Monroe, established the Monroe Doctrine, the continuing basis of U.S. relations with the nations of its own hemisphere.

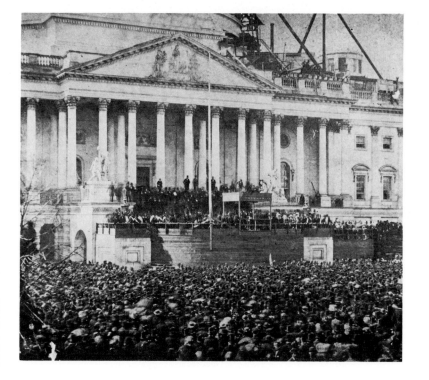

Presidential inauguration. Abraham Lincoln, born in a log cabin in the backwoods of Kentucky, being inaugurated as the sixteenth president of the United States of America, March 4, 1861.

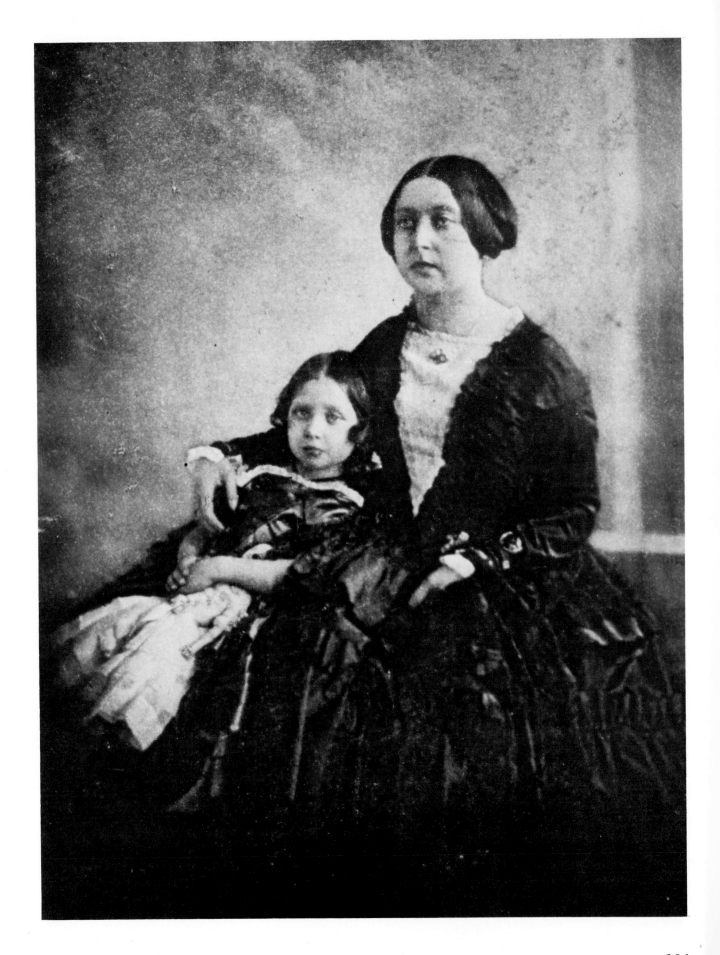

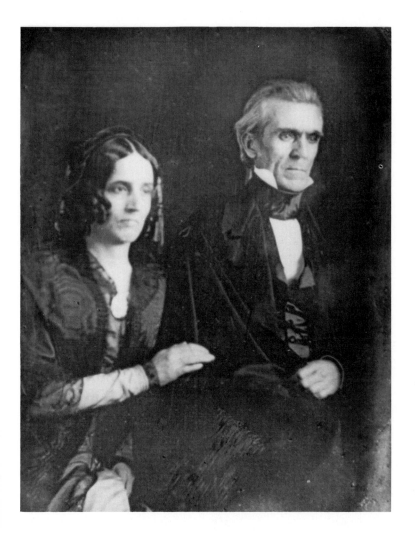

President and First Lady (U.S.A.). This is the first photograph of an American president in office; his wife is with him. John Plumbe, Jr., took this picture of the eleventh president, James Knox Polk, and Sarah Childress Polk, probably early in the year 1846. The political power of photography became apparent less than two decades later. Abraham Lincoln spoke of his own portraits made by Mathew Brady as one of the factors helping his election to the presidency.

opposite:

Queen Victoria. Queen Victoria's first camera portrait was taken with her eldest child, Victoria, the Princess Royal, by her side. Henry Collen, the calotypist, made the picture about 1844. Both Her Majesty and Prince Albert were great fans of photography and gave it royal support.

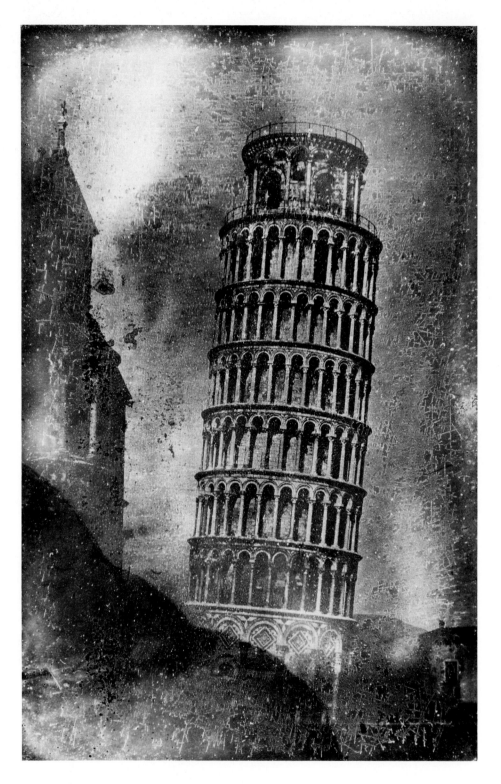

Pisa's leaning tower. A daguerreotype of Pisa was copied for inclusion in *Excursiones Daguerriennes,* but this view of the famed leaning tower is the earliest extant. The daguerreotype was made between 3:45 and 3:52 P.M. on June 25, 1841, by Dr. Alexander John Ellis.

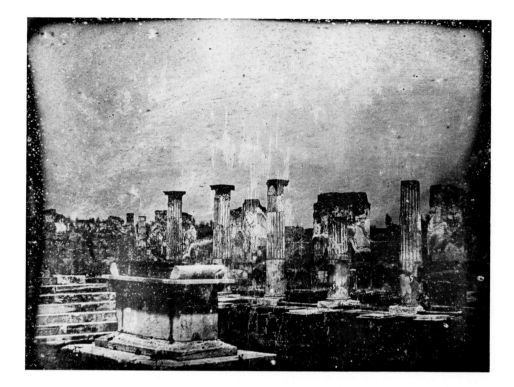

Pompeii. On August 24, A.D. 79, Vesuvius erupted;
by the end of the next day Pompeii was covered
with twenty feet of volcanic debris and ashes. Nearly
seventeen hundred years later excavations began
haphazardly and looting continued until 1860.
Dr. Alexander John Ellis made this daguerreotype of
Pompeii showing the interior of the Temple of Venus
on April 22, 1841. It is, along with the others he
made there, the first photographic documentation of
this famous ruin of antiquity.

Portugal. The caption written by the photographer
C.G. Wheelhouse to accompany this picture of
the doorway of the Convent of San Geronimo in
Lisbon reads:

*This I believe to have been the first photograph taken
in Portugal.*

*Photography, or as it was then sometimes called
"Heliography," had never been heard of there.*

*A market was being held around the Convent at the
time I took it, and a mob soon collected around me, and
would have been dangerous had I not been well guarded
by members of the crew whom I had taken with me, in
anticipation of some such difficulty.*

Wheelhouse, a medical officer in charge of a yachting
party that traveled during 1849 and 1850 to Egypt,
Palestine, Petra, Portugal, and Spain, made calotypes
in each location. Many of his photographs are of
places never before captured with the camera.

Pyramid interior. After nearly five months in Egypt and with his time there nearly over, the Astronomer Royal for Scotland, Charles Piazzi Smyth, had still not achieved one of the objectives of his research on the Great Pyramid of Giza: to make photographs of the King's Coffer and the Queen's Chamber. In 1865, magnesium flare had just been introduced but not much was known about how to use it with wet-plates. Smyth wrote about his experiences at the pyramid:

On the next morning our party was organized again; and with my wife in the company we started at six a.m. hoping now to have all the interior of the Pyramid to ourselves. . . . We placed measuring bars round the coffer to give, at first, its outside proportions. Then erected the camera and operating box at the other end of the room; poured out all the solutions; appointed who was to appear in the picture, and who was to light the magnesium wire when the nick of time came, enjoined sombre silence and the utmost quiet on all of them, lest they should raise the fine dust; looked again into the cameras to see that they were both nicely focused [he had two cameras to make stereographs and presumably carried oil lanterns to see by] and truly directed; and then stepping carefully lest I should break my own rules, began to pour the collodion on to the first glass plate that had ever been prepared for photography within the Great Pyramid.

Five hours later, Smyth was still unable to determine the right amount of magnesium to use and with each attempt the chamber filled with more and more smoke.

Finally, during his last week in Egypt, Piazzi Smyth made this first successful picture. It shows Jessie Smyth next to a measuring rod by the coffer in the King's Chamber in April 1865. James Nasmyth, inventor of the steam hammer, later wrote to Smyth, "My dear friend Sidebotham has told me of the magnesium light inside the King's Chamber! What a scene it must have been to see the most ancient of man's great works brought again to light by the most modern of his scientific aids. Photography and Light-par magnesium, both well worthy of the place & occasion!"

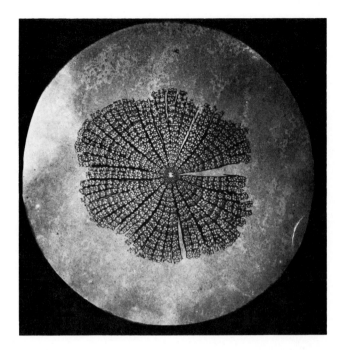

Photomicrograph. Before Fox Talbot ever put light-sensitive paper in his camera obscura, he tried using the paper with the solar microscope. He achieved his first success in making photographs of enlarged botanical specimens in February 1835, and although this picture could date from that time, it was probably made a few years later. Talbot had loved peering through his microscope, especially at crystal structures, about which he wrote extensively, but he became frustrated when he tried to draw what he saw. The application of photography to microscopy delighted Talbot enormously, and soon it became one of the most important tools of scientific research.

Quasi-stellar Radio Sources

3C 48

3C 147

3C 273

3C 196

Quasar. It was not until the twentieth century that astronomers concluded the universe was expanding: ten billion galaxies, each containing one hundred billion stars, all racing away from one another. The cause, according to the new prevailing theory (there have been others) is the explosion of a kind of cosmic egg, into which the whole universe had been packed, more than fifteen billion years ago. The measure of the speed of an object moving away from an observer (the astronomer's telescope) is indicated by the red shift, i.e., the shift in the spectrum of its radiation toward the longer wavelengths; the greater the shift, the faster the object is running away, and, it seems, the fastest is farthest away.

Searching the farthest reaches with radio telescopes, sources of enormous energy were discovered that were receding at speeds comparable to that of light. They were named quasi-stellar objects; here is the initial photograph taken of one by the 200-inch telescope at Hale Observatory in the early 1960s. The explanation for quasars has still not been worked out. If the red shift is truly a measure of speed and distance in an expanding universe, then quasars' fantastic energy output is quite incomprehensible. A whole galaxy of stars must have blown up to create it. If another explanation is given for the red shift—that it is caused by gravitational effects, for example—then the whole of modern astronomy is based on a false premise. It is rather amazing that so much information can be derived from spots on photographs.

Punch and Judy show. This is perhaps the earliest photograph of Punch and Judy battling before an audience. The battles were designed to amuse children but always seduced grownups to watch, too, horrified by the violence that enchanted the kids. The picture was made in 1892 by the Englishman Paul Martin, considered one of the first "candid cameramen," or masters of the snapshot.

opposite:

Penguins. In 1872, the British Admiralty and the Royal Society dispatched a 2,300-ton wooden sailing ship, the *Challenger*, to study the currents and weather, flora and fauna of the seven seas. After four years the *Challenger* returned with what may be called the first modern scientific oceanographic report. The fifty volumes published from 1890 to 1895 are still standard reference. Photography was not yet a vital tool on such expeditions; scientists still relied on their own colored sketches and descriptions. The attendant photographer, John Horsburgh, concentrated on the shorelines, harbors, native populations, towns, and occasionally, as in this photograph, on groups of animals. The penguins are the inhabitants of Inaccessible Island, Tristan da Cunha (St. Helena). These penguins, whose black and white plumage matched the austere formal dress of high society, were described by the crew as an insufferably pushy and noisy mob. To escape from their fearless jostling, the nature-lovers apologetically shot their way back to the boat. Early pictures of penguins captured the imaginations of artists and satirists. In *Penguin Island* (1908) Anatole France exploited the resemblance between that waddling bird colony and French society.

Propeller-driven steamship. The steamship *Great Britain*, designed by the famous bridge builder Isambard Kingdom Brunel, was the first driven by propeller. For caution, she still carried six masts for 15,000 square feet of sail, but happily she crossed the Atlantic in 1843 without ever setting sail. This picture, taken in 1844, was probably made by William Henry Fox Talbot, as the ship was being fitted out in Cumberland Basin, Bristol, England. The stern is still reminiscent of a sailing ship's high transom.

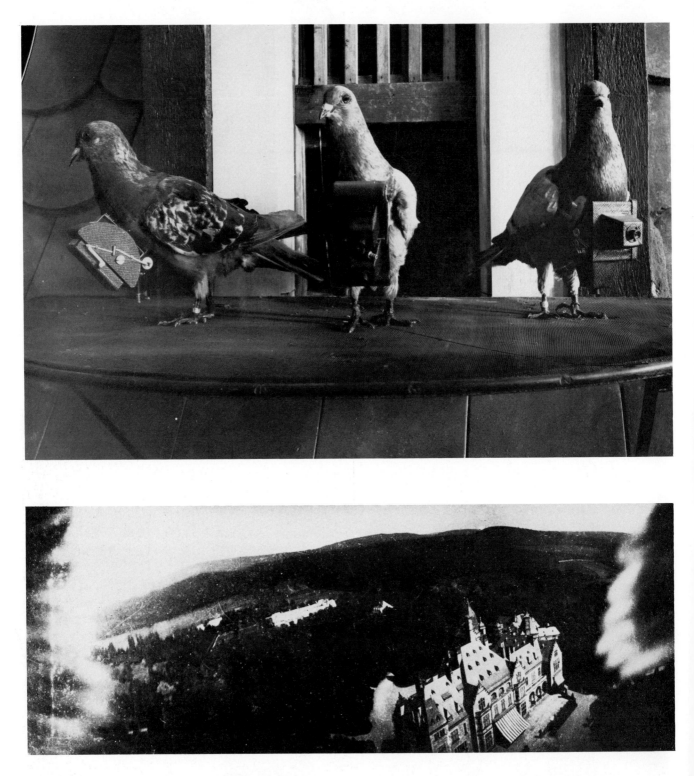

Pigeon photography. These three camerabirds have little to say on the subject of photography and art, but their lack of a theory on the nature of photography did not stop them from taking pictures. The impulse to get photographs taken from the air was so strong that man pressed pigeons into service. The bottom photograph was made by one of these little fellows (who modestly refrained from signing his work) in 1907, while on a flight in his native Germany. The cameras the pigeons have on their chests were patented in 1903 by Julius Neubronner. They weighed 2½ ounces and made negatives 1½ inches square. Timing mechanisms triggered the cameras at half-minute intervals. In 1912, Neubronner designed a panoramic camera for his fine-feathered friends.

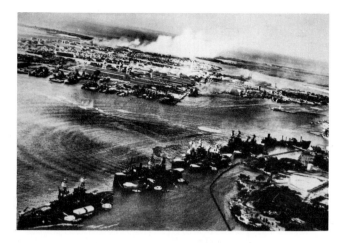

Pearl Harbor attack. On December 7, 1941, the Japanese Navy launched an aerial attack on Pearl Harbor (Oahu, Hawaii), where the might of the U.S. Pacific fleet was gathered. They sank 19 naval vessels, including 8 battleships, and destroyed 188 U.S. aircraft, with a loss of 2,340 lives. These two pictures are from a small group of photographs taken by the Japanese as they were dropping the bombs; later, the photos were seized by the U.S. "Thanks to the blessing of heaven," begins one of the Japanese captions that accompanied the photographs, "and the aid of the gods, the sky opened up suddenly over the Hawaiian Naval Base of Pearl Harbor, and below our eyes were ranged in rows the enemy's capital ships." The other reads, "Alas, the spectacle of the American battleship Fleet in its Dying Gasp. The attack of our assault force was extremely accurate and achieved direct hits with all bombs. The leading ship of the *Oklahoma* Class is already half sunk. The *Maryland* type and the *Pennsylvania* type are blowing up from several direct hits. The ships crumble and their hulls are twisted and keeling over. Crude oil gushes forth fearfully. This view of the wretched enemy's capital ships which were converted into a sea hell was photographed from directly overhead by the heroes of our calm, valorous attack force."

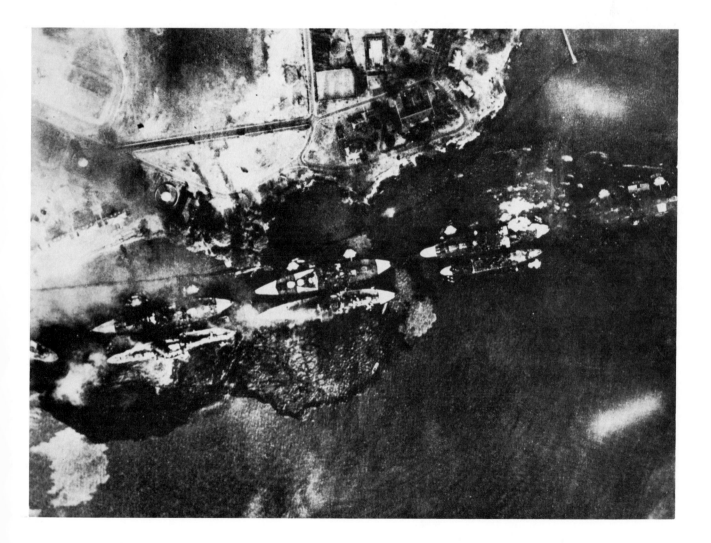

Underwater in color. In the January 1927 issue of *National Geographic Magazine* a wonderful article appeared titled "The First Autochromes from the Ocean Bottom," by Dr. W.H. Longley and Charles Martin. These are two of the eight autochromes reproduced. The inventors of photography had always wanted "full color" and it was a disappointment that they had to settle for monochrome. Not until the twentieth century could photographers explore the world in all its hues, and one of the most exciting breakthroughs was the technology that allowed them to reveal the dazzling color of life in the oceans. The photograph on the top is "Gray Snappers and One Yellow Goatfish Among Sea Fans and Other Gorgonians" and the one on the bottom is "A Saucer-eye Porgy Beside a Large Corrugated Brain Coral."

Aerial in color. Melville Bell Grosvenor was the first person to take a color camera up in the air and make successful photographs. "A Bathing Club Near Asbury Park, New Jersey" was one of his first, taken in July 1930 and published two months later in his *National Geographic Magazine*. He used the Finlay Color Process, which had appeared on the market only the year before. It used a screen of red, green, and blue squares, not unlike other color processes before it, the difference being that it was a "high-speed" plate with greater exposure latitude. Advertisements for Finlay color in British journals included the following message: "Adopted by the National Geographic Magazine of America for colour work involving movement."

Color photograph at night. The first color photograph taken at night is also the first to show neon lights. Neon has transformed romantic gaslit cities into glowing, colorful fun fairs offering music, food, theater, and good times.

Discovered in 1898 by the English chemists Sir William Ramsay and Morris W. Travers, the familiar tube filled with neon gas that could be made to emit bright light when electrically charged was developed by French physicist Georges Claude. Neon lights were soon used for decoration, and this autochrome of December 18, 1910, shows the Grand Palais in Paris all dressed up for Christmas.

Animals in nature in color. This picture of swans is one of four plates printed in full color in an article titled "Ornamental Birds on the Country Place" in *Country Life in America* (May 1909). The photographer is Arthur G. Eldredge. The following accompanied the piece:

[Note.—The accompanying illustrations represent a distinct and remarkable achievement in the use of color photography for magazine illustrations. While these engravings are not as perfect, technically, as some that we have published of stationary subjects, they are extraordinary in that they are the first successful autochromes ever made of living creatures in the open. When you consider that these plates require at least sixty times the exposure of ordinary fast photographic plates, the marvel of the feat becomes apparent. THE EDITORS.*]*

Rainbow in color. In his autobiography *As I Remember*, Arnold Genthe described how he made this autochrome of a rainbow in the Grand Canyon in 1911:

I had arranged my trip to New York so that I would have at least one week in the Grand Canyon. I had been there in 1904, prepared to take a number of pictures. I did not take any. "It is useless," I had said. "Unless it can be done in color it would be a desecration." Now I planned to make some color plates.

In the deep gorges of the canyon there was rich picture material. One day I went down to the bottom on foot, and after most of my plates had been used up I started back on the seven-mile climb to the top, when I was caught in a terrific thunderstorm. It was not just one thunderstorm but a convention of them. As there was no place to seek shelter, all I could do was to trudge on carrying my camera which seemed to be getting heavier every minute. When I got to the rim of the canyon, the storm had subsided, and there before me, descending into the purple depths, was the most magnificent rainbow I have ever beheld. I had just two plates left. Quickly I set up my camera. It was still drizzling and I had nothing to protect the lens from moisture, since my hat had blown off in the storm. Glancing around I saw a forest ranger on horseback to whom I signaled. He came cantering up. "What's the trouble?" he asked.

"I want to make a photograph of this rainbow," I said. "Would you be kind enough to hold your sombrero over the lens?"

Silently he did as I requested. When I had finished he gave me a doubtful look, asking, "Can you really take a picture of a rainbow?"

Sunset in color. This autochrome by Arnold Genthe is the first of many, many, many color photographs of sunsets. It was made about 1911.

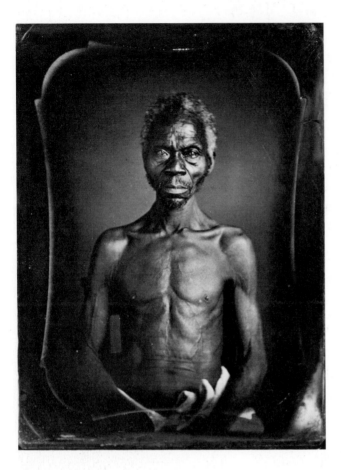

Slaves. In 1850, Louis Agassiz addressed a meeting of the Association for the Advancement of American Science in Charleston, South Carolina, and stated that the races were "well marked and distinct" and did not come "from a common center . . . nor from a common pair." Many thought these words blasphemous, for they denied Adam and Eve, but many in the audience realized that his statement could be considered a "scientific" justification of slavery. According to the Bible, all the ancestors of mankind had been together on Noah's Ark, and racial differences had developed only because individuals were dispersed over various climates and continents.

Agassiz' argument preceded the publication of Darwin's *Origin of Species* by nine years, but that book did not settle the questions raised, nor did Darwin's *Descent of Man* in 1871. For most of the world's population, it still is not settled. The key to Darwin's theory was the age of the earth. A Bishop Ussher had calculated in the seventeenth century, by counting all the begats in the Bible starting with Adam, that the world had been created in 4,004 B.C. No one argued with this impressive scholarship until geologists early in the nineteenth century began to think in terms of millions of years, to explain the processes of erosion and sedimentation. Darwin could not have proposed his theory if he had not also believed in millions of years of natural selection as a basis for speciation.

Supporters of slavery before Darwin found support in Agassiz' "scientific" opinion and were delighted by some of the explanations that were proposed for the different races—one being that the races had been created separately by God for different purposes. Agassiz, a recently arrived immigrant to the United States from Switzerland, prided himself on his meticulous research, and after the Charleston meeting he traveled to plantations in Columbia, South Carolina, where he studied the African-born and first-generation American slaves and concluded that they were indeed very different from the other races. He requested that some of them be photographed undressed for further study, and a daguerreotypist, J.T. Zealy, was commissioned to do the work. On the left is Renty, born in the Congo and working on the plantation of B.F. Taylor, Columbia. His daughter Delia, born in the United States, is on the right. These pictures, however, apparently were not compared to similar poses by whites, Indians, Moslems, Chinese, South Sea Islanders. The illumination cast by the discovery of the structure of DNA on the process of inheritance leaves no room for logical opposition to the theory of evolution, but the fundamentalists, of course, still prefer the Biblical story.

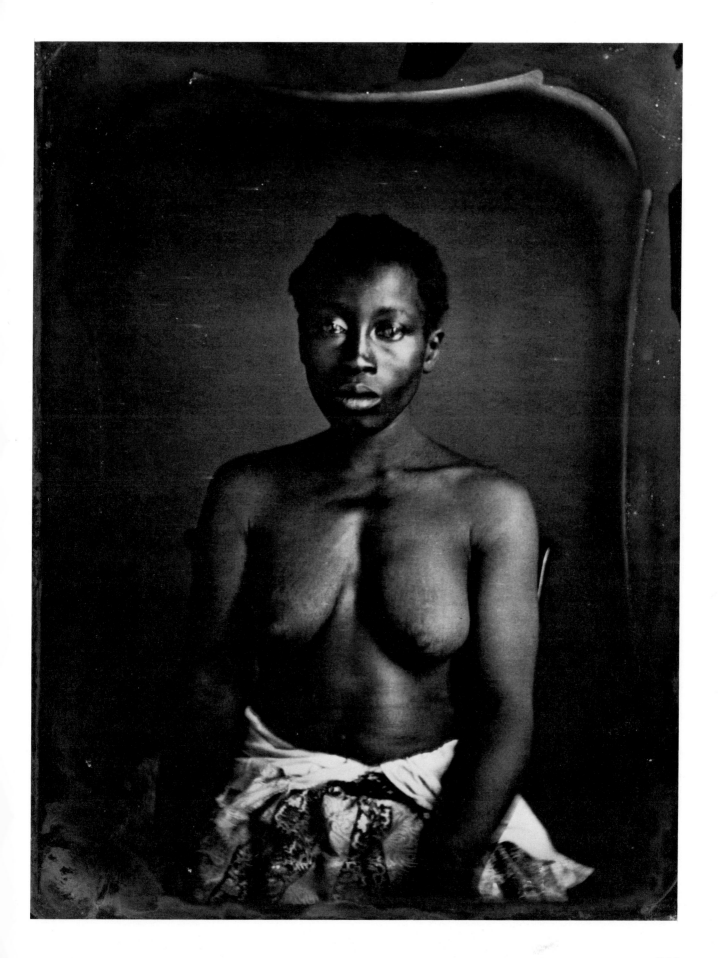

Slave group in the United States. On June 8, 1857, Captain James Rembert's seventy-fifth birthday was celebrated at the Stirrup Branch Plantation, Bishopville, South Carolina. An unknown cameraman was invited to photograph the captain with his wife and descendants on the front porch. Then he went behind the house for this tintype of Captain Rembert's slaves, arranged by rank.

Slums. Photographers first began having an investigative eye in the late 1860s. This is quite distinct from reporting an event, for investigation reveals hidden details of something ongoing and often unchanging. These photographers' objective frequently was to improve a social situation. One of the first targets of photographic scrutiny was lower-class housing, a subject that still arouses the socially committed cameraman or woman. Between 1867 and 1877, Thomas Annan of Scotland photographed in and around slum areas for the Glasgow City Improvement Trust. His work was of a high standard even compared with that of those who followed, such as Jacob Riis and Lewis Hine, although they probably never saw his pictures. Annan revealed all the details with a minimum of staging, considering he was using wet-plate apparatus, and always allowed the people watching him to remain during the exposure. This picture selected from Annan's work is "No. 11, Bridgegate," 1867.

opposite:

Slave market in Africa. John Hanning Speke, the English explorer who discovered Lake Victoria, the source of the White Nile, in 1858, returned in 1862 to map the region. On this trip he took a wet-plate stereo camera, operated by J.A. Grant. The pictures of a slave market in Zanzibar and of natives from the Country of the Moon have their own captions.

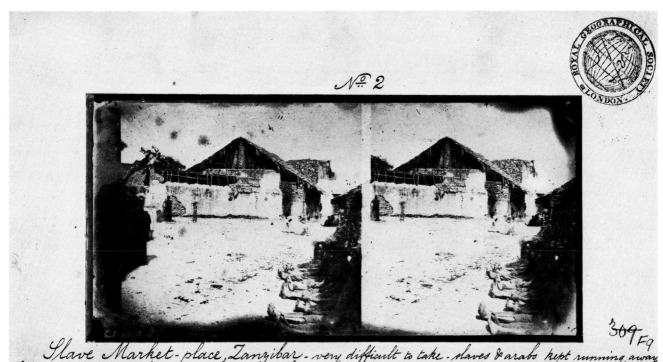

No 2

369 F9

Slave Market-place, Zanzibar - very difficult to take - slaves & arabs kept running away leaving only a line of women slaves whose legs and a face or two may be observed - the women's entire dress is a blue cotton sheet or cloth tied tight under arms and extending as far as the knee-their heads are cropped as short as scizzors can crop them - very often they have for ornament a hole through the upper lip - at the market they come out very clean - Houses are blocks of coralline partly plastered - an indistinct wily arab squats to the right eyeing the women

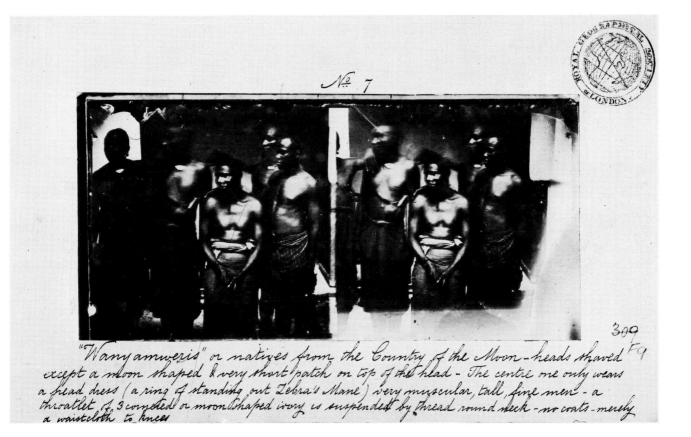

No 7

399 F9

"Wanyamwezis" or natives from the Country of the Moon - heads shaved except a moon shaped & very short patch on top of the head - The centre one only wears a head dress (a ring of standing out Zebra's Mane) very muscular, tall, fine men - a throatlet of 3 connected or moon shaped ivory is suspended by thread round neck - no coats - merely a waistcloth to knees

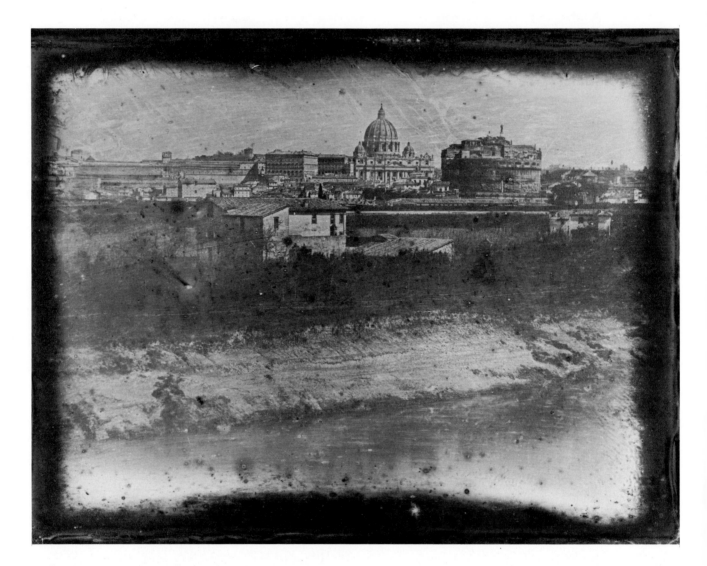

St. Peter's, Rome. On the back of this whole-plate daguerreotype is written "The first photograph ever taken." The reference is correct pertaining only to Italy. This view, almost certainly made in 1839, is identical with an engraving in *Excursions Daguerriennes*, the marvelous two-volume work published by N.P. Lerebours in 1840 and 1841 (see Introduction).

Royalty. Prince Albert, the prince consort of Queen Victoria, was a passionate advocate of photography and he helped speed up its acceptance. He was also one of its first collectors. These daguerreotypes were taken in 1842, possibly by William Constable of Brighton. They are not only the first photographs of Prince Albert, but are probably the first of any member of a royal family anywhere. Within twenty-five years the elegant *carte-de-visite* portraits of Victoria and Albert were placed on the first page of family albums everywhere in Great Britain. It did not matter how photogenic royalty was. But for the first time in history, the general public was able to examine the photographed faces of politicians for a clue to their character and intelligence. Thus the camera has been in a real sense as important as newspapers, radio and TV, in wooing the voting public.

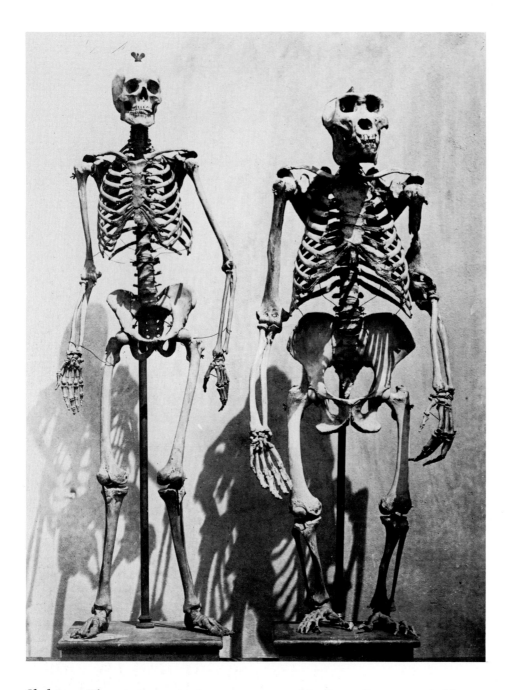

Skeletons. These primate cousins were compared by Roger Fenton, probably at the British Museum, about 1854. Bone for bone, gorilla matches man, though the lengths and articulation differ here and there. Charles Darwin's *Origin of Species*, published in 1859, merely marshalled the evidence he saw for a theory of evolution. He did not spell out his belief that man, too, was a descendant of earlier creatures that were not men. The implications, however, were grasped by scholars and the general public and a storm broke within days of the publication and is still raging. In *The Descent of Man* (1871), Darwin emphasized that man did not descend from apes but that apes and man had a common ancestor. But who, a few years before Darwin's first book was published, thought of putting the two skeletons together? Fenton, the photographer? The museum staff? Or, some scientist who wanted to study the bones in greater detail?

Sales catalogue. The first photographic sales catalogue featured clocks, and it was strange indeed. There were no pages to flip through to get an idea of what was for sale; the catalogue consisted of a box of daguerreotypes, each plate showing a different model clock. The clocks were identified on the back as to type and price. This was not common in the 1850s, and Mr. N.L. Bradley, the traveling salesman to whom the case originally belonged, probably had a considerable edge over other salesmen on the road.

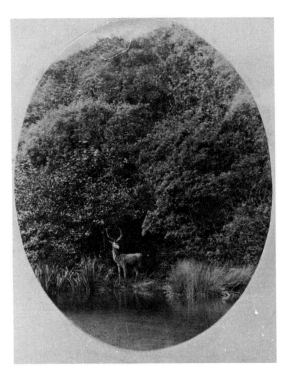

Stag. For some years after photography was invented, most of the animals that appeared in photographs were stuffed, as in the small picture (left) by J.D. Llewelyn, circa 1856-59. The portly stag (below) with the disdainful expression, however, was very much alive and probably the first to get its portrait taken. The photographer was Mr. Bambridge, a member of Queen Victoria's household, and the stag was a denizen of Her Majesty's Windsor Park. The picture was taken on November 3, 1854.

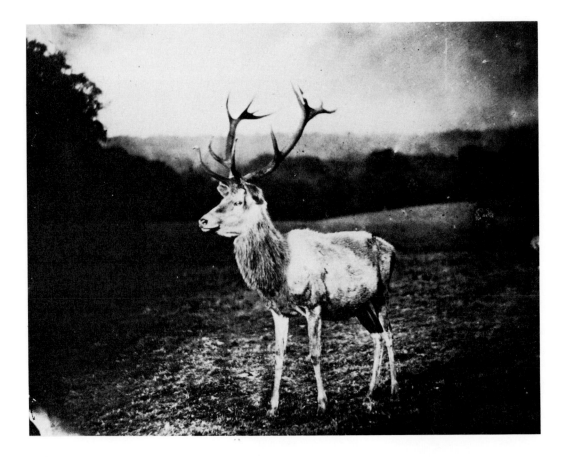

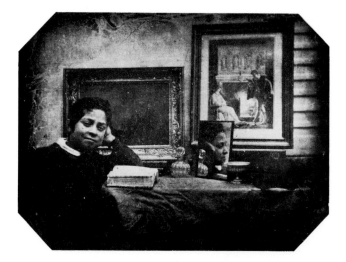

capabilities of photographic materials were necessary in the early days. Photographers had to learn, for example, which wavelengths of light (our eyes "see" color instead of wavelengths) their plates were sensitive to. Once they satisfied themselves, they often explained aspects of the nature of photography to the public. Even what would seem to us today the most obvious facts were questions tossed about in the nineteenth century, e.g., the photographer does not "draw" the picture with his own hand; it does not take any longer to photograph a group of people than a single person; the daguerreotype can capture the reflection in a mirror on its own mirrory surface.

The picture at left—only 3 by 4 inches in the original—was probably taken outdoors, for it was not at all unusual to assemble the props in bright sunlight. It looks as though this daguerreotypist was experimenting with the notion that human vision as well as the camera frames everything.

Reflection in a mirror. The daguerreotype was often called a "mirror image" or a "mirror with a memory." It was adventurous of this unknown daguerreotypist to have put, in October 1841, an actual mirror in his composition. Such experiments to discover the

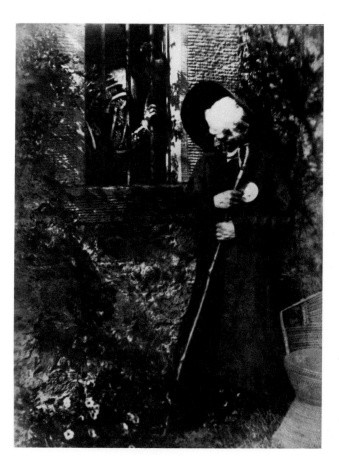

Story illustration. One of the first great popular novelists was Sir Walter Scott, who poured out an enormous number of volumes early in the nineteenth century. By then, etchings and woodcuts were commonplace as illustrations in books. The desire on the part of photographers to tell stories, too, was met by finding people willing to dress for different parts and pose in familiar scenes from a book, poem, or well-known tale. Here, in a photograph by Hill and Adamson, taken during the summer of either 1846 or 1847, are Mrs. Cleghorn as Edie Ochiltre and John Henning, the sculptor, as the beggar, from Chapter 12 of Scott's *The Antiquary.*

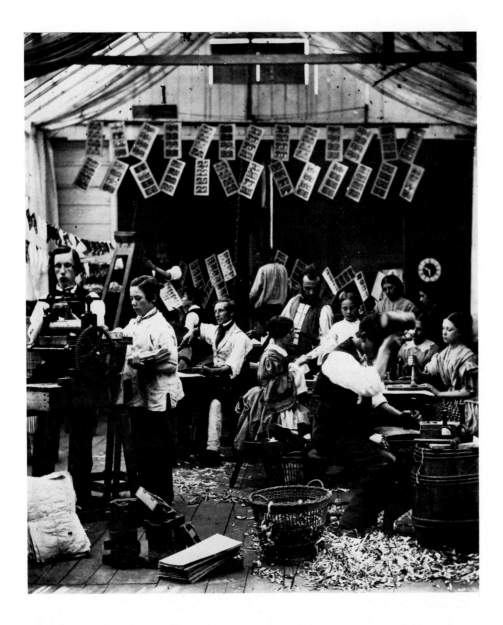

Stereoscopic slide manufacture. Not only is this the first photograph showing the production of stereoscopic slides, it is one of the earliest pictures showing the interior of any kind of manufacturing establishment, even though the manufacturing here goes on under a glass roof and with no heavy machinery. Everything is done by hand, using simple tools, with men, women, girls, and boys working closely together to produce the pictures for the stereoscope, the "optical wonder of the age."

The stereo viewer with its slides was the means by which millions of Victorians informed themselves of the worlds they would never see in person. This picture is from the 1850s and shows the work force of Ferrier Père et Fils and Soulier. Without stretching the imagination, one can compare this scene, which shows the beginning of modern visual mass media, with scenes in TV studios, where the staff assembles the scripts and videotapes for the evening news.

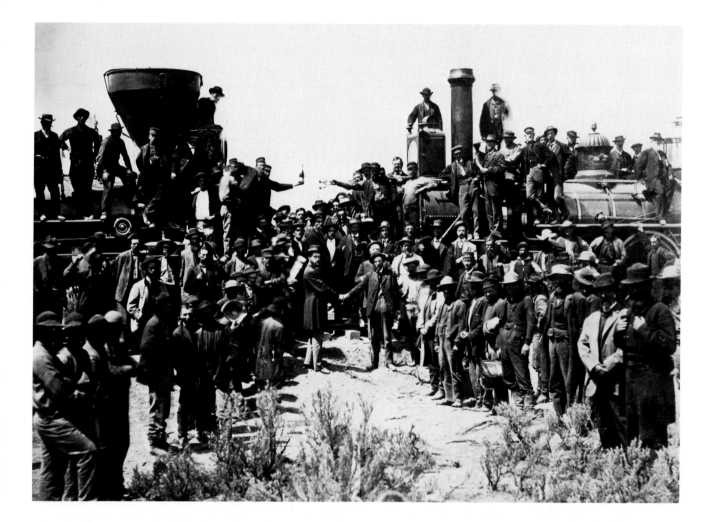

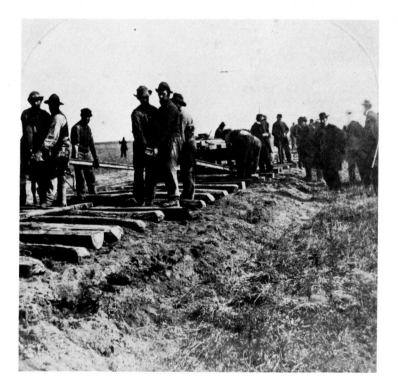

Railroad across the United States. There are many photographs of railroads previous to this event at Promontory Point, Utah, on May 10, 1869, but this is from the special group that immortalized the joining of the tracks laid from the East with the tracks laid from the West. It shows a golden spike being driven into the final sleeper on that momentous day. The photographer A.J. Russell had been employed by the Union Pacific to record the building of the railroad. This picture (above) has been reproduced countless times and has become the clinching symbol of the beginning of the end of the American frontier.

The picture at left, by J. Carbutt, commemorates only the nameless gandy dancers who made it all possible. They laid two miles of track a day without philosophical or political discussions concerning their role in the manifest destiny of their country.

Sutter's Mill, California, Gold Rush. In 1848, the man in the foreground, James Wilson Marshall, a carpenter, discovered gold on wealthy John A. Sutter's land while he was employed by Sutter to build a sawmill. This is a 1918 copy of a daguerreotype, now lost, made probably by R.H. Vance in January 1851. Marshall looks disgusted, and it is not surprising, for by this time both Sutter and Marshall had been robbed of their would-be fortune. The news of the strike had spread quickly and gold-crazed men rushed across the continent in 1849, arriving on Sutter's land, killing his cattle and stealing his gold. In 1851, Sutter, well known for his generosity and his enormous debts, moved to Pennsylvania, a ruined man. Marshall became misanthropic and worked as a gardener. California became populated and Sutter's Mill is now the site of Sacramento.

opposite:

Ranch interior. There is nothing that surprises us in this 1872 picture, taken by William Henry Jackson, best known for his landscapes of the American West, of men sitting around the fireplace of a ranch house in Idaho Territory. From other photographs, from illustrations for stories in magazines, and from the movies, the details are familiar. Only the number of guns and rifles may seem a little excessive.

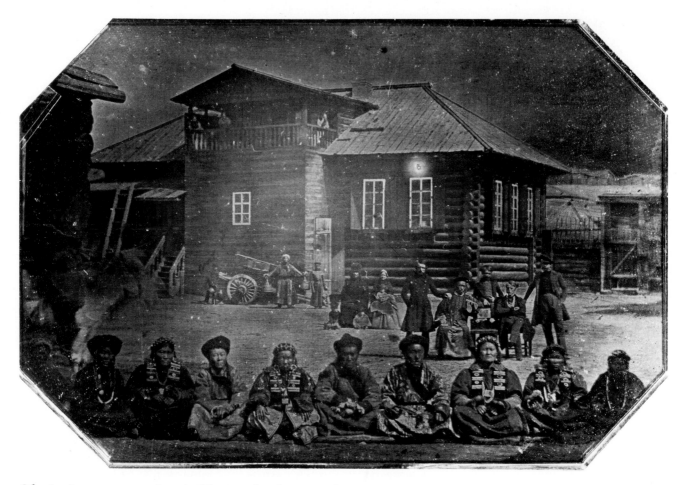

Siberia. A scene, somewhere in Siberia, taken by a traveler, J.-P. Alibert, in 1845. He may be sitting or standing with his companions at right-center. The difficulties of transporting the cumbersome daguerreotype equipment certainly means that he did not take only one picture. It is not unusual at this early date for a photographer to have twenty or more failed plates to one success, to meet some misfortune en route, or for the plates to be lost or destroyed. The style of clothing does not seem to have changed much in the more rural parts of Asia.

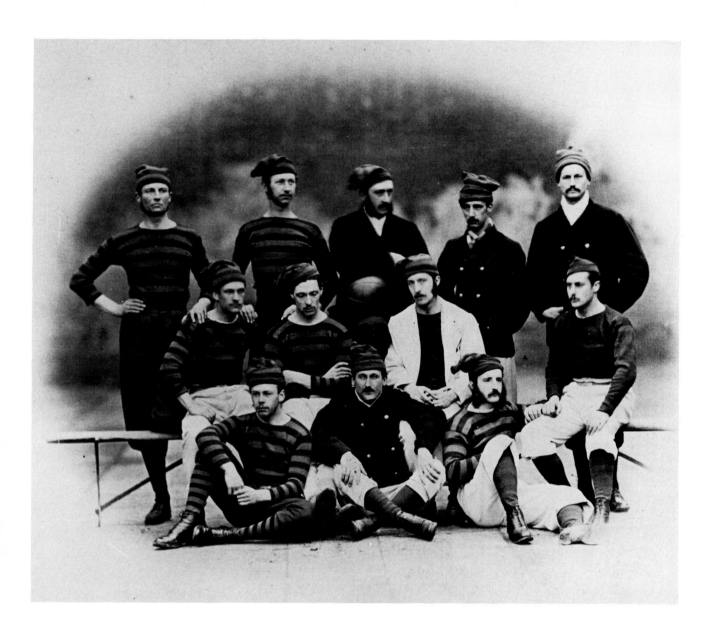

Soccer (football) team. Although kicking a ball around had been going on for a long time, it was not until October 26, 1863, that the Football Association was formed in Great Britain to establish some proper rules for the game of soccer, or football as it is called there. The *Encyclopaedia Britannica* states that "soccer became one of Britain's greatest exports, spread by soldiers, sailors, merchants, engineers, priests." This must be one of the first teams that played by the rules. The players are officers of the Royal Engineers. The photograph is in an album dated 1868 that includes pictures of the Royal Engineers, who, with their surveying and photographic equipment, joined others for the invasion of Abyssinia that year.

Subway (Underground), London. The earliest part of the London underground was finished in 1862. An unknown cameraman overcame the problems of manipulating his wet-plate apparatus in gaslit scenes to immortalize the occasion on May 24. Prime Minister Gladstone sits in the center, to the right of the man in the white hat. The open carriages were pulled by steam engines that spewed smoke and cinders on the passengers. Half a million people shoved and pushed for a ride on this day, and the jamming on subways has not stopped since.

Subway, New York City. The dignitaries of the city assembled by Mayor McClellan for the first ride through the subway—financed, owned, and operated privately—in February 1904. Photographer Edwin Levick used a magnesium flash.

Shop sign. Hippolyte Bayard made this photograph of the entrance to a horse dealer's courtyard about 1846. The integration of a shop sign or advertisement with the composition of a picture is a common motif, used by many photographers from the earliest days to the present. Walker Evans, for example, was a master at accentuating elements in his pictures with advertisements and posters. Done skillfully, the visual strength of the poster enhances the photograph, adding the complexity of a picture within a picture, showing how the culture expresses itself pictorially.

The above serves as a reminder that photographers frequently incorporate such techniques—including words, signs, and numbers—as part of their aesthetic signature.

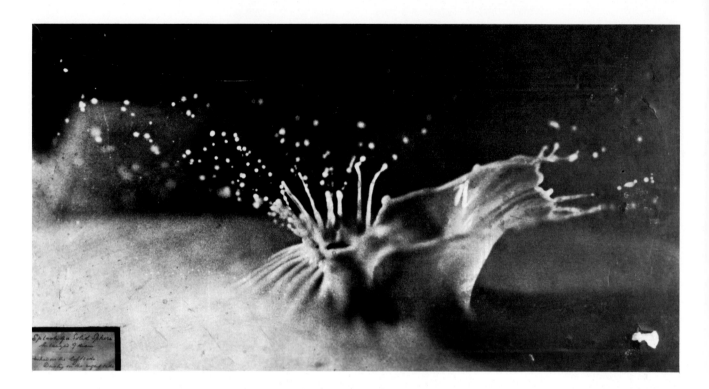

Splash. The first photograph of a splash was taken by A.M. Worthington about 1900. A solid sphere was dropped into milk and a Leyden jar between magnesia terminals provided the illumination for stop-action photography.

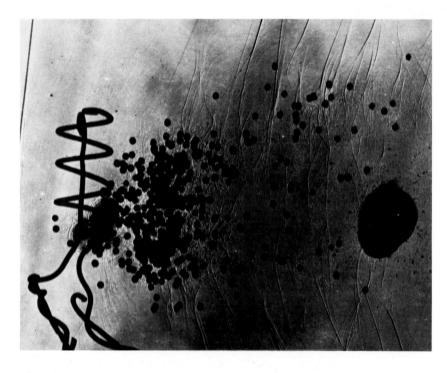

Shot flying. C.V. Boys in 1892 photographed the wad from the shell followed by the charge of pellets exploding from the barrel of a shotgun. He had developed a system for taking high-speed photographs using two wires that formed part of an electric circuit. The circuit was switched on at one instant of the projectile's flight and produced a discharge, marked by a spark of great brilliance and of less than one microsecond duration. The shot is seen as a silhouette against the background of the spark. He also photographed bullets in flight the same year.

opposite:

Soap bubble bursting. An airy soap bubble with its shimmering colors explodes too fast for the eye to see the whole process. Dr. Lucien G. Bull recorded the burst in 1904 at 1,100 pictures per second. It marks the beginning of the study of surface tension. The film of the bubble is only a few molecules thick.

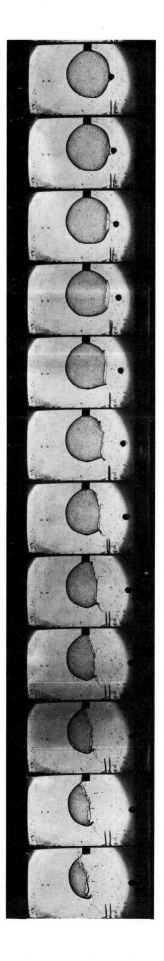

Snowflake. One man, Wilson Bentley, slowly worked out a system for photographing snowflakes and ice crystals through a microscope. On January 15, 1885, when he was twenty years old, after many, many failures, he had his first success. Later he wrote: "The day that I developed the first negative made by this method, and found it good, I felt almost like falling on my knees beside that apparatus and worshipping it! I knew then that what I had dreamed of doing was possible. It was the greatest moment of my life."

Bentley lived all his life in Vermont and never went to school, although he read every book in his parents' house including an encyclopedia and was given a microscope by his mother in 1880, when he was fifteen. The method he used to photograph snowflakes began with the capture of hundreds of snowflakes on a chilled black tray that he held up to the storm. In the farm's cold room he picked up a perfect sample by touching it with the end of a broom splint, to which it stuck, and then transferred it to a glass slide, pressing it there with a feather. This went under the microscope. Exposures were from 10 to 100 seconds. At all times he wore thick mittens to keep his body warmth from the flake and, of course, he held his breath. "I never have used liquor, tobacco, or any stimulants that affect my nerves. My hand is perfectly steady," he explained. His book, *Snow Crystals*, published by the U.S. Weather Bureau in 1931, has 2,500 microphotographs selected from 4,500—all different.

Stonehenge (England). This is the first photograph of Stonehenge—the most famous ruin of antiquity in England—built around 1500 B.C. on Salisbury Plain. Taken in 1853 by W. Russell Sedgfield, it shows the tumbled condition of the site before its reconstruction in the 1860s. One theory concerning the reason Stonehenge was built is that it served as a perpetual calendar presumably linked to religious observances.

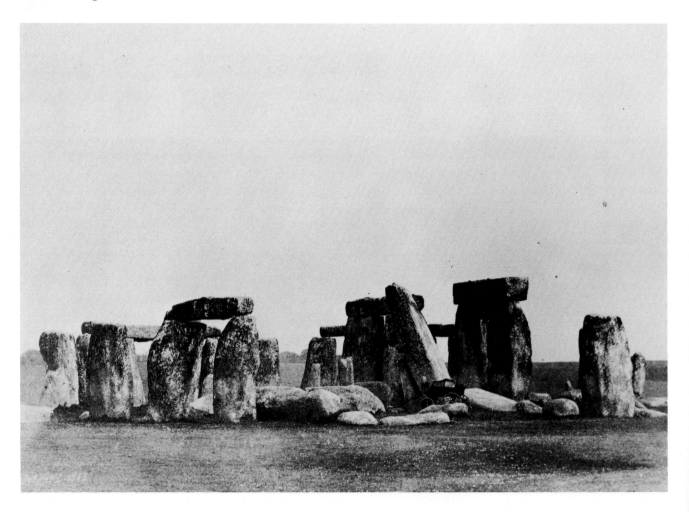

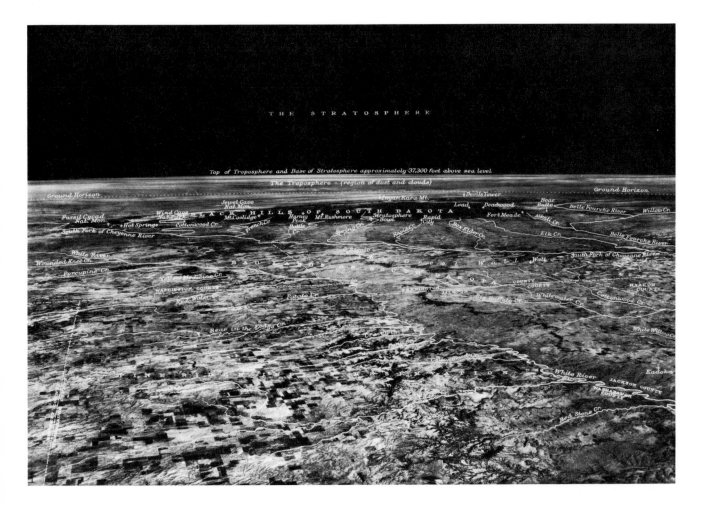

The Stratosphere

Top of Troposphere and Base of Stratosphere approximately 37,300 feet above sea level

The Troposphere - (region of dust and clouds)

Stratosphere. By the 1930s, meteorologists had developed a reasonable map of the earth's envelope of gases, using high mountains and balloon-borne instruments to measure temperature, pressure, humidity, and wind velocities. On November 11, 1935, the experimental balloon *Explorer II*, sponsored by the National Geographic Society/U.S. Army Air Corps, was released with instruments, a camera, and Captain Albert W. Stevens heavily bundled up. They rose and rose and rose, the balloon swelled steadily, and at 72,395 feet, higher than any human being had ever been, Stevens took this picture of the Black Hills of South Dakota. But the reason scientists were thrilled by the panorama was that because the camera was looking down at the top of the troposphere—that portion of the atmosphere up to 30-40,000 feet, containing almost all the weather, dust, and pollutants from human activity—the demarcation between it and the absolutely pure stratosphere was dramatically drawn. The earth's shallow curvature is also clear. Because of a special lens filter and infrared sensitive film, the camera reveals details the eye can never see.

This photograph is important not just to weathermen, but also because it is in the sequence of expanding knowledge about the planet Earth in space. Since that flight much more has been discovered, some of it wholly unsuspected, such as the Van Allen radiation belt, which finally explained the mysterious aurora borealis.

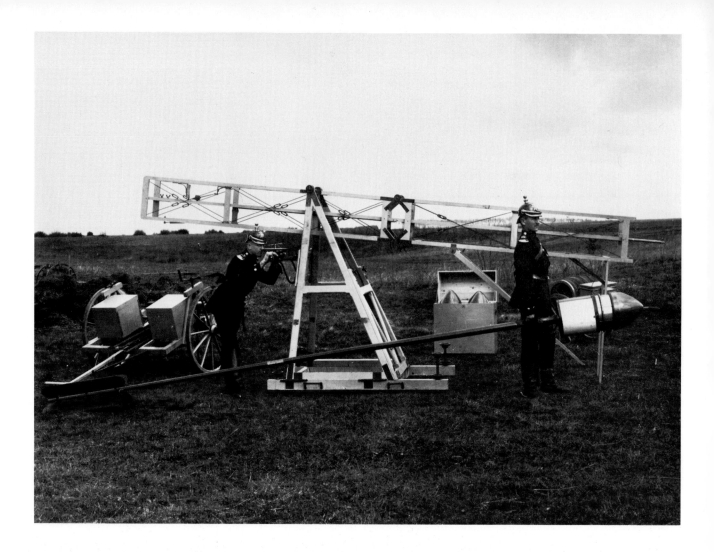

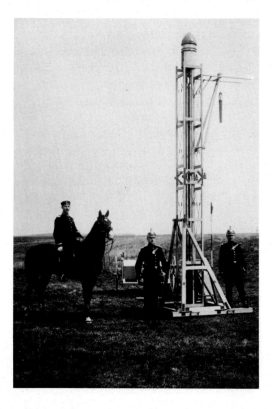

Rocket photography. Alfred Maul of Germany patented a photo-rocket in 1903. The camera aimed by a gyroscope was in the nose cone of a rocket that rose to 2,600 feet in eight seconds when this photograph (right) was taken. The cone separated from the rocket, the camera, fastened to a parachute, was ejected, the glass plate was exposed by a timing device, and then the camera floated back to earth. Military men were in full control, as can be seen by the helmeted soldiers (left) guarding the launching pad for the 55-pound rocket powered by gunpowder. (What's a horse doing there?) Cameras without photographers had been lofted before this—by pigeons, unmanned balloons, and kites—but this is truly the first step (about 1912) in the exploration of the solar system that came fifty years later.

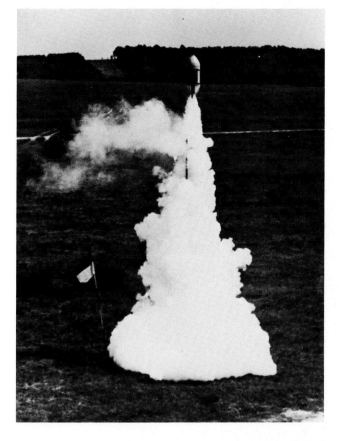

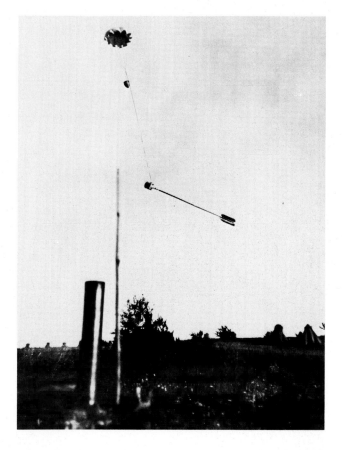

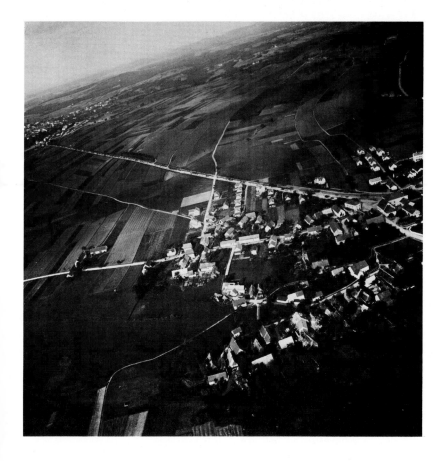

Rocket transport in the United States. Dr. Robert Hutchins Goddard, born in 1883, was the father of American rocketry. Dr. Goddard's fame is posthumous; he invented and tested practically everything that after his death in 1945 was of basic importance to the development of the U.S. space program. Above, he is towing one of his rockets to the launching site, circa 1930. Despite how funny this setup looks compared to the behemoth transport machines and pads at Cape Kennedy, today's rockets use the same principles as Goddard's. Far more sobering is the fact that Isaac Newton in the 1680s had calculated the escape velocity and orbital path of any object launched from earth.

Rhinoceros charging. With a large, unwieldy box camera, A. Radcliffe Dugmore faced a charging rhinoceros on a Kenya plain in the year 1909 and made one of the most famous of all wildlife photographs. Even though he had a telephoto lens for his monstrous machine, he wanted to get closer and closer to the fearsome beast, and when this shot was made, Dugmore was 15 yards from his prey. He wrote:

As quietly as possible we stalked the sleeping creature until at thirty yards we were close enough for all practical purposes. My companion stood slightly to one side, and I made some noise. Like a flash the big animal was up and without waiting a moment he headed for us with tail erect and nostrils dilated, snorting as he came. It was a splendid sight, but not one to linger over. I was watching him on the focusing glass of the camera, and when he seemed as close as it was wise to let him come, I pressed the button and my companion fired as he heard the shutter drop. The shot struck the beast in the shoulder and fortunately

turned him at once. At the point of turning he was exactly fifteen yards, but it seemed more like five.

According to our priorities today, it seems cruel to wound an animal in order to get a picture. Nevertheless, in 1909, the world had never seen a charging rhinoceros and the image, like the animal, is powerful.

Various species of rhino inhabit Africa and Asia, but recently most of them have been declared endangered, not because of the deterioration of their environment, but because their horns, ground into a powder and sprinkled into drinks, are believed to be an aphrodisiac by the Chinese and Indians. That horn is also in very high demand as a handle for daggers worn in the Middle East. Furthermore, almost every part of the beast from its skin to its internal organs is believed to have curative powers for all sorts of diseases. Thus poachers, each time they shoot a rhinoceros, literally make a killing on the pharmaceutical market.

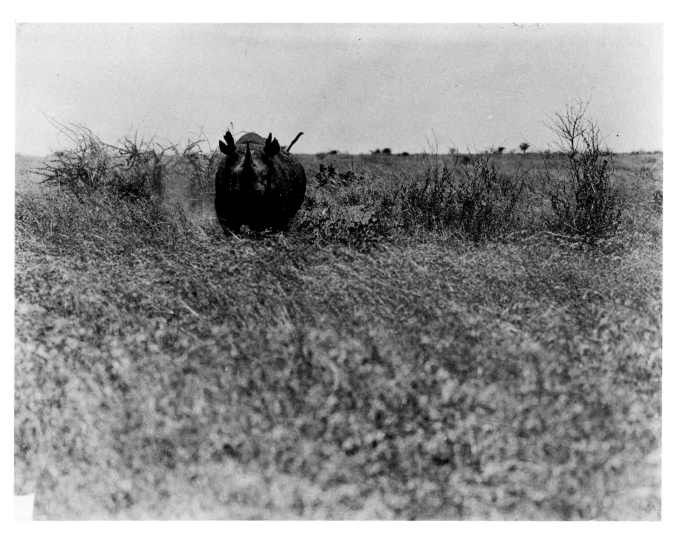

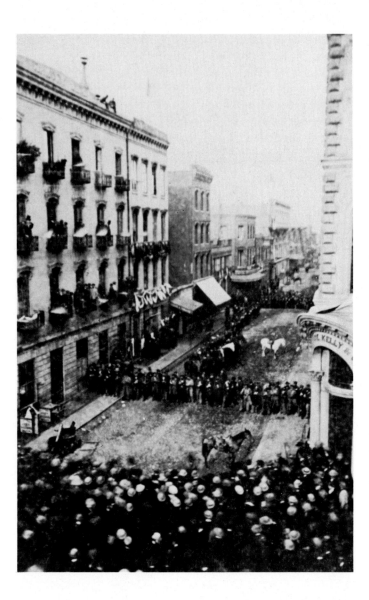

Riot. Until the 1860s, very few photographs were made in the open streets of a city showing people moving about, because of the need for long exposures. This is one of the earliest of a confrontation between angry massed citizens and phalanxes of police ordered to disperse them. The original is a *carte-de-visite* by Bradley and Rulofson, of San Francisco, and was almost certainly sold commercially. On this particular print there is a handwritten caption: "Police dispersing the mob in front of the 'Alta' newspaper office, April 15th, 1865." Lincoln died on that day in Washington and the news was telegraphed to San Francisco, where it precipitated the riot.

In the United States. A Mr. D.W. Seager, on September 30, 1839, exhibited in New York a daguerreotype that he had made three days earlier. Because there is documentation pertaining to it (although the picture has long since disappeared), historians consider Seager's plate of St. Paul's Church on Broadway and Fulton Street, New York City, to be the first photograph made in America.

But the earliest extant photograph is the below. It was taken by the Philadelphian Joseph Saxton on October 16, 1839, from a window of the Mint and shows the Philadelphia Arsenal and the copula of the Central High School. The original is only 1¼ by 2 inches, and although it is a strong, geometric picture, it was made by converting a cigar box to a camera obscura and using other imaginative transformations.

opposite:

Red Cross (American) abroad. Clara Barton organized an agency to obtain and distribute supplies to wounded Civil War soldiers, and in 1865, President Abraham Lincoln asked her to set up a bureau for tracing missing men. In her travels abroad she had become familiar with the work of the International Red Cross and in 1881, she established the American branch, of which she was president until 1904.

On Barton's initiative, the Red Cross's activities were expanded from serving only during wars to the caring for people in times of natural calamities such as floods, earthquakes, cyclones and famines. In 1898, Mrs. Barton (first full-length figure on the right in the picture) and her team followed American soldiers to the Spanish-American War. Here they are, a mixed bag of angels of mercy about to land in Cuba.

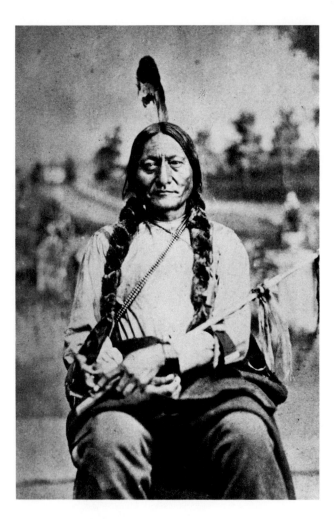

Sitting Bull. The best known of all American Indians, Sitting Bull, Chief of the Sioux, led the Plains Indians in their greatest victory over the white man at Little Big Horn—where, on June 25, 1876, Custer made his last stand. After winning the battle, the Indians could not survive a gradual cutting-off of their food supply. In May 1877, Sitting Bull led

his remaining followers to Canada, but by 1881, hunger amongst his people forced him to make another difficult decision. He returned to the United States, where he was arrested by military authorities at Fort Buford, Dakota Territory, on July 19. Ten days later he and 187 men, women, and children boarded the steamer *General Sherman* for their trip down the Missouri River to the Standing Rock reservation.

On August 1, the steamer stopped at Bismark, North Dakota. Sitting Bull was invited to the studio of the town's photographer, Orlando Scott Goff. He didn't want his photograph taken. He believed it to be "bad medicine" to have the "white man shadow catcher" point his black box at him—it would mean some part of his spirit would be taken away. The more pictures taken, the more spirit he would lose. Even without black boxes, Sitting Bull distrusted the white man, but, nevertheless, when promised $50 if he permitted Goff to take his portrait, the brave warrior agreed. Within four days the above photograph was in the hands of engravers in New York City and his face was seen in newspapers and magazines by millions of folks who shuddered at the name of Sitting Bull.

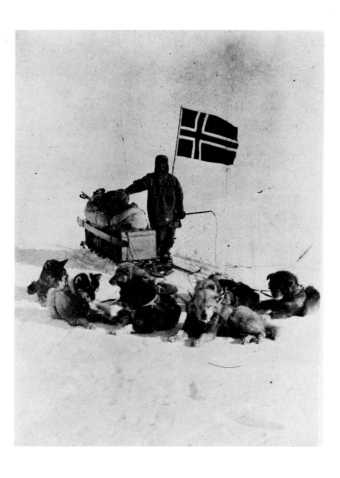

South Pole. These dogs pulled the first four Europeans to the South Pole, where a grateful Capt. Roald Amundsen recorded the event on December 14, 1911, with a few snapshots, the Norwegian flag prominently displayed. They had left their base camp on October 20, and the dogs, hopefully, were given an extra ration of frozen fish for their heroic effort. Thirty-five days later the Englishman Robert F. Scott arrived at the Pole with his companions, found that Amundsen had already been there and also took pictures; but he perished on the way back.

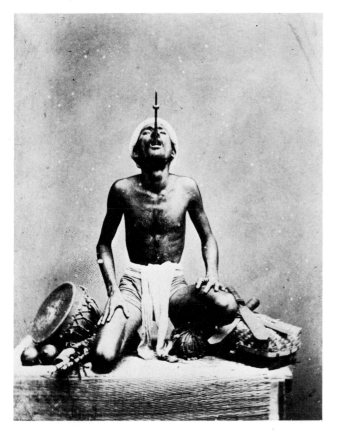

Sword swallower. At the South Kensington Exhibition of 1873, there was an album of photographs titled *Trades and Occupations of India*, in response to English curiosity about the Empire. Among the many photographers were Nicolas & Curths of Madras, who took this picture of an Indian juggler performing the sword feat sometime between 1863 and 1873.

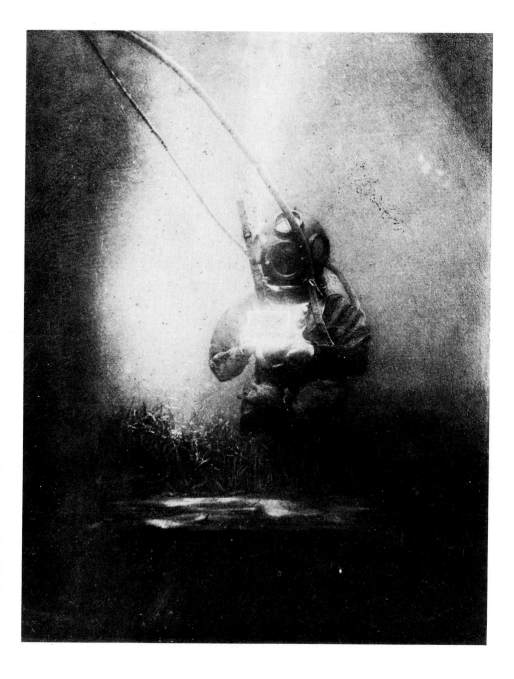

Underwater. Professor Louis Boutan at the Zoological Station in Banyuls-sur-Mer, Eastern Pyrenees, France, invented an underwater camera to explore the ocean floor. In 1893, these two pictures were made, the one of the sign by Boutan, and the one of Boutan by his assistant in the boat above. They were published with others in 1900 in *La Photographie sous-marine et Les Progrès de La Photographie,* in which Boutan also explained in detail the camera and the process. By 1912, divers were taking photographs underwater in color. Captain Jacques Cousteau named his first research vessel the *Boutan.*

Target. This picture is interesting not only because it is the first photograph of a target; it also resembles paintings in a movement that was to flourish one hundred years later—abstract expressionism. It was taken by Roger Fenton on July 2, 1860, at the first prize meeting of the National Rifle Association in Wimbledon.

A former painter who had studied with Paul Delaroche in Paris in the 1840s, Fenton could not have ignored the visual impact of such a composition, although the obvious concern he shows here with geometric shapes in the picture plane was entirely unknown in his day. Fenton did not make the photograph solely in order that the Queen could have a memento of her shot. Fenton chose to make this picture for his own reasons, and, liking the result, he matted his abstract picture and presented it to Her Royal Highness. It is still kept at the Royal Archives, Windsor Castle, but perhaps those who see the photograph today find it remarkable only because Queen Victoria almost hit the bull's-eye.

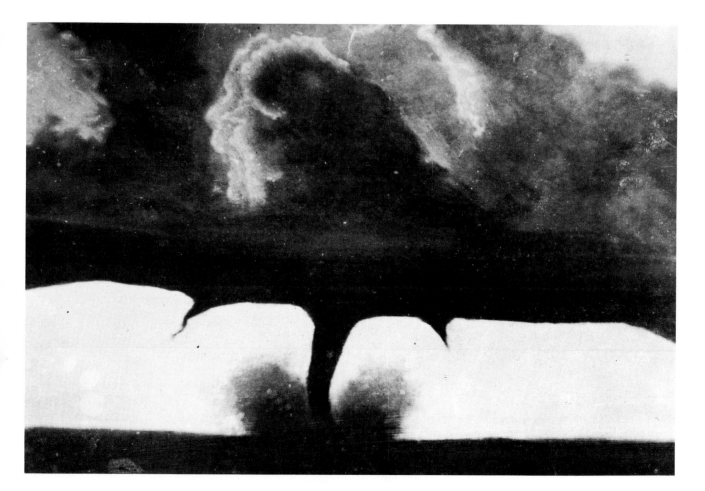

Tornado. Before 1884, the year this picture was taken, cameras had to be supported on tripods, and the glass plates had to be coated with collodion and light-sensitive chemicals before each long exposure. For outdoor pictures, the photographer had to travel with a portable darkroom. But the hand camera, using dry plates (photographic plates already prepared and available in shops) with faster emulsions (short exposure times), became popular around this date and a picture such as this one of a raging tornado near Howard, South Dakota, could not have been made until then. The winds and the erratic travel of a tornado would have defeated (and possibly killed) a terrified tripod-laden cameraman. The photograph was made on August 28, 1884.

Troops returning. Everyone cheers and the women cry when an army returns from the battlefield. The victors come home and no words can express the joy. It used to be the province of painters to commemorate the day, but starting with this daguerreotype of French troops returning from Italy (late 1849 or 1850), photographers realized this was to be their responsibility. We now re-view those days of victory (or defeat) in newsreel films, videotapes, press pictures, home movies, and personal snapshots—the more close-ups, the better. The victorious troops in this picture had been sent by Louis-Napoleon in 1849 to fight Mazzini and Garibaldi, who were trying to establish a Roman Republic.

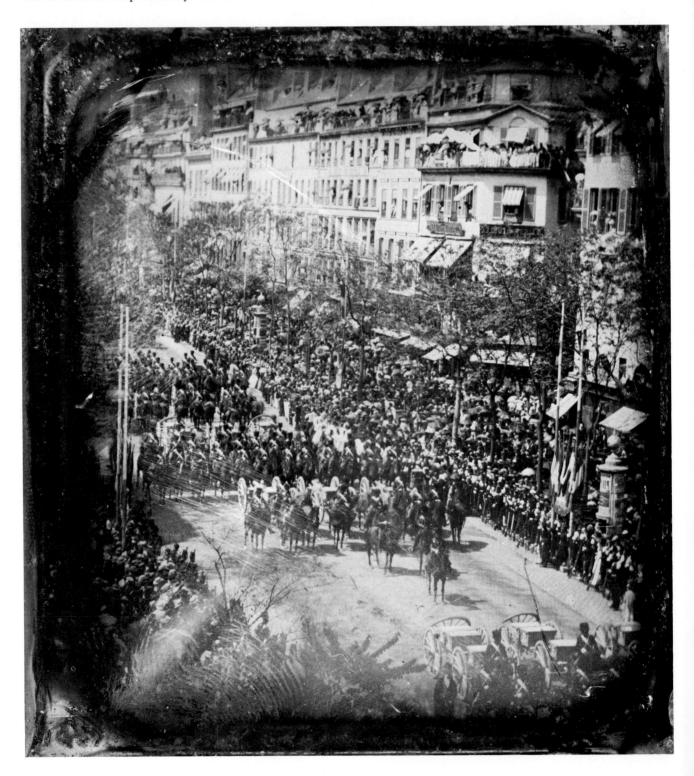

Theatrical production. At midnight one evening in September 1872, an unknown photographer stopped the action on the stage of the Prince's Theatre, Manchester, England. The play was Shakespeare's *Henry V* and the scene was the battle in Act IV. The actors are frozen on stage into a remarkable reenactment of a painting of the same subject. The photographer by this time had a choice of lights: candles, whale oil, gas, lime, acetylene, and magnesium flares. The footlights at the bottom of the picture probably would not have been sufficient to create the brilliant illumination of the figures.

Before this photograph was discovered, it was believed that the first picture taken in a theater of an actual production was by William Notman in 1880, who installed five hundred dollars worth of electric lights to provide sufficient illumination. He made a profit on it, nevertheless, through its sales.

Train crash. One of the first of untold millions of train, plane, and car crash photographs, this daguerreotype of the accident on the Providence and Worcester Railroad near Pawtucket, Rhode Island, August 12, 1853, strikes the viewer as remarkably strange. One realizes that this has less to do with the fact that the steam engines are in a frightful state than with the fact that this type of picture would be surrounded by a gilt frame—but this was not unusual for a daguerreotype. It is rare to see people unposed in such an early photograph; L. Wright was the cameraman on the scene. Most photographs of accidents are never published, but are used only for record-keeping purposes to provide police and judges with evidence, inform insurance companies, and help manufacturers learn what went wrong.

Tank (published). Britain's secret weapon in World War I was the tank, shown in this first photograph published on November 22, 1916. The *Daily Mirror* (London) paid the huge fee of £1,000 for the exclusive right to reproduce a set of these pictures. The German secret weapon was poison gas, which failed in the end because a shifting wind could blow the cloud back into the German trenches.

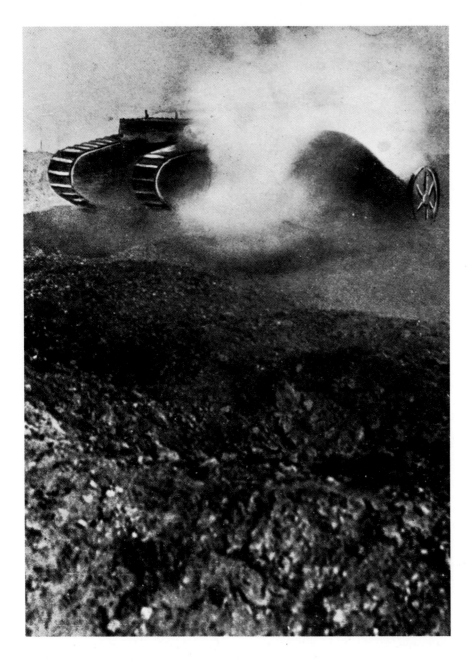

opposite, top:

Turban folding. This is from a group of photographs showing the trades of India, made by different photographers between 1863 and 1873 expressly for British viewing. By this time, British industries led the world in ingenuity and excellence and the public delighted in seeing the quaint craftsmen and their antique technology, as it validated their own unapproachable superiority.

By 1900, manufactured goods were replacing handmade objects even in Asia and Africa, yet ironically, it was the revival of cottage industries that focused Mahatma Ghandi's long, long pacifistic campaign against English industrial overlords and the British crown. Here is the trade of the folding of turbans.

opposite, bottom:

Tea plantation. Tea drinking was a vital part of the social pleasures in nineteenth-century England, and a lifesaver in all the corners of the Empire. Not only was the ritual a comforting reminder of home, but the brew itself was a mild palliative against the miseries of colonial life. Earlier, of course, the tax on tea forced on the American colonies had led to their Declaration of Independence. This picture, circa 1860, of Nepalese women sorting tea leaves on a plantation near Darjeeling, was at least one against the many thousands of pictures showing English folk with teacups.

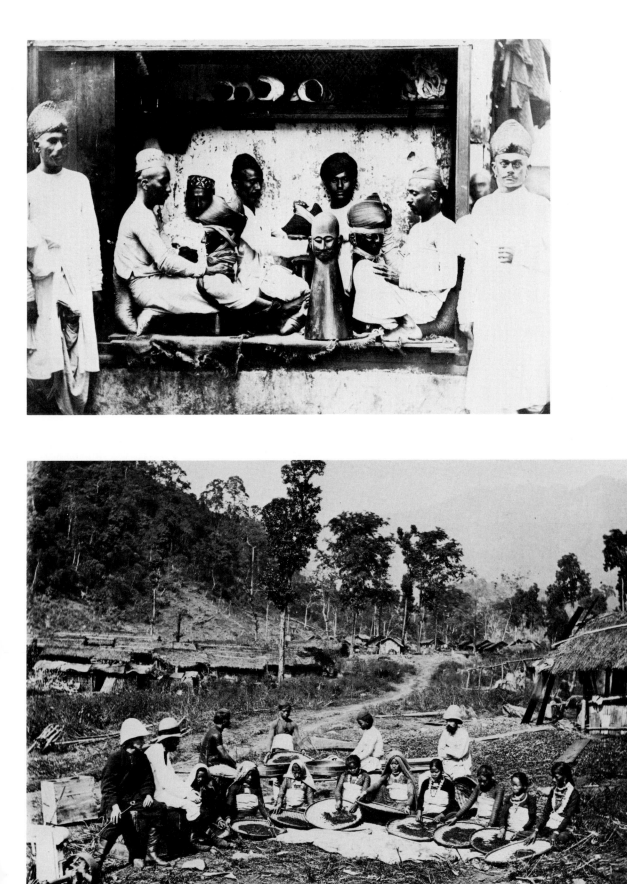

Transatlantic cable landing. The first invention using electrical impulses sent along a wire to transmit a message was built in 1816. Several basic improvements later, the world's first commercial telegraph was set up in 1839 between London and Birmingham. In 1865, the steamship *Great Eastern*, with propellers and paddle wheels, laid the first cable across the Atlantic from west to east. Three years later on July 23, the two-masted, square-rigged steamship *Chiltern* landed the end of a cable she had laid from England to Duxbury, Massachusetts. Here, in the first pictures of such an event on American shores, we see the cable being snaked across the sands while a thousand people watched and clapped and cheered. The impact these cables had on commerce, industry, science, the arts, politics, the military, banking, family relations, and everything else is well known.

opposite:

Telephone exchange. This is the switchboard of the first telephone exchange in Boston, 1883, and its operators. The very first exchange was built in 1878 in New Haven, Connecticut, but no pictures of it are known. By 1880, the number of exchanges was 138, scattered through the United States, with thirty thousand subscribers.

Trouser suit. Women have stepped into men's trousers many times in history. But the first trouser suit designed for Western ladies was worn with a short skirt and was modeled by the designer herself, Dr. Mary Walker, about 1865. The good doctor served on the medical staff of the Federal Army during the Civil War and was annoyed when her long skirts hampered her movements among the wounded. Yet women objected to her outfit, and when she was appointed to a position in the U.S. Treasury Department after the war, and refused to give up trousers, the women workers there campaigned against her and she never could assume her position.

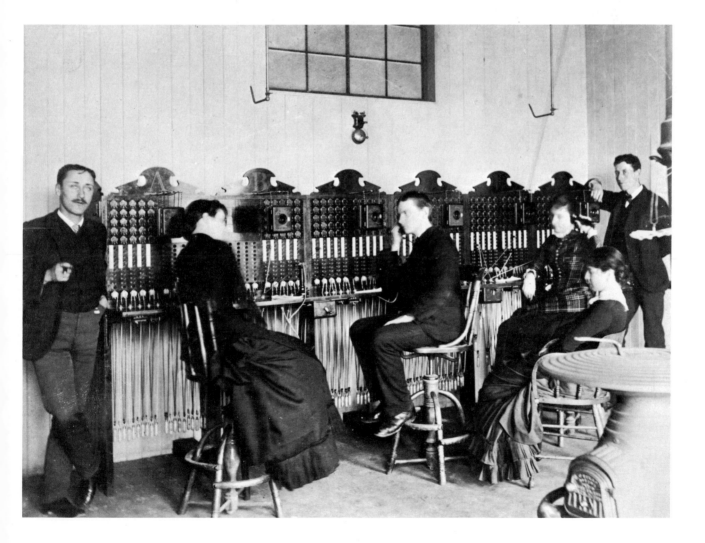

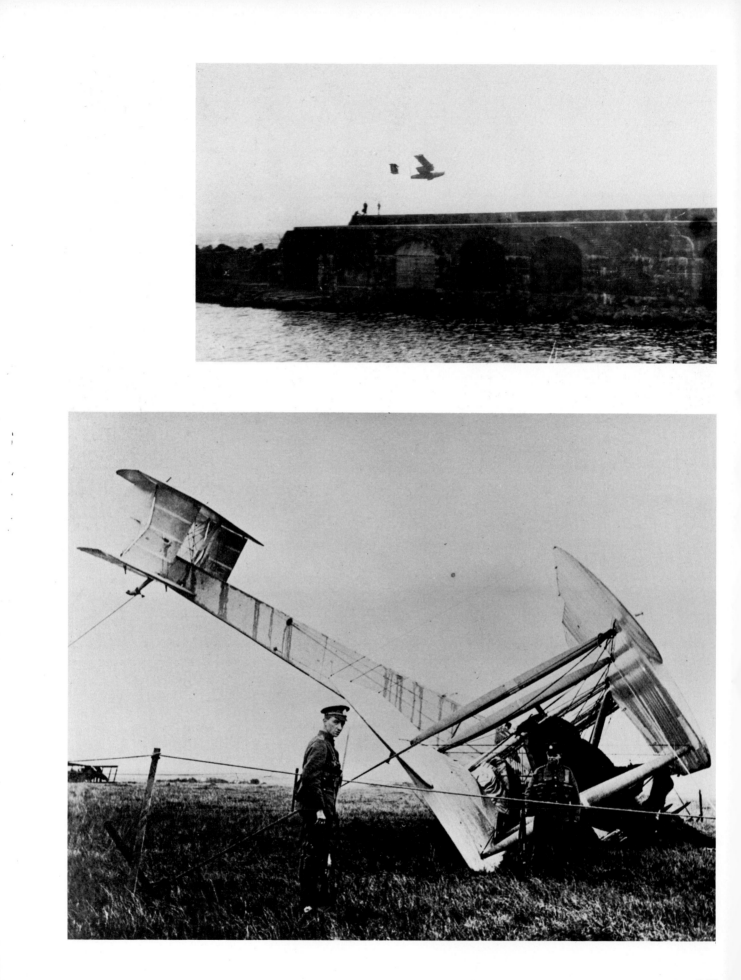

Transatlantic flights. Three U.S. Navy Curtiss flying boats left Rockaway, New Jersey, on May 8, 1919, heading for Plymouth, England. They touched down at seven places during the intended 3,925-mile journey. One plane crashed and sank but its crew was saved; one ditched 200 miles west of the Azores and taxied that distance to safety; and one flew the whole distance, arriving on May 31. The picture opposite (top) shows this plane landing in the Azores, with Lt. Cdr. Read and four crew members.

Also in 1919, the London *Daily Mail* offered a prize of £10,000 for the first nonstop crossing of the ocean, and Vickers, the aircraft manufacturing company, prepared the successful plane. Captain John Alcock and Lieutenant Arthur Brown, Britishers in the Vickers Vimy biplane, completed the first nonstop flight from St. John's, Newfoundland, to Ireland on June 14, 1919. The passage took sixteen hours and twenty-seven minutes. In the words of Captain Alcock, they picked the softest bog in the Emerald Isle to land on, which flipped their plane on its nose without injuring them, as seen in the picture opposite (below).

By far the most dramatic proof that the airplane had evolved into a reliable conveyance for world-girdling flights came when Charles A. Lindbergh piloted solo the *Spirit of St. Louis*, a high-wing monoplane, from New York to Paris, arriving on May 21, 1927. He won a $25,000 prize that a group of St. Louis businessmen had raised for the project. Lindbergh's courage in facing loneliness for 33½ hours over the empty ocean, his knowledge of aircraft and engines, and his navigational skill made him an international hero.

The photograph above shows Lindbergh's arrival at Le Bourget airfield at 10:22 P.M. Paris time. Lindbergh wrote: "I circled low over the field and landed. . . . The entire field was covered with thousands of people all running towards my ship. . . . I cut the switch to keep the propeller from killing someone . . . the ship began to crack from pressure of the multitude . . . no word could be heard in the uproar." The next day (Sunday) the *New York Times* carried the following headline across its front page: "Lindbergh Does It! To Paris in 33½ Hours. Flies 1,000 Miles Through Snow and Sleet; Cheering French Carry Him Off Field."

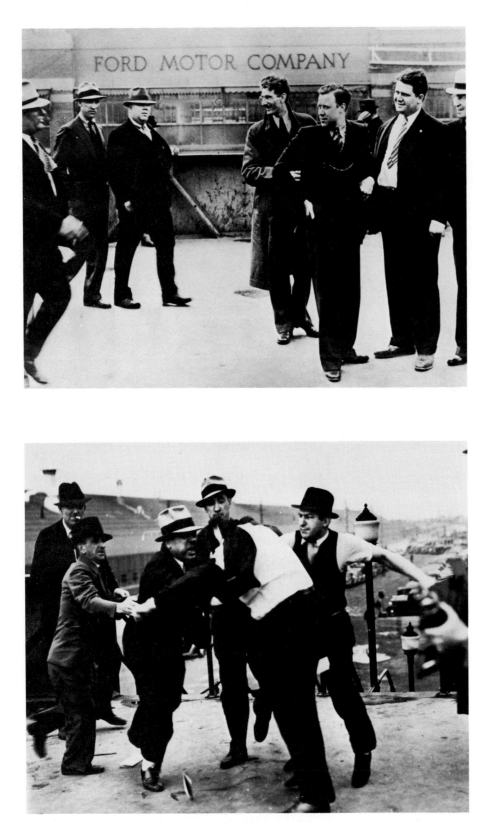

Union battle. On May 26, 1937, United Auto Workers organizers were attacked by members of the Ford Motor Company Service Department at the Rouge plant. This is probably the first time such fighting was documented by photographs. Robert Kanter, Walter Reuther, Richard Frankensteen, and J.J. Kennedy are left to right in the union group. Richard Frankensteen is the one being beat up in the second photograph. The photographer was James R. (Scotty) Kilpatrick.

The day before, Walter Reuther had told a reporter that he planned to have union men distribute organizational leaflets at the Ford plant, the management of which was strongly anti-union. When told, "You'll be beaten to a pulp," Reuther replied, "They won't dare. Not with all the photographers and reporters who'll be at the scene."

The next day, the union men handed out the pamphlets and all went smoothly until Kilpatrick, covering the event for the *Detroit News,* suggested that the union organizers should pose on an overpass, behind which could be seen the Ford Motor Company sign. Thugs appeared and fighting began in what came to be known as "The Battle of the Overpass." Naively, the Ford servicemen who demanded that Kilpatrick turn over to them all his photographic plates, accepted unexposed ones before Kilpatrick raced off to his newspaper offices with the actual pictures.

Union merger, AFL/CIO. Only twenty-five years ago, in December 1955, the two great unions of America merged after bitter fighting. In this photograph the magnetic Walter Reuther (left), then President of the Congress of Industrial Organizations, wields the gavel with the indestructible George Meany, then President of the American Federation of Labor, as they join their two organizations.

For twenty-seven years Sam Reiss was one of the leading labor photographers in the United States. He was the only photographer, although there were many present, who caught Meany and Reuther slamming the gavel down. Reiss had ducked a barricade and leaped onto the stage to snap what many call the greatest moment in labor history.

A working man himself, Reiss began recording labor history in 1948. He worked for the Amalgamated Clothing Workers Union, the Transport Workers Union, the International Brotherhood of Electrical Workers, the AFL/CIO News, and the New York City Central Labor Council. His pictures were used mostly for the labor press.

"You can photograph to hurt and you can photograph to help," said Reiss shortly before his death in 1975. "I try to show the dignity of working at an everyday job." George Meany, a keen amateur photographer, thought Reiss had a good occupation and once told him, "Sam, when I retire as president of the AFL/CIO I'm going after your job."

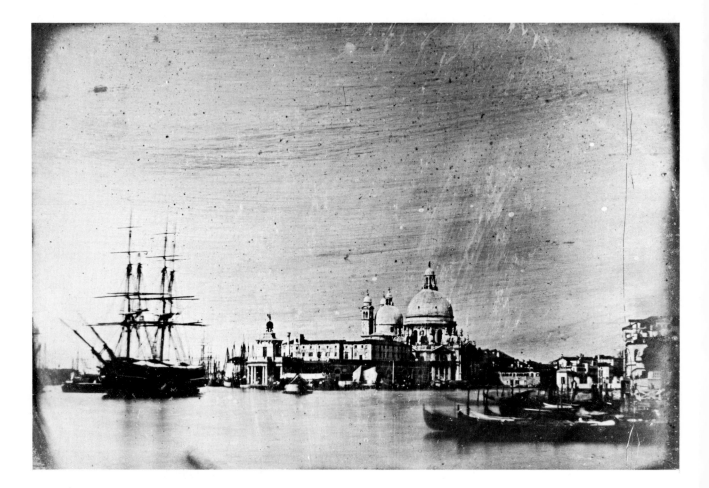

Venice, Italy. This picture shows the entrance to the Grand Canal with a ship at anchor and gondolas tied up. The daguerreotypist (most probably a Dr. Ellis) in 1840 or 1841 evoked a memory of the painter Canaletto, who, the century before, used the camera obscura for sketching identical scenes.

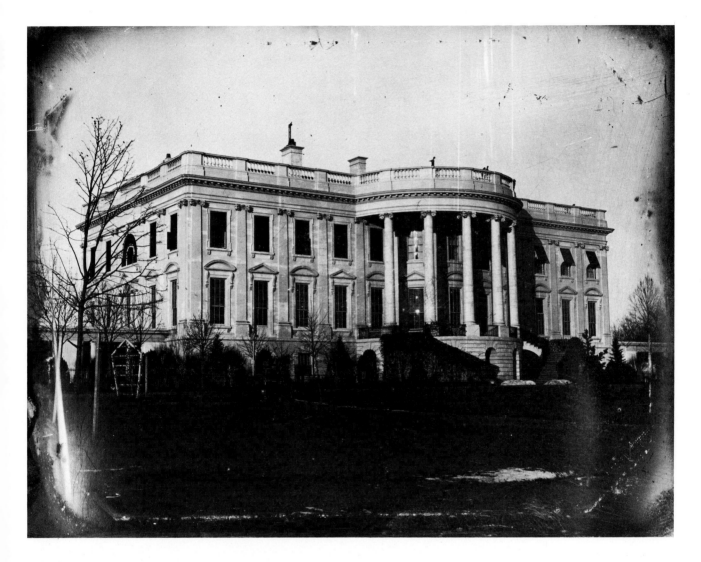

The White House. A daguerreotype made about 1846 by John Plumbe, Jr., shows a wintry view of President Polk's residence. By then, the whole world knew that the president of the United States lived in a white house—not a palace, not a castle, not a fortress.

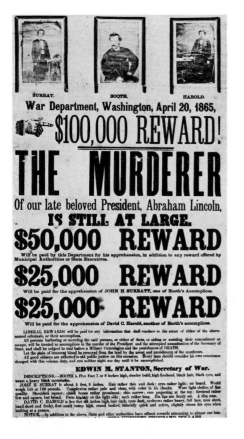

War Department, Washington, April 20, 1865,

☞ $100,000 REWARD!

THE MURDERER

Of our late beloved President, Abraham Lincoln,

IS STILL AT LARGE.

$50,000 REWARD

Will be paid by this Department for his apprehension, in addition to any reward offered by
Municipal Authorities or State Executives.

$25,000 REWARD

Will be paid for the apprehension of JOHN H. SURRATT, one of Booth's Accomplices.

$25,000 REWARD

Will be paid for the apprehension of David C. Harold, another of Booth's accomplices.

LIBERAL REWARDS will be paid for any information that shall conduce to the arrest of either of the above-
named criminals, or their accomplices.

All persons harboring or secreting the said persons, or either of them, or aiding or assisting their concealment or
escape, will be treated as accomplices in the murder of the President and the attempted assassination of the Secretary of
State, and shall be subject to trial before a Military Commission and the punishment of DEATH.

Let the stain of innocent blood be removed from the land by the arrest and punishment of the murderers.

All good citizens are exhorted to aid public justice on this occasion. Every man should consider his own conscience
charged with this solemn duty, and rest neither night nor day until it be accomplished.

EDWIN M. STANTON, Secretary of War.

DESCRIPTIONS.—BOOTH is Five Feet 7 or 8 inches high, slender build, high forehead, black hair, black eyes, and
wears a heavy black mustache.

JOHN H. SURRATT is about 5 feet, 9 inches. Hair rather thin and dark; eyes rather light; no beard. Would
weigh 145 or 150 pounds. Complexion rather pale and clear, with color in his cheeks. Wore light clothes of fine
quality. Shoulders square; cheek bones rather prominent; chin narrow; ears projecting at the top; forehead rather
low and square, but broad. Parts his hair on the right side; neck rather long. His lips are firmly set. A slim man.

DAVID C. HAROLD is five feet six inches high, hair dark, eyes dark, eyebrows rather heavy, full face, nose short,
hand short and fleshy, feet small; instep high, round bodied, naturally quick and active, slightly closes his eyes when
looking at a person.

NOTICE.—In addition to the above, State and other authorities have offered rewards amounting to almost one hundred thousand dollars.

Wanted poster (U.S.A.). Probably even ancient Egyptians posted notices informing and urging the general public to action. The photographic historian Helmut Gernsheim writes in his *History of Photography* that the first wanted notice with a photograph was made in France in 1854. It had a picture by Lerebours of Pianort, the man who had tried to kill Napoleon III, and was circulated to police forces in France and other countries. But the first time a wanted poster with a photograph was put in public places by the police was in England, in 1861. Nine years later, Parliament made the photographing of criminals compulsory. The picture at left is the earliest extant wanted poster with photographs from the United States.

below:

War. This is one of the four or five daguerreotypes that could be called a document of the Mexican War and the earliest photographic record of any war. General Wool and his staff are riding through Saltillo, Mexico, in the winter of 1846-47. The photographer is unknown, probably not a soldier encumbered by the complicated equipment but, rather, a local Mexican daguerreotypist.

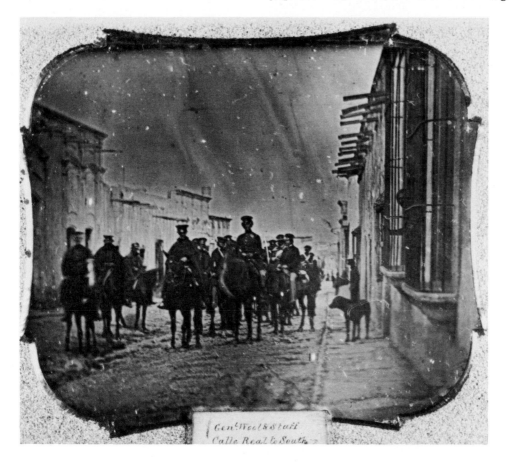

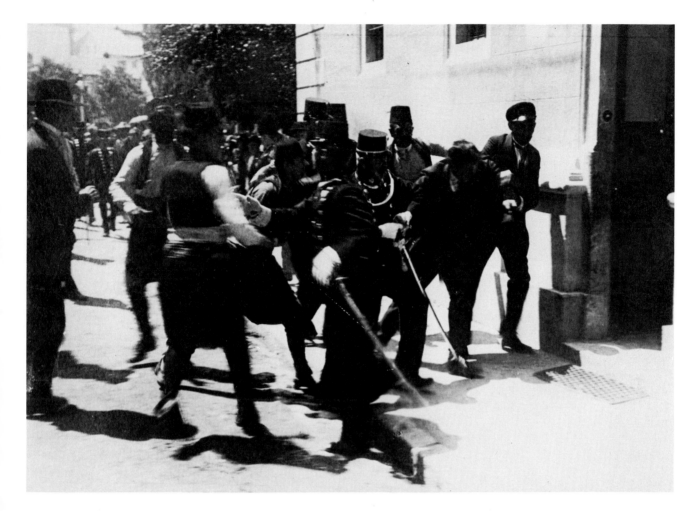

World War I prelude. The clouds forecasting war had been moving across the European sky for some years, though most governments did not believe that anything more than border disputes would break out. Then on June 28, 1914, Archduke Ferdinand, heir to the throne of Austria-Hungary, and his wife, the Duchess Sophie, were assassinated during a parade in Sarajevo. The assassin, a Serbian student named Gavrillo Prinzip, was a member of the Serbian nationalist movement that wanted independence from Austria. The sequence of events immediately following the day this picture was taken could be compared to a house of cards falling—the house being a complicated structure of international treaties both secret and public, alliances, promises, ambitions, and jealousies, drawn up as a peaceful balance of power among the nations of Europe and the Orient. The first world war in history was in full swing only weeks later. The photographer was Philipp Rubel, and Prinzip is the figure second from the right. The above is the third of four pictures made of the incident that historians claim precipitated the Great War.

It is worth noting here that historical events have been commemorated pictorially ever since Sumer, the first civilization, was founded. Emperors, kings, dictators, presidents, and generals commissioned painters and sculptors to depict the great moments for future generations of plain folk. In the 1850s the notion was beginning to grow that photographers could also do the job; Roger Fenton, for example, photographed the generals on the Crimean battlefield. By the 1880s, the action that artists composed in their historical paintings, distinct from portraiture, became possible for photographers. And they took full advantage of this by turning up with their equipment at important, newsworthy, public events.

Clearly photographers had several enormous advantages over the painters; most important was fidelity of detail. Speed of distribution was almost as important, especially as this often occurred so quickly authorities did not have time to censor the record. Finally, since anyone can manipulate a portable camera, and do it without even being noticed, amateurs as well as professionals began to make historically important pictures.

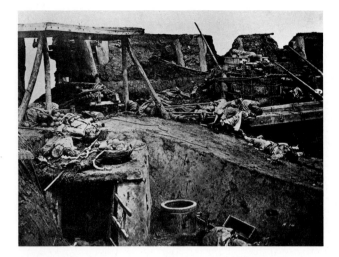

War dead. Romanticized war movies make the battlefield action quite exciting. Still photographs of the real thing are, in contrast, sobering. Although bloody scenes of battle have been painted for centuries, photographers only gradually considered the recording of war dead something they could respectably and patriotically do. It was not until 1860

that the gruesome aftermath of a battle was photographed. Felice Beato showed the actual dead after the battle at North Taku Fort during the China War. The Crimean War was fought and photographed five years before, but the photographic record left behind shows the idealization of war more than the reality.

During the American Civil War, however, Mathew Brady made photographs of Antietam that prompted Oliver Wendell Holmes to write in the *Atlantic Monthly* for July 1863:

Let him who wishes to know what war is look at this series of illustrations. These wrecks of manhood thrown together in careless heaps or ranged in ghastly rows were alive but yesterday. . . . Many people would not look through this series. Many, having seen it and dreamed of its horrors, would lock it up in some secret drawer, that it might not thrill or revolt those whose soul sickens at such sights. It was so nearly like visiting the battlefield to look over these views, that all the emotions excited by the actual sight of the stained and sordid scene, strewed with rags and wrecks, came back to us, and we buried them in the recesses of our cabinet as we would have buried the mutilated remains of the dead they too vividly represented.

War casualties (Great Britain). This picture shows three men, all age twenty-three, who fought in the Crimea. Left to right they are: Private William Young, whose feet were amputated after a shell wound on June 18, 1855; Corporal Richard Burland, and Private John Connery, whose legs were amputated because of frostbite. The Crimean War was the first war fought with modern weapons and communications and it was bungled from beginning to end at every possible level, resulting in more deaths from other causes than from enemy bullets. That was why Florence Nightingale went out to organize nursing.

Queen Victoria, Prince Albert, and their eldest children sometimes inspected the sick and wounded upon their return to England, occasionally in the garden of Buckingham Palace and sometimes at military hospitals and bases. Young, Burland, and Connery were seen by the Queen at Brompton Barracks, Chatham, with about seven hundred other disabled veterans. The day after such a visit, she sometimes ordered photographs to be made of the severely wounded who had attracted her attention— an interesting insight into her character. That there are no photographs taken of the dead and wounded

on the battlefield of the Crimea is often explained by authorities as due to the belief that "Victorian" taste would have been offended by such pictures and therefore photographers did not take them.

Queen Victoria also commanded that the deputy Inspector-General of Hospitals choose which men would be given artificial limbs, paid for from Her Majesty's Privy Purse, and they were photographed, too.

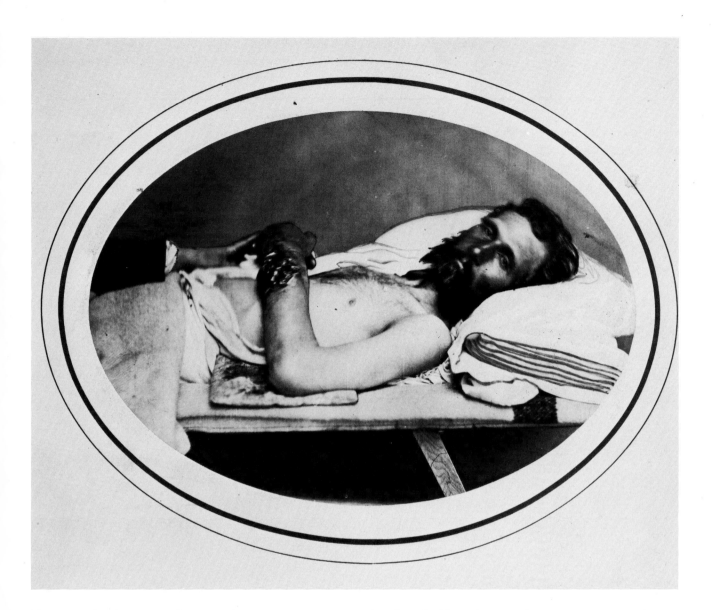

War casualty (U.S.A.). The Armed Forces Institute of Pathology has sixty-two albums dating from 1864 to about 1876 of photographs and case histories of Civil War casualties. Sometimes the wounds were hand-colored in red. Sometimes, if the photographs were to be on display—as they were in 1876 at the Philadelphia Centennial Exposition—fig leaves were placed in the correct position on the portraits of soldiers with minor wounds. No photographs of major amputations were shown to the general public, who had come to the Centennial to commemorate the birth of America.

The photographs have contradictory messages. One of a horribly wounded soldier might have the eyes retouched, making them even more sympathetic and yearning than they naturally were. (The photographer probably was only carrying out his normal studio procedures.) In the studio shots, young boys and men stand next to photographers' props, the headrest holding them as they pose wearing only a shirt. Handsome young men lie on hospital cots exposing enormous wounds or bedsores that sometimes developed because no one had the time to move the patients. Often, before an amputation, a photograph was taken and notes detailed to tell exactly what was going to happen. Unquestionably, amputations in the nineteenth century were far, far more drastic than they would be today. (Piles of legs and feet were also photographed, for no apparent reason.)

These photographs documented the surgical aspects of battle wounds and recorded the medical prognosis, the action taken, and the result. Never before had such a series been made, but it was filed in medical libraries and the general public remained uninformed about the more grisly realities of war. These photographs were also used to confirm the formal claims made for pensions by the veterans.

Zulu and Earthmen. By the mid-nineteenth century, anthropology was beginning to take shape as a scientific discipline. Natives of what were called primitive cultures were shipped to Europe and America to be exhibited to scholars and the general public. They were also photographed and the pictures sometimes sold as educational material. Above, right, are children of a tribe called the Earthmen. The picture was taken August 8, 1853, by Nicolaas Henneman, who also photographed this Zulu Kaffir on June 14, 1853, in his London studio. Both pictures were sent to Queen Victoria, who no doubt saw them as further proof of the humanitarian ideals in British colonialism.

Witch. Were people too frightened to photograph witches before 1880? Or were witches frightened of the black box? Even though witch hunts reduced their numbers and industrialization made their services to the community less necessary, still there are self-avowed witches even today, and some should have been vain enough to pose in the first four decades of photography. Photographers made scores of pictures of the Welsh ladies in their traditional high hats on which some witch costumes were modeled, but no one seemed to want to tangle with the real thing. This witch and prophetess in Tahiti might not have known or cared about the contraption that Col. H. Stuart-Wortley carried with him on his travel in the South Seas. The photograph is reproduced in his book *Tahiti*, with text by Lady Brassey, published in 1882.

Western Canada, the 49th parallel. In 1858, the British government sent a group of Royal Engineers under Lt. Wilson to survey the border between the U.S. and Canada. A photographer went along, packing his cumbersome glass plates. The terrain across which they had to determine a border would have turned lesser men back. Actually, the first photographer did desert and had to be replaced. The report of the engineers' four-year ordeal reads like a document of man against nature. The picture barely suggests the difficulties. What cannot be shown are the biting insect pests, the cold and wet, the monotony of diet, the general hardships in unknown country, and the long, long isolation. Luckily, the Indians they encountered were peaceful.

By this time, individual photographers were also adventuring in the Middle East and Asia with the same equipment, but their numbers were few. Lt. Wilson, after the successful Canadian survey, was sent to map Jerusalem and the Sinai. Whereas in the Rockies the water for washing the plates had frozen, in Egypt the dust-laden winds ruined collodion negatives.

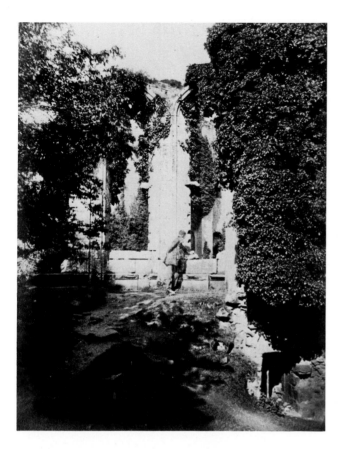

Wet-collodion. In the 1860s and 1870s, one method of photography dominated over all others. It was called the wet-collodion or wet-plate process and was invented by the Englishman Frederick Scott Archer (1813-57). Julia Margaret Cameron, Roger Fenton, Nadar, the Civil War photographers Mathew Brady, Alexander Gardner, and Timothy O'Sullivan; and Francis Frith, Henry Peach Robinson, O.G. Rejlander, and countless other famous and anonymous, professional and amateur cameramen and women used this difficult, but exquisite, means of making pictures.

The wet-collodion process ousted both the calotype and the daguerreotype by the end of the 1850s. This photograph of Kenilworth with the ghost figure of Scott Archer himself was made in 1850 or 1851. It is from a group in an album titled *Photographic Views of Kenilworth*, which has written in the front the following: "The First set of Views taken by Scott Archer by his newly invented Collodion Process . . . Ruins of Kenilworth 1851."

Words and picture. There is a big difference between a caption to a photograph and words included by the artist in the picture itself. The first is purely informational; the second, part of the composition. There is a growing number of photographers today, classified as conceptual artists, who use writing as part of the aesthetics of their pictures, reflecting on the relationship of a word to the object. The above, made about 1857, is an early, perhaps original, attempt to do this.

It is also interesting to note that another preoccupation of photographers today is focusing on the texture and pattern of walls constructed of individual bricks. This goes along with the scientific concept that all things are assemblages of smaller units, more or less alike—atoms are the building blocks of matter, as cells are of life, and stars are of galaxies.

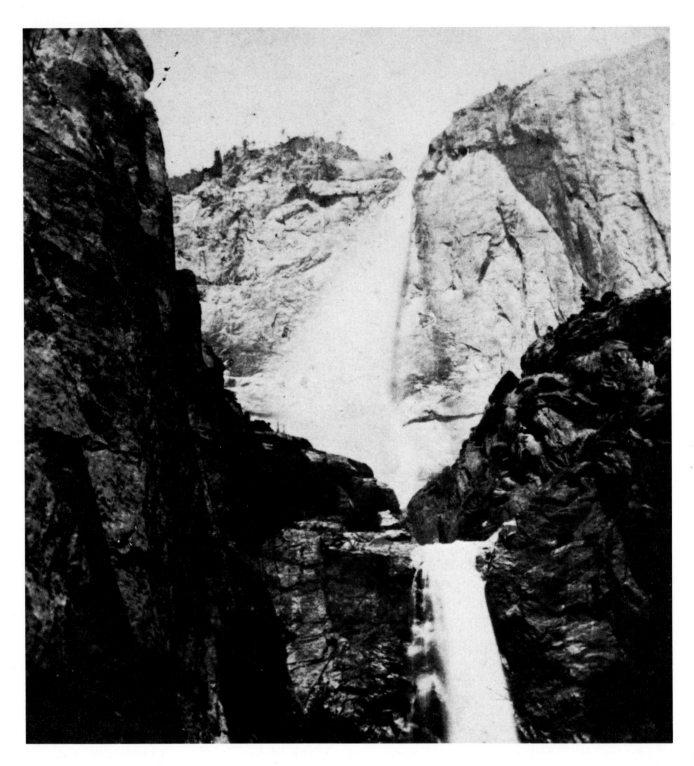

Yosemite, California. Taken at 11:25 A.M., June 18, 1859, this photograph of Yosemite Falls by Charles Leander Weed is the first of this very photogenic and popular territory, but as a stereograph it is poor. Soon after, however, some of the best photographers in America, such as Carleton Watkins, William Bell, and Edweard Muybridge, took Yosemite as the finest challenge to their skill. Today, Ansel Adams's work makes the public gasp with amazement. Weed took at least twenty large glass-plate negatives and forty stereo views during his first visit. His photographs of Yosemite five years later show a much improved technique.

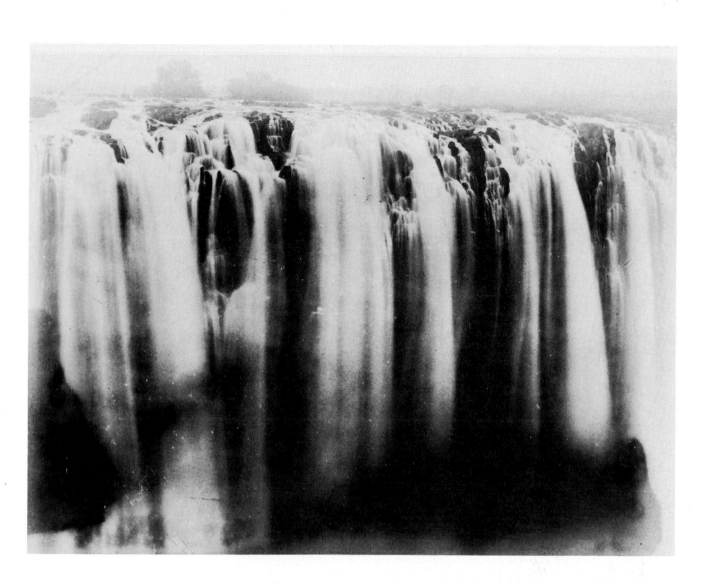

Victoria Falls. The most publicized target in the first explorations of Africa by Westerners during the nineteenth century was the source of the Nile. In the course of discovering passageways into the heart of Africa, Victoria Falls was found on November 17, 1855, by David Livingstone, whose private aim was to spread the Gospel, generate trade, and abolish the slave markets. Not until 1892 did W.E. Fry take this photograph of Victoria Falls, the source of the White Nile. It is one of a group of thirty-nine pictures Fry took of the Falls and deposited at the Royal Geographical Society.

The natural wealth of Africa, a source of animal skins, ivory, gold, precious stones, and slaves, has lured adventurers since the pharaohs. And between 1880 and 1912, all of the great continent except for Liberia and Ethiopia had come under the control or protection of European powers seeking to exploit this wealth.

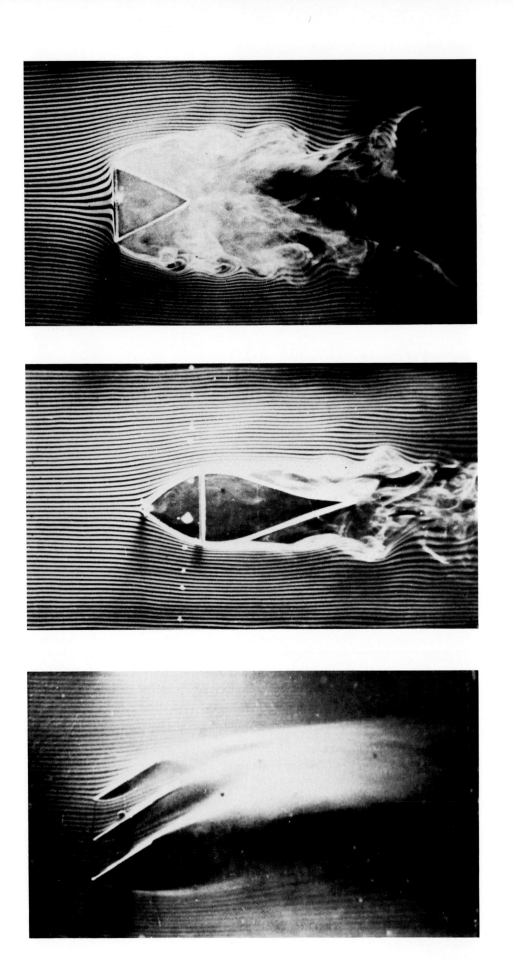

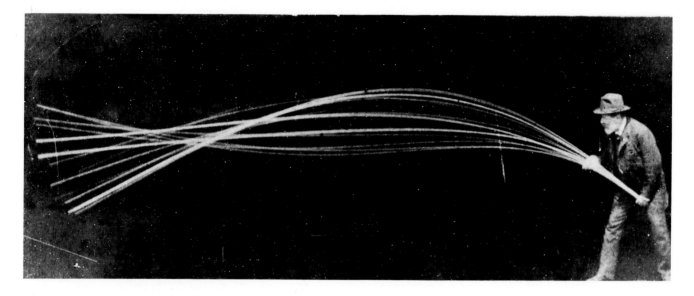

Wave motion. The study of waves is as old as physics. The method called chronophotography, devised by Marey helped enlarge this field of study. This photograph dates from about 1884, and the figure holding the flexible cane appears to be Marey himself.

opposite:

Wind tunnel. The urge to pioneer in photography has produced truly remarkable results. In 1873, Etienne-Jules Marey published pictures of birds in flight, using his own specially designed camera. This work led to an interest in aerodynamics generally, and in the 1890s, Marey built a wind tunnel. The first wind tunnel, for the purpose of studying flight, had been designed in 1871 by two Englishmen, F.H. Wenham and John Browning, but taking photographs in a tunnel had to wait until Marey thought of doing it and devised a method.

These are the first such pictures made, using objects with different shapes suspended in a steady flow of air impregnated with smoke. The smoke created visible patterns in the flow around the object, showing turbulence and thus revealing which shapes created the least resistance. Marey's experiments were basic to the development of the science of aerodynamics.

X-ray. The Crooke's tube was a device invented in the 1880s for studying the emission of what came to be called electrons from the negative pole of an electrical circuit. Nothing was known of the structure of atoms at the time. In 1890, W.N. Jennings and Professor Goodspeed of the University of Pennsylvania obtained an X-ray picture while experimenting with a Crooke's tube. Not knowing anything about this strange type of rays, they could not understand what they had obtained.

X-rays for medical purposes were discovered in 1895 by Wilhelm Conrad Roentgen, then professor of physics at the University of Würzburg. Seen here is the initial and famous X-ray photograph made that year of a hand with a ring. In 1901, Roentgen received the first Nobel Prize for Physics for his discovery of X-rays, ushering in the age of modern physics and revolutionizing medicine. By 1898, as can be seen in this picture of an army surgeon and a patient in Egypt obviously unaware of the lethal effects of X-rays, the British were taking X-ray photographs of broken bones. There is even an earlier photograph, however, showing an X-ray being made. It is a picture dated 1896 and was taken in Colorado where Dr. C.E. Tennant and H.H. Buckwalter had made X-ray apparatus from parts gathered from Denver telephone and electric companies.

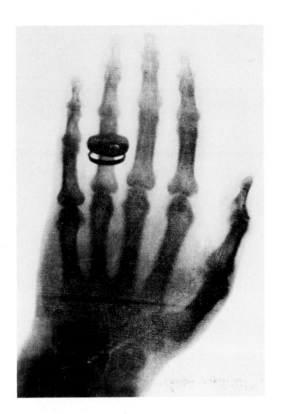

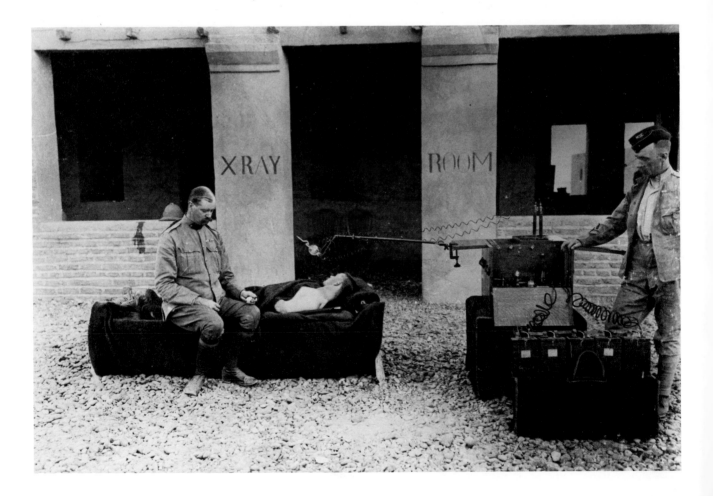

By wire. Today Associated Press and United Press International have hundreds of wire, cable, and laser transmission and receiving stations all over the world. Images of events happening around the globe arrive within minutes of their being transmitted. But as early as 1901, Professor Alfred Korn in Munich had developed an apparatus for sending simple figures and signs by a process called scanning. By 1905, he had refined this and sent his first photograph, a picture of the prince regent of Bavaria, seen above. He was not the only inventor in the field; a Frenchman, Edouard Bélin, had also worked out a successful technique for transmitting photographs by wire.

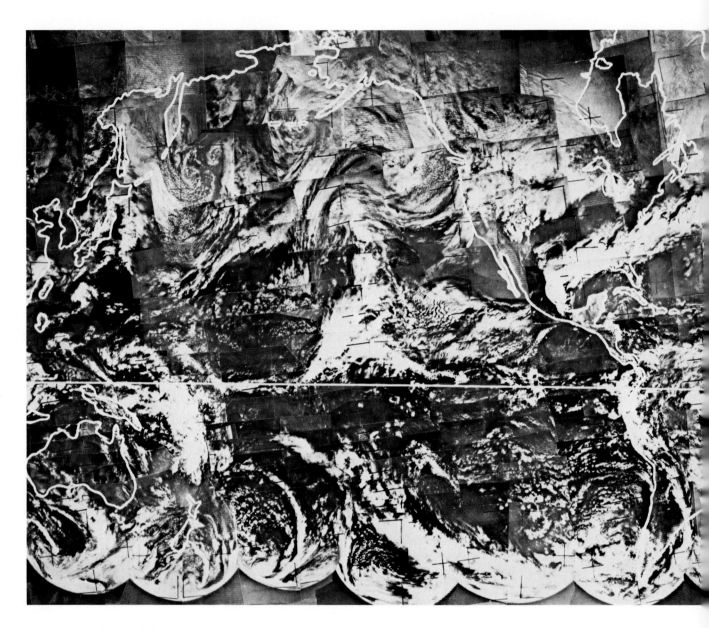

Weather of the world. The first complete view of the world's continuously changing weather was taken during a brief interval by the American satellite *Tiros IX* on February 13, 1965. All this information, never before collected in one image, gives the question "What kind of day is it?" philosophical proportions.

opposite:

Volcano in outer space. The space probe *Voyager I,* on March 4, 1979, took this picture of Io, one of Jupiter's moons, while it passed 310,000 miles away from it. On it can be seen several volcanoes. There are altogether nine planets of the sun, and they drag around with them a total of over thirty moons. Yet, until this picture was taken, no volcanoes except those on Earth were known to exist anywhere on those whirling bodies. The photographs of Io show eruptions going on all the time, and infrared measurements indicate a far higher surface temperature than was expected.

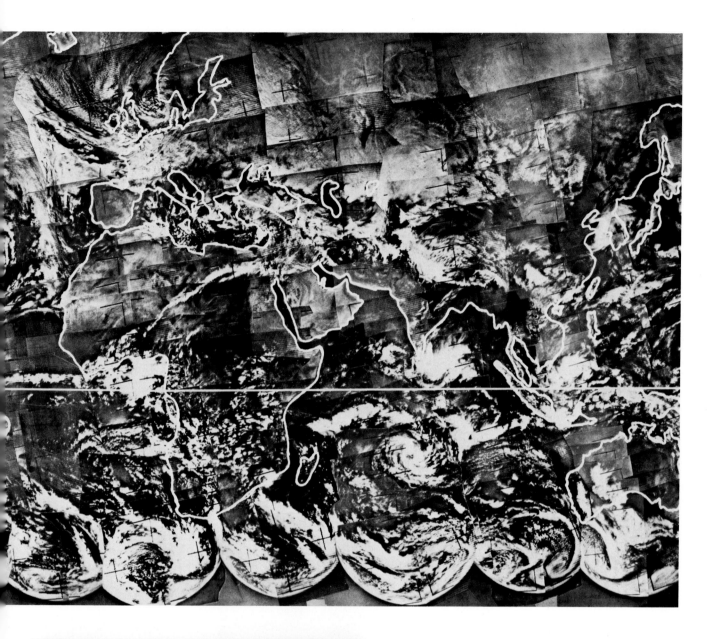

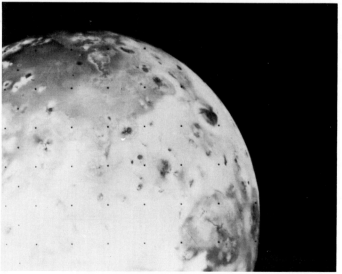

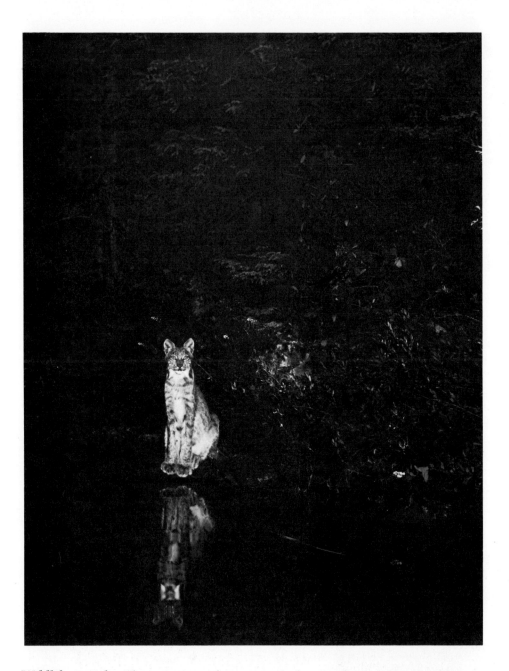

Wildlife at night. The pioneer in shooting animals at night was George Shiras, who gave up hunting for photography. Over many years he developed a flashlight device, used like a pistol, that got him excellent shots after he had located the game. Later he perfected a trip wire so that the animals could take their own pictures. From 1908, his work was published in *National Geographic Magazine.* The lynx gazes with sweet innocence above its reflection in 1909.

Arthur Radclyffe Dugmore shot a zebra for bait in 1909 to attract lions, set up two cameras and an electric flash apparatus, and with a companion settled down to wait in the blind. Suddenly the king was there, making his presence felt. The blinding flash sent him racing off a hundred yards and then to roaring thunderously. When a second lion joined him, the hunters changed the plates in the cameras and waited for another shot, but the lions had had enough and did not return. Here is one of the two portraits.

The importance of these, besides their charm, are that they are among the first photographs of each species in the wild.

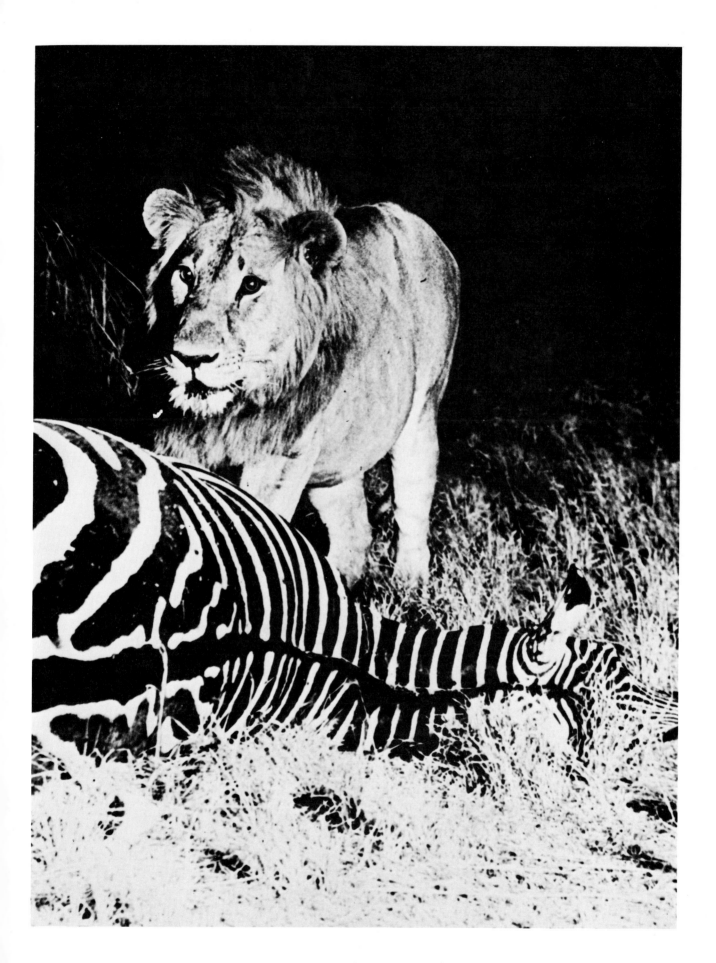

Glossary

Albumen paper Paper coated with a solution of egg white and salt made light-sensitive by applying silver nitrate. Introduced in 1850 by the Frenchman Louis-Désiré Blanquart-Evrard, it was the most popular photographic printing paper until the 1890s. It had a smooth, slightly shiny surface that was able to record the fine detail of the wet-collodion negatives from which early prints were usually made. Albumen prints are brown or sepia.

Ambrotype The name used in the United States for glass collodion positives, a type of photograph popular from the 1850s to the 1870s. It is a wet-collodion negative, slightly under-exposed, that is set against a dark background or painted black on one side so the image appears positive. Ambrotypes are sometimes mistaken for daguerreotypes as they, too, are mostly portraits and found in standard-size decorative cases.

Autochrome A process of color photography invented in 1903 by Auguste and Louis Lumière. This process was based on the use of equal amounts of microscopic starch grains dyed red, green, and blue violet which are mixed together and sifted onto a glass coated with a sticky substance, thus forming a color screen. The glass plate was then coated with a panchromatic emulsion, exposed in the camera with the mosaic toward the lens, developed, and then reversed. The final result appeared as a dense, positive color transparency. The first method of color photography to be put on the market (1907), it was introduced as sheet film in 1933.

Calotype process In September 1840, William Henry Fox Talbot discovered that by briefly exposing iodized silver nitrate paper in the camera, a latent image was produced that could be developed (made visible) with gallic acid. Exposure times were much shorter than in the photogenic drawing process, and portraiture on paper was possible for the first time. Calotype negatives were usually waxed to make them transparent and contact printed in daylight on salted paper. Virtually the only negative/positive process in use before 1850.

Camera obscura Literally "dark chamber"; the optical principle was known to Aristotle and was first described by the tenth-century Arabian scholar Alhazen. For centuries it was used by artists as an aid to drawing a scene. If a tiny hole is made in the wall of a completely darkened room or enclosure, a small, reversed image of the view outside will, under favorable circumstances, be thrown on the surface opposite the aperture. In later designs, the camera obscura was in the form of a portable box with a lens, mirror, and ground glass. This developed into the photographic camera.

Carte-de-visite Professional portraits (approximately 4 by 2½ inches) mounted on cards that were often exchanged between friends and relatives or purchased, if of a celebrity or nobility. Albums were designed and manufactured to fit this format, and the "family album" filled with *cartes*, as they were called, was a familiar sight in the Victorian home. Patented in 1854 in France by Adolphe-Eugène Disdéri, they were most popular from the late 1850s through the 1870s, but lasted into the beginning of this century. The negatives were usually made

with a specially built camera with several lenses that used wet-collodion plates; the positives were printed on albumen paper.

Daguerreotype The name of the photographic process discovered in 1837 by L.J.M. Daguerre and announced in January 1839. A copper plate with a silver layer was vigorously polished before being sensitized with iodine vapor. It was then exposed in the camera for several minutes, removed, and treated with a vapor of heated mercury until the latent image on the plate became visible. The picture had to be fixed and was usually gold-toned, covered with glass, and placed in a leather or plastic case or in a frame.

Glass collodion positive *See* Ambrotype

Photogenic drawing The name given by W.H.F. Talbot to a photograph made by the method he discovered in 1834 and announced two weeks after Daguerre's in January 1839. It was a negative/positive process in which plain writing paper was treated with a silver chloride solution. The paper could be used for making photograms (laying objects on the paper and exposing it to light) or in the camera or solar microscope. The negative, often waxed to make it transparent, could be reversed (made positive) by putting it in contact with another piece of photogenic drawing paper and exposing it to natural light.

Paper negative Generally a negative produced either by Talbot's photogenic or calotype processes or Gustave Le Gray's waxed-paper process. The term simply refers to a negative on a paper base, as opposed to glass or film. Paper negatives are still made today for various purposes.

Salted paper Usually photogenic drawing paper.

Stereograph A pair of nearly identical photographs mounted on a card 3½ by 7 inches that give the illusion of three dimensions when viewed with a stereoscope. The photographs are taken from two points whose distance apart is approximately the same as an individual's eyes. The pictures can be made with one camera that has two lenses, called a stereoscopic camera, or with two cameras set at the correct distance apart.

Stereoscope Viewer in which stereoscopic pictures (stereographs) can be seen as a single image in three dimensions. They were a familiar feature in nineteenth-century drawing rooms after the Great Exhibition of 1851.

Stroboscopic flash Electronic flash unit that can be repeatedly fired, at intervals ranging from hundreds to thousands per second, to produce ultra-high speed photographs or multiple-exposed photographs that record progressive stages of a movement on one negative. Often referred to as a "strobe" light.

Waxed paper process Introduced by Gustave Le Gray in 1850, this is a modification of the calotype process. The paper was treated with wax before sensitizing, making the paper transparent and improving its image-retaining qualities.

Wet-collodion This process required a sheet of glass to be coated with a collodion-containing potassium iodide and other iodides and then dipped in silver nitrate. The glass plate was exposed in the camera while still wet, developed directly after exposure, and then fixed. Invented by F. Scott Archer, the description was published in 1851 and used extensively until the 1880s. This is also referred to as the wet-plate process.

Photo Credits

Courtesy of The American Museum of Natural History: 98, 99, 174 (bottom)

American Petroleum Institute: 169 (bottom)

Annan, Photographer, Glasgow: 204 (bottom)

The Archives of Labor and Urban Affairs, Wayne State University: 115

Armed Forces Institute of Pathology: [negative no. 75-10848-8] 241 (top), [negative no. 77-6891-21] 251

A.T. & T. Co. Photo Center: 241 (bottom)

Courtesy of Dr. H.D. Babcock: 81 (bottom)

Bancroft Library, University of California, Berkeley: 256

Barnardo Photo Archives: 178

Bayerische Nationalmuseum: 177

The Beinecke Rare Book and Manuscript Library, Yale University: 248 (bottom)

Bettman Archives: 32, 54 (top), 120 (top), 248 (top), 260 (top)

Bibliothèque Nationale: 26, 72 (bottom), 79, 103 (bottom), 132, 133

Bildarchiv Preussischer Kulturbesitz: 37, 63

Courtesy of Alfred M. Bingham: 155

Birmingham Public Library: 75

Courtesy of the Boston Public Library, Print Department: 27

British Museum (Natural History): 24 (top and bottom, left), 193

Buffalo Museum of Science: 221 (right)

California Historical Society: 34, 35, 53 (top), 179 (bottom)

California Historical Society/Title Insurance and Trust Co. (Los Angeles Collection of Historical Photographs): 130

California State Library: 171

Courtesy of Walter Clark: 92

The Coca-Cola Company. Courtesy of the Archives: 71 (top)

Crown copyright, Ordnance Survey, Southampton: 148, 149

Crown copyright, Science Museum, London: 24 (bottom, right), 40, 76 (bottom), 117, 125, 138 (bottom), 147 (top), 150 (top, left), 157 (bottom), 164 (top), 180, 182 (top), 188, 189 (bottom), 191 (top), 220, 246

The Daily Mirror, London: 143, 238

Photograph by Stephen Dalton: 109

Detroit News photo by James R. Kilpatrick: 244

Deutsches Museum: 116, 194, 224, 225

Drake Well Museum: 169 (top)

Dr. Harold E. Edgerton: 121, 168

Edward Epstean Collection. Rare Book and Manuscript Library, Columbia University: 232, 233

Flaherty Collection, Rochester, N.Y.: 172

Florida Photographic Archives, Florida State University Library: 30

Fotogram, Agence Photographique, Paris: 198 (bottom)

Foto-Historama, Agfa-Gevaert AG: 50 (bottom)

John A. Fairfax Fozzard: 96, 97

Gabinetto Comunale delle Stampe, Archivio Fotografico Comunale, Rome: 119

General Research and Humanities Division. The New York Public Library. Astor, Lenox and Tilden Foundations: 58, 59 (top), 69, 128, 157 (top), 165 (bottom), 199, 240, 253, 261

Collection GERARD-LEVY, Paris: 66, 173

Gernsheim Collection, Humanities Research Center, The University of Texas at Austin: 102, 176 (top)

Courtesy of Arthur T. Gill: 156, 181, 190, 211 (bottom)

Girl Scouts of the U.S.A.: 113

Courtesy of Mrs. Esther C. Goddard: 226

Guildhall Library, City of London: 218 (top)

Hale Observatories: 85, 111, 191 (bottom)

Harvard College Observatory: 83, 116 (bottom)

The Historical Association of Southern Florida, photo by Ralph Munroe, from The Forgotten Frontier, by Arva Moore Parks: 153

The Historical Society of Pennsylvania: 144 (bottom), 229

The Howarth-Loomes Collection: 110

India Office Library and Record: 51 (top), 129, 231 (bottom), 239 (top)

Institution of Royal Engineers: 64, 65, 101, 122, 217, 254

International Museum of Photography at George Eastman House: 44, 71 (bottom), 74, 78, 81 (top), 112, 118 (bottom), 145, 206, 236, 237 (bottom)

André Jammes: 41, 174 (top)

Copyright Dr. Cherry Kearton: 123 (bottom)

Keeneland Library, Keeneland Race Course: 126

Courtesy of William Langenheim: 166 (top)

The Library of Congress: 28, 39 (bottom), 47, 55, 60, 61 (bottom), 65, 91, 140, 141 (bottom), 169 (top), 170, 200, 204 (top), 213 (bottom), 228 (bottom), 231 (top), 247, 280 (top and bottom)

Los Alamos Scientific Laboratory: 42

The Manchester Public Libraries, Central Library: 114

Massachusetts General Hospital News and Archives: 36

Carl Mautz: 53 (bottom), 104 (top)

Ministère de la Justice. Services Généraux. Service d'Identification Judiciare, Brussels: 160, 161

Missouri Historical Society: 144 (top)

Courtesy of Richard Morris: 210 (top)

Musée Marey Beaune: 52 (top), 258

Musée National des Techniques du C.N.A.M. (Arts et Metiers): 162, 163, 259

Museum of the City of New York: 51 (bottom), 218 (bottom)

NASA: 86, 89, 90 (top), 94, 95, 150 (top, right; bottom), 151, 263

NASA/USGS EROS Data Center: 87

National Air and Space Museum, Smithsonian Institution: 31, 242 (top)

National Archives: 29, 62 (bottom), 108, 134, 135, 154, 167, 195, 214

National Army Museum, London: 49, 62 (top), 260 (bottom)

Copyright of the National Galleries of Scotland: 158 (right)

Copyright National Geographic Society: 48 (top), 197, 198 (top), 264

National Maritime Museum, London: 193 (top)

National Oceanic and Atmospheric Administration: 235

Index by Category

Index by Chronology